CHARLES M. RUSSELL

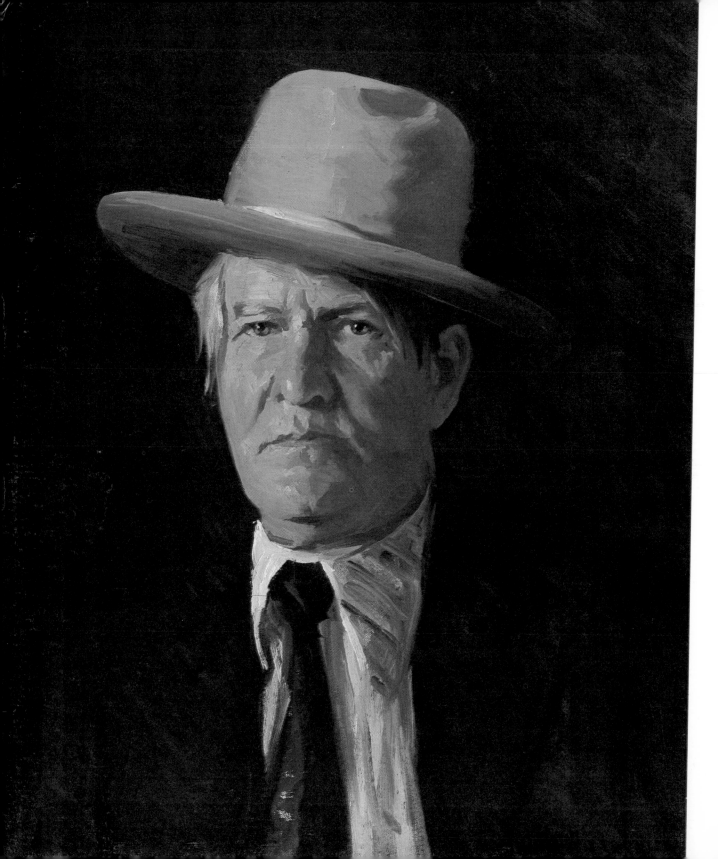

1. Russell Portrait

The Russells were spending the winter of 1924 in California when Nancy Russell persuaded her husband to pose for Arthur M. Hazard, the well-known portrait painter of Boston and Los Angeles. The result was this excellent likeness of the cowboy artist at sixty years of age. The painting was reproduced in the mid-December, 1926, issue of *The Art Digest*. The Grand Central Art Galleries of New York City and the Biltmore Salon of Los Angeles also used it as the cover illustration on their exhibition catalogs of Russell's work.

1924. Oil on canvas, 26 1/2 × 22 1/4″. Signed lower right: A.M. Hazard [Arthur Merton Hazard]. Ex-collection: Sid Willis, The Mint, Great Falls, Montana. (ACM 220.61)

Charles M. Russell

PAINTINGS, DRAWINGS, AND SCULPTURE IN THE AMON CARTER MUSEUM

by Frederic G. Renner FOREWORD BY RUTH CARTER JOHNSON

NEW CONCISE N A L EDITION

Published by HARRY N. ABRAMS, INC.
in Association with the AMON CARTER MUSEUM OF WESTERN ART
Distributed by NEW AMERICAN LIBRARY

The Amon Carter Museum was established in 1961 under the will of
the late Amon G. Carter for the study and documentation of westering
North America. The program of the Museum, expressed in
publications, exhibitions, and permanent collections, reflects many
aspects of American culture, both historic and contemporary.

LIBRARY OF CONGRESS CATALOGING IN PUBLICATION DATA

Amon Carter Museum of Western Art, Fort Worth, Tex.
Charles M. Russell; paintings, drawings, and
sculpture in the Amon Carter Museum.

Bibliography: p.
1. Russell, Charles Marion, 1864–1926. 2. The West
in art. I. Renner, Frederic Gordon, 1897–
ND237. 1976 709'.2'4 76-22656
ISBN 0-8109-2057-3

FOREWORD

To reminisce publicly about one's father is one thing; to write about his acquisition of a sizable collection of paintings and sculpture, in which one has shared but slightly, is quite another. Nonetheless, the task is dear to my heart, just as he was and as his memory is. I beg indulgence for moments of sentiment, as well as for reliance on outside sources for certain documentary information.

That one may estimate a man by what he collects is a true assumption in the case of my father. His art collection, like his religious beliefs, was an extremely personal affair, not shared with many. I am indebted to my mother, to Mrs. Carl Deakins, and to C. R. Smith for their valuable recollections of the years for which I have no exact memories.

Amon Giles Carter was born in a log cabin, its walls yet unchinked on December 11, 1879, in Crafton, Wise County, Texas. He attended the local country school until he completed the fifth grade. As with many men of his time, this was the end of any formal education for him. When his mother died in 1892, and his blacksmith father remarried, he "picked up stakes" and embarked on a series of adventures, which are typically those of self-made men of this great nation of ours. The success story came to an end on the night of June 23, 1955, after seventy-five years of accomplishments, among them, the founding of a highly successful newspaper-radio-TV complex, as well as substantial accumulations of the world's goods, a host of friends and numerous enemies, children and grandchildren, and a sizable collection of paintings and sculpture.

It is this collection with which I am concerned at the moment. As is true with many "proud possessors," my father's life and collecting run parallel with other giants of this country, who found inner hungers satisfied by the acquisition and enjoyment of the visual arts. Like others, he did not begin by assembling a collection but by purchasing a picture which captured his imagination, and then another and another. Through his friendship with Will Rogers he became acquainted with the work of Charles M. Russell. His first purchases were Russell watercolors in 1935, and the purchase money was borrowed. Almost simultaneously he purchased the first oil in the collection, Frederic Remington's *His First Lesson*.

To me, and to those who have known and loved my father, it is very understandable that he would have been a collector of the works of Russell and Remington. Always responsive to beauty and appreciative of it, his taste in art sprang more from an historic sense than from one of mere esthetics. The art of the West was to him a documentation of the history of a people and of a time with which he identified himself. His affection for these earliest acquisitions was to intensify the longer he lived with them and the more he collected. They were all his favorites.

The impact of the visual on him was obvious, because of its immediacy. He was always in a hurry, time being too precious for the more lengthy perusal of books and manuscripts or for the hearing of music. His comprehension of the visual material was instantaneous, though he had never been a cowboy or a soldier or a pioneer in the literal sense of the word. He bought paintings and sculpture because the work of art pleased him, and because he felt that it was good. My father's decisions to buy were delayed only by the lack of ready cash, and on more than one occasion he borrowed the money.

Essentially it was his pioneer spirit—his own courage, determination, and ambition—which conformed with the works of Remington and Russell. He felt very much at home with the characters they depicted, seeing in them the virtues which he admired—honesty, fortitude, and hope, as well as tenacity and "stick-to-itiveness" against difficult and often insurmountable odds.

One might be tempted to surmise that his collecting habits arose during his years of material affluence. His friendships ranged far and wide among men of great wealth, power, and sophistication. It can be safely said that never did he buy a painting for prestige purposes; the collection itself reveals his personality to such an extent that no one could conceivably think he bought for other than his own pleasure and edification.

The first time I reviewed the collection in its entirety I was amazed and excited to behold that my father's philosophies could shine through so decisively. In many of the works the artist revealed that life itself often depended upon individual alertness and courage, upon the tenacity and doggedness of a people facing the hardships and rigors of survival. My father could identify himself with these people and what they stood for, just as he could share their ambitions and all their strong emotions, which guaranteed successful existence in a young country like the West. There was no place in this pioneer environment for weaklings or sissies, and above all no place for mediocrity, which he loathed.

To my knowledge, my father never realized how the collection spoke for him, perhaps because it was never under one roof during his lifetime. Now it is most apparent—the entire gamut of his personality is shown. One notices in the paintings and sculpture the reflected attitudes of compassion and gentleness to women, children, and animals. Here on the canvas and in the bronze are my father's respect and demand for loyalty, honesty, and the assumption of responsibility and duty. His awe and wonder at God's Creation, and his never-ending response and delight in the created beauty of the world are revealed here.

My father was not an intellectual in the dictionary sense of the word. However, his own intellectual curiosity and tremendous acquisitiveness of facts and figures, coupled with a sensitive nature and extraordinary vision, gave him an understanding of the value of cultural pursuits to mankind. His humanitarian efforts are well documented, both in word and stone, but little has been said of his cultural pursuits. The newspaper accounts of his death, the eulogies heaped upon him, the attestations of his accomplishments—none mention his collection of art. One wonders why? His own interpretation of what the terms "educational" and "charitable" meant is revealing. At the time the Carter Foundation was established he made these remarks: "I have always understood, and have been advised that the term 'educational' includes sponsoring and promoting interest in and knowledge of paintings, sculpture and other things of an artistic nature; and that the term 'charitable' includes the exhibition to the general public, on a non-profit basis, of objects of art."

To say that my father was without ego would be a foolish statement. He had a great deal of it, and yet the satisfaction of it played a minimal role in his life. He enjoyed possessions, but was not possessed by them. He was a giver, not a taker, to put it bluntly. Being aware that his accomplishments were the result of Providence, as well as his own initiative and hard work, he never lost sight of the responsibilities of stewardship or denied them. This sense of obligation, along with his innate good taste, came, I believe, from his mother, who gave him so much of herself in those thirteen short years.

The environment of children soaks into their unconscious, and they take it for granted, not really bothering to notice it until change occurs, or outsiders bring it to their attention. The young simply accept living with art just as they accept the food they eat and the air they breathe. I cannot remember when I was not aware that there were paintings and sculpture in our home or at my father's office and club. Usually outside influences direct attention to what one daily lives with. Thus it was that my role in the collecting experience of my father began in my late teens, and by that time he was buying Remingtons and Russells like any avid collector.

Though not yet expressed in words, the concept of a museum to house the collection was firmly established, I believe, by the early 1940's. This would be another way for my father to serve and enrich his beloved city. He saw the future good which a museum could bring to a city and its population. No project was ever undertaken because of its popularity but because of its need. The paintings and sculpture were always intended to be shared with others. During the last decade of his life the museum concept became vocalized, and the purpose of the collection formalized. A site was selected and exhibition policies were discussed in broad outline. The pleasure of daily living with his treasures would never have been relinquished, so the museum was to be a posthumous creature.

Ultimately and naturally for him, the collecting of Russells and

Remingtons became a source of good for his beloved Fort Worth, not as a memorial to himself, but as an act motivated by a love for the city and for its people that had given him his opportunities and recognition. In acknowledging an indebtedness, he was willing to put together fine works of art for the benefit and enjoyment of others, to document for the young their pioneer heritage, showing them the American West, where opportunity lay waiting for those who had the courage, the determination, and the gumption to work hard in order to achieve their dreams.

Again, my father's own words speak far more eloquently than any others. I quote from his last will and testament:

I have learned while climbing the steep path of fortune and I have come to realize that they who acquire wealth are more or less stewards in the application of that wealth to others of the human family who are less fortunate than themselves. Year in and year out, it has been borne in upon me that money alone, nor broad acres, nor newspapers, nor stocks, nor bonds, nor flocks and herds, nor estates of oil and gas hidden in the recesses of this planet can, of themselves, bear testimony to the fine quality of a man or woman.

As a youth I was denied the advantages which go with the possession of money, and therefore, I am endeavoring to give to those who have not such advantages, but who aspire to the higher and finer attributes of life those opportunities which were denied me. I am a part of the heritage of Texas. Its pioneer spirit that peopled the wide spaces and laid the foundations of a happy future comes down to me in the strain of the blood, and I wish to share it with others who would make Texas their home and inspiration.

Finally, as heirs to this legacy of the spirit and ideals of our father, my brother and I, with his children and mine, are dutifully bound to protect and nourish it through the instrumentation of this museum which bears his name. I might add, sentimentally, that no statue, no portrait could ever represent him, what he was and what he did. Hopefully then, the excellence of the museum's program projects, the additions to the permanent collection, and the top quality strived for in everything connected with it must never waver or fall short. The philosophies and memory of Amon Carter will be kept alive by the vitality of the Carter Museum of Western Art, the beauty of the building itself, the collections, and the publications—these will be a most suitable and living memorial.

RUTH CARTER JOHNSON

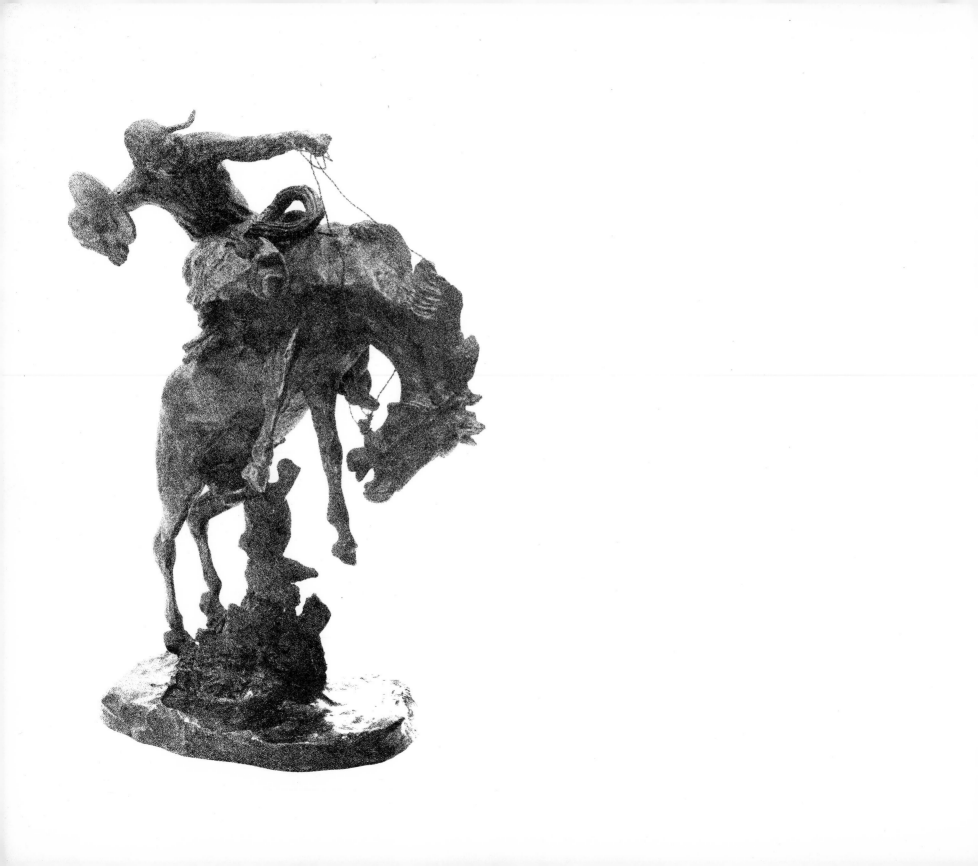

CONTENTS

ACKNOWLEDGMENTS

I am indebted to many persons and institutions for aid in the preparation of this book. To many of them I have made specific acknowledgment in the text and notes. I wish to express particular thanks, however, to Michael Stephen Kennedy and members of his staff, Miss Mary K. Dempsey and Mrs. Harriet Meloy, for giving me access to the records and files of the Montana Historical Society and for permitting much of the Russell material to be photographed; to Alexander and Robert Warden for allowing me to use the invaluable *Tribune-Leader* index to find information on Russell's early life in Montana as it was recorded in the files of these newspapers; to my wife, Maxine Renner, for her help of many weeks in reading these newspapers and assisting in the sorting out of pertinent facts about Charlie Russell and his friends; to Miss Helen L. Card for her generous gift of an unpublished manuscript, which told of Charlie Russell's first serious efforts as an artist; to the staff of the Amon Carter Museum of Western Art for supplying all curatorial data, and especially to its Director, Mitchell A. Wilder, whose enthusiasm and support have made this book possible.

FREDERIC G. RENNER

Note: Over the years many of Russell's paintings, drawings, and even some of his sculpture have become known under more than one title. In some cases a single painting has been published under four or five different names. Much of this confusion has arisen from the fact that authors, publishers, and art dealers have been unaware of the titles Russell gave to his works, and have simply invented new ones.

To the fullest extent possible the titles of the individual works of art appearing in this publication are the ones Russell supplied. This information has been obtained from copyright applications in the artist's handwriting, his correspondence, facts furnished by his wife, Nancy, or from the first publication of the particular painting during the artist's lifetime under a title he is assumed to have authorized. For those works published here for the first time, the titles provided at the time of their purchase by the present owners are used unless Russell's title is known.

It will be noted that Russell experimented with his signature, just as he did with all other aspects of his painting. The very earliest examples of his work are signed with his simple initials, as in Plate 2. In 1885 he turned to a simple monogram, and two years later to a more elaborate one. For a time he signed his work "C M Russell" with the letters at a downward angle; at a later period his signature had a decided upward slant. It wasn't until 1897 that Russell settled on the signature familiar to most collectors, the one he was to use the remaining twenty-nine years of his career. The various ways in which Russell signed his paintings and the periods in which the different signatures were used are shown on page 156.

10

INTRODUCTION:
Charles Marion Russell, 1864-1926

Charles Marion Russell, the second son of a family of one girl and five boys, was born to Mary Elizabeth Mead and Charles Silas Russell on March 19, 1864, in Oak Hill, Missouri. The Russell family had extensive farm lands as well as mining interests and had long been prominent in business and public affairs. Young Charlie's father, who had attended Yale University, was secretary of the family-owned Parker-Russell Mining and Manufacturing Company, one of the largest makers of fire brick in America. His grandfather, James Russell, had been an editor, a member of the Missouri Legislature, and a judge of the St. Louis County Court. One of his great-grandfathers, Silas Bent, had been chief surveyor of Louisiana Territory and was later the chief justice of the Supreme Court of Missouri Territory. Ancestors on his mother's side included Solomon Mead, who had served with distinction as a captain of Cromwell's Roundheads, and "Rifle Jack" Acker of Revolutionary War fame. These were some of the forebears from whom Charles Marion Russell inherited his spirit of independence and his thirst for adventure.

Charlie's parents assumed that with this background their young son would naturally seek a proper education and eventually take a position of responsibility in the family business.

The youngster received his first schooling from his mother. Then, in 1872, the Reverend John Norton Chesnutt arrived in Oak Hill to take up his duties as the pastor of the little Episcopal church. For a time the young minister served as a tutor to Charles, his older brother, Silas, and their sister, Sue. Charlie later attended the Clinton and Oak Hill schools, but his poor grades so alarmed his parents that they became concerned over their son's future. It wasn't that the boy didn't have the ability to keep up with his fellow students, it was simply that other interests had more appeal for him than musty school books.

Among these interests were drawing and modeling. Almost before he could walk, Charlie was drawing pictures of the characters that came to his vivid mind as his mother read to the youngsters from the family Bible. One day, when he was barely four, Charlie wandered away from home and was found following a man with a trained bear on a chain. That night he modeled a small figure of the bear from the mud taken from his shoes. According to the family, this was the "earliest" example of Charlie's budding talents as a sculptor.[1] When he was twelve one of his drawings was awarded a blue ribbon at the St. Louis County Fair.

Charlie's other interest, which was almost an obsession, was the West. His great-uncles, Charles, William, George, and Robert Bent, had built their famous fort on the Arkansas River in 1828, and years before that had been fur traders on the Upper Missouri. Family stories of their adventurous lives undoubtedly stimulated the boy's interest in the frontier, and playing "Trappers and Indians" in the neighboring woods became one of Charlie's favorite pastimes. This was much more fun than going to school. When he received a pony of his own on his tenth birthday, Charlie's decision was made—one day he would go West and become a cowboy.

The youngster's progress in his studies was becoming hopeless; so shortly after Christmas, 1879, he was packed off to a military school,

[1] Florence M. N. Russell, in private correspondence dated March 5, 1937, from copy in possession of the author.

Burlington College at Burlington, New Jersey. His parents hoped the discipline of such an institution would have a sobering effect on the boy. A school notebook that has been preserved from Charlie's sojourn at Burlington suggests that this was a forlorn hope. Instead of problems in arithmetic or other assignments, its pages are filled with sketches of cowboys and Indians. Charlie's closest friend at Burlington was Archie Douglas, a St. Louis neighbor. Years later Archie recalled that Charlie had spent most of his time at Burlington "walking guard duty," punishment for his inattention and repeated pranks. The one term he spent at Burlington concluded Charlie's formal education.

Despairing of their son's indifference to school, Charlie's parents gave him permission to take a trip to Montana with a friend of the family. Such a trip, they thought, would help cure Charlie of his wanderlust, and then when summer ended he would be glad to return home and settle down to his school work. The trip started just a few days before Charlie's sixteenth birthday. In company with Wallis (Pike) Miller, Charlie traveled by rail to Ogden and Fort Hall and on to the end-of-track at Red Rock, Montana Territory. From there he took the stage to Helena, continuing on to the Judith Basin by horseback.

It is difficult to imagine how raw and unsettled Montana Territory was when Charlie arrived there ninety-eight years ago. There were no transcontinental railroads in Montana in 1880. The one narrow-gauge line over which Charlie had made part of his trip had barely crossed the southern boundary of the Territory the preceding September. Most of the travel from "the States" then, and for another ten years, was by steamboat up the Missouri to the head of navigation at Fort Benton. From there the wayfarers waited for an uncertain stage to the mining camps, or traveled by horseback to other destinations.

Indian wars were still a vivid memory to many Montanans in 1880. Custer and most of his Seventh Cavalry had been wiped out only four years earlier and Chief Joseph and his tribe of fighting Nez Perce had been beaten and captured only three years before. Even though these were to be the last of the major Indian fights in the Territory, the Indians were still considered dangerous.

Military establishments, built to keep a watchful eye on the Indians and to protect the lives and property of the scattered settlers, were numerous. The oldest of these was Fort Shaw, built in 1867 a few miles above the mouth of Sun River, in the heart of the Blackfoot country. The largest was Fort Assiniboin, built in 1879 not far from the Canadian line—its purpose, to guard against the return of Sitting Bull and his followers from their sanctuary north of the boundary. It was here that a young officer named John J. Pershing was to serve as a lieutenant a few years later. Other posts were Forts Ellis, Missoula, Custer, Keogh, Logan, Maginnis, and Benton; the last, an old fur-trading post purchased by the government in 1869 to serve as a supply point. Each of these posts was manned by a garrison of less than three hundred soldiers, who, despite their military importance, had comparatively little influence on the normal life of the pioneers.

Aside from the military forts, settlements of other kinds were few and far between. Most of the more important of these were mining camps. Helena, the largest, had become the territorial capital, boasting of a population of seven thousand persons in 1880. The roistering camp of Butte had less than half that number and most of the others a few hundred or less. "Great Falls" was only a waterfall on the Missouri River, the town of that name, now the largest in the state, not yet existent.

The vast area north of the Marias and Missouri Rivers and from the Continental Divide east to the Dakota line was "Indian country," set aside as a reservation for the Blackfoot Indians and their allies. Another large area south of the Yellowstone River was the home of the Crows. These were "reservations" in name only. Numerous bands of Indians, some of them bent on mischief, roamed at will over the territory.

In the great interior east of the Rockies were the beginnings of a few scattered ranches although the hills were still "black with buffalo" in some areas. It was to be another two years before the last great Indian buffalo hunt of 1882. Game was abundant everywhere and buffalo tongue, roast venison, and saddle of antelope were standard items on the menus of the stage stations and the few other public eating places.

In describing the South Fork of the Judith, Russell wrote:

Shut off from the outside world, it was a hunter's paradise, bounded by walls of mountains and containing miles of grassy open spaces, more green and beautiful than any man-made parks. These parks and the mountains behind them swarmed with deer, elk, mountain sheep, and bear, besides beaver and other small fur-bearing animals. The creeks were alive with

trout. Nature had surely done her best, and no king of the old times could have claimed a more beautiful and bountiful domain.[2]

Russell's deep feelings for the prairies and mountains of Montana were to be expressed again and again, in his letters to his old friends, in his stories, and, above all, in his paintings. This was the country Charlie Russell saw, fell in love with, and made his home in for the next forty-six years.

Pike Miller and his partner, Jack Waite, had a sheep ranch in the Judith Basin, where Charlie had his first job herding sheep. In describing his early days in Montana some years later, Charlie wrote:

I did not stay long as the sheep and I did not get along well, but I do not think my employer missed me much, as I was considered pretty ornery. I soon took up with a hunter and trapper named Jake Hoover. This life suited me. We had six horses, a saddle apiece, and pack animals. I stayed about two years with Hoover, when I had to go back to St. Louis. I brought back a cousin of mine who died of mountain fever two weeks after we arrived. When I pulled out of Billings I had four bits in my pockets and 200 miles between me and Hoover. There was much snow, as it was April, but after riding about fifteen miles I struck a cow outfit coming in to receive 1,000 dougies for the 12 Z and V outfit up the basin. The boss, John Cabler, hired me to night-wrangle horses. We were about a month on the trail and turned loose on Ross Fork, where we met the Judith roundup. They had just fired their night herder and Cabler gave me a good word, so I took the herd. It was a lucky thing no one knew me or I never would have had the job.

I was considered pretty worthless, but in spite of that fact I held their bunch, which consisted of 200 saddle horses. That same fall old True hired me to night herd his beef, and for 11 years I sung to the horses and cattle.[3]

During these eleven years Charlie was painting and sketching at every possible moment. At the first light of day a man was sent out to relieve the night herder, and after getting back to camp Charlie had his daytime hours pretty much to himself. In the morning the horses would be milling in the rope corral, where some of the men roped their mounts for the day's work, while others saddled up. Perhaps one would be putting blinders on a particularly bad bronco, hoping he could stay aboard when his friends sang out "ride 'im cowboy." After getting a few hours of sleep, Charlie had the rest of the day to watch as the crew worked and branded the herd, while he made quick sketches. There were always ideas for a painting around a cow camp.

In the first part of this period it is doubtful that Charlie had any notion of eventually earning his living as an artist. He was painting and sketching for his own amusement, giving away the results of his efforts to anyone, friend or stranger, who admired them. Most of these went to his cowboy friends and were tacked up on bunkhouse walls.

His first formal commission was from James Shelton, a saloon man of Utica, Montana. Shelton wanted a decoration to hang behind his bar and approached Charlie with a request that he paint something that would interest his patrons. Charlie had neither canvas nor other materials and there was no place in the Judith Basin where he could buy them. A smooth pine slab nearly seven feet long and a foot and a half wide served for a canvas and his oils were presumably house paints, the materials that Russell was to mention years later as those he used for one of his first oil paintings in Montana. The painting hung in a Utica home for more than fifty years, an eloquent reminder of the first crude efforts of the youngster who was to become the foremost artist of the Western scene.

In the winter of 1885 Charlie completed what was at that time his largest oil painting on canvas. This was a lively scene, eighteen by thirty-six inches in size, of the Utica roundup crew. Charlie called the painting *Breaking Camp* (Plate 11). Without mentioning it to anyone, he sent the painting off to be shown at the St. Louis Art Exposition of 1886. This was Russell's first painting to be exhibited outside the state of Montana. The next year numerous stories about his work began to appear in several of the Montana newspapers. The first of these was *The River Press* of Fort Benton, which commented on the painting shown at St. Louis in its January 12, 1887, issue. On May 24 of that year the *Helena Weekly Herald* noted that Russell's pictures "had found their way to centers of population, until now his works in oil and watercolors, evolved amid the rough surroundings of a cattle ranch, adorn the offices and homes of wealthy citizens of Montana's principal cities." *The Independent* of Helena had stories about Russell's paintings in its June and July issues, one of these making the first reference to Russell as the "cowboy artist." On August 3, 1887, *The River Press* carried the story of an event of some importance in the artist's career. This was the announcement that one of Russell's paintings was to be reproduced as a lithograph by a Chicago firm.

[2] Charles M. Russell, "A Slice of Charley Russell's Early Life," *The Roundup* 11 (1918), 48–50.

[3] *Fergus County Democrat*, December 13, 1904, p. 3.

Few Russell collectors have ever seen this early print but it was the first of approximately 250 that were to appear in later years.

Accounts of Russell's early life in Montana invariably tell about his stay with a tribe of the Blood Indians in Canada. Actually, this trip was more or less an accident. Charlie spent the winter of 1887–1888 in Helena, where he and several other cowboys batched in a small cabin. During this time Charlie became staunch friends with Phil Weinard, whom he had met the previous summer. Weinard was a man of many parts, having been a "hand" on the river boats, a bull whacker, a cowboy, a "wolfer," and, during that winter and the following spring, a vaudeville actor at the Coliseum Theatre in Helena. The Theatre was operated by a Mrs. Hensley, better known as "Chicago Jo," whose attractive niece Weinard secretly married. Expecting opposition, Weinard sent his bride east by train while he and Charlie made plans to pull out for Canada.

The two men left Helena, May 16, 1888, by horseback, taking with them one of Charlie's friends, a faro-dealing cowboy called "Long Green" Stillwell. After the trio reached their destination, Weinard made arrangements for Charlie and Long Green to live in an unused cabin before he went to work as foreman of Walter Skrine's Bar S ranch.

Charlie and Long Green spent the summer loafing and visiting their numerous friends in the vicinity of High River. As they had no desire to spend the winter in Canada, when the first snow fell in September they headed back to Montana. Crossing the Blood Reserve they met a band of Indians and stopped for a visit. Black Eagle, the chief of the tribe, was an old friend, and Charlie decided to spend the winter in the "lodge of his red brothers." Long Green apparently continued on south, while Charlie remained with the Indians until the following March. When the Benton trail opened up he joined a south-bound freight outfit and got back to the Judith Basin in time for the spring roundup.

There is no doubt that this stay with the Blood Indians, unplanned though it was, gave Charlie the opportunity to acquire a vast store of firsthand knowledge about Indian life. The results of this six-months stay with the Bloods were to appear time and again in his future paintings.

After Charlie's return from Canada, accounts of his work continued to appear in Montana newspapers and the artist became somewhat of a local celebrity. Not all of these stories were especially flattering, although most of them were. In his first article about Rus-

sell's work, the editor of *The Great Falls Tribune*, in commenting about a painting on display in a local store window, observed that "the whole tone of the picture seems a little dim, although it is a fair scene of a puncher roping a steer."[4] That same year, 1891, *The Helena Journal* reproduced six of Russell's oil paintings in its July 4 issue. One of these was *Cowboy Camp during the Roundup* (Plate 7). These were the first of the cowboy artist's work to appear in a Montana newspaper. The following month the editor of the *Fergus County Argus* proclaimed somewhat enthusiastically that "Russell's paintings of Indian life and wild Western scenes have made him famous throughout the West, in fact all over the country."[5]

Despite the encouragement of this publicity and much more that followed, Charlie continued his life as a cowboy until 1893. As he put it, "That fall, after work was over I left [the range] and I never sang to the horses and cattle again."

With the end of the roundup that year, Charlie was one of the cowboys selected to accompany the beef train to Chicago. After spending a few days taking in the sights of the World's Fair, he continued on to St. Louis to visit his parents. While there, Charlie called on William Niedringhaus, a prominent St. Louis hardware merchant, who also had ranching interests in Montana. Mr. Niedringhaus had moved to St. Louis from Granite City, Illinois, where he had founded the Granite City Steel Company. His was the first company to make and patent the then-popular enamel kitchenware and part of the money from this profitable enterprise had been invested in Texas longhorns. These had been trailed to Montana, where on a number of occasions Charlie had worked on the Niedringhaus N Bar N ranch. The outcome of the visit to the Niedringhaus home in St. Louis was a commission for several paintings, the price unspecified and the choice of subject entirely Charlie's.

It was undoubtedly this commission that led Charlie to give up his life as a cowboy. Although he had previously sold a number of his paintings, the income from such sales had been both small and irregular. Charlie probably decided that here was the opportunity to find out whether he could earn his living as an artist.

Returning to Great Falls, Charlie soon found the distractions of the town and his irresponsible friends too great to permit much painting. Accordingly, he decided to spend the winter in Cascade, a small town twenty miles upriver. Here he set up his studio in the unused court-

[4] *Great Falls Tribune*, March 28, 1891, p. 6.
[5] *Fergus County Argus*, August 27, 1891, p. 3.

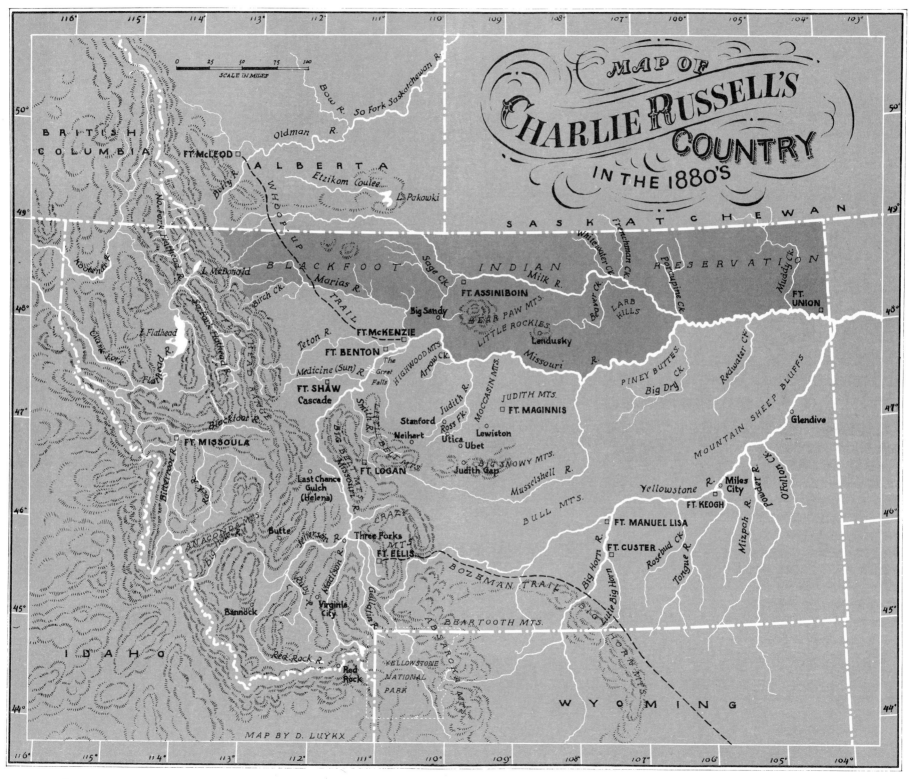

MAP OF CHARLIE RUSSELL'S COUNTRY IN THE 1880'S

BRITISH COLUMBIA

ALBERTA

SASKATCHEWAN

SCALE IN MILES
0 25 50 75 100

Bow R.
So. Fork Saskatchewan R.
Oldman R.
FT. McLEOD
Etzikom Coulee
L. Pakowki

Kootenai R.
No. Fork Flathead R.
Belly R.
WHOOP UP TRAIL
L. McDonald
Marias R.
BLACKFOOT
Sage Ck.
INDIAN
Milk R.
FT. ASSINIBOIN
Big Sandy
BEAR PAW MTS.
Whitewater Ck.
Frenchman Ck.
Beaver Ck.
Porcupine Ck.
RESERVATION
Muddy Ck.
FT. UNION

Birch Ck.
Middle Fork Flathead R.
L. Flathead
Flathead R.
Teton R.
FT. McKENZIE
LITTLE ROCKIES
Landusky
LARB HILLS

North Fork
Blackfoot R.
Medicine (Sun) R.
FT. BENTON
The Great Falls
HIGHWOOD MTS.
Arrow Ck.
Missouri R.
PINEY BUTTES
Big Dry Ck.
Redwater Ck.

Bitterroot R.
FT. SHAW
Cascade
Smith R.
JUDITH MTS.
FT. MAGINNIS
MOUNTAIN SHEEP BLUFFS

FT. MISSOULA
Blackfoot R.
Judith R.
Stanford
Neihart
Ross Fk.
MOCCASIN MTS.
Utica
Lewiston
Ubet
Glendive

Big Blackfoot R.
LITTLE BELT MTS.
Judith Gap
BIG SNOWY MTS.
Musselshell R.
Yellowstone R.
Miles City
FT. KEOGH

ANACONDA MTS.
Big Hole R.
FT. LOGAN
Last Chance Gulch (Helena)
CRAZY MTS.
BULL MTS.
FT. MANUEL LISA
Mizpah R.
Powder R.
O'Fallon Ck.

Rock Ck.
Butte
Jefferson R.
Three Forks
FT. ELLIS
BOZEMAN TRAIL
Big Horn R.
FT. CUSTER
Rosebud Ck.
Tongue R.

Ruby R.
Madison R.
Gallatin R.
Virginia City
Bannock
BEARTOOTH MTS.
Little Big Horn R.
Big Horn R.

IDAHO
Red Rock R.
Red Rock
YELLOWSTONE NATIONAL PARK
ABSAROKA MTS.

WYOMING

MAP BY D. LUYKX

2.

room of Judge Switzer and proceeded to get to work on his commission.

One of Charlie's friends in Cascade was Vin Fortune, a former cowboy who had a job for the winter in Shepard & Flinn's general store, which housed the little fourth-class post office. When Charlie finished a painting he would take it to his friend to be wrapped and mailed. Vin also agreed to write a letter to Mr. Niedringhaus, telling him the price of the painting. Charlie was always hesitant to put a price on his work but at his friend's prompting would say, "Well, do you think they would balk at, say $25.00?" Vin would "allow" this sounded about right but when he wrote the letter he would double Charlie's price. This went on for some time and when the drafts from St. Louis began to arrive for twice the amount Charlie had asked, or thought he had, he became worried. His first thought was to send the money back, but Vin convinced him that his client was doubtless so pleased with the paintings that he had decided to double the amount of Charlie's bill. Charlie finally caught on to what was happening. "Hey," he ejaculated, "What the hell? Have you been padding my prices? You'll ruin me. They'll never send me another order." But, of course, they did.[6] Over the years, Charlie painted more than fifteen paintings for various members of the Niedringhaus family. Nine of these are now in the Amon G. Carter Collection (Plates 12, 23, 86–91, 93).

While at Cascade, Charlie also did seven watercolors and an oil painting for his friend John Beacom. Beacom was a young army officer stationed at near-by Fort Shaw and the paintings were to illustrate a series of Blackfoot legends the lieutenant had written. These, along with Charlie's illustrations, were published the following year.[7] Returning to Great Falls, Charlie painted steadily and during the next two years completed more than forty watercolors and twenty oils.

By the fall of 1895 Charlie was in need of a little vacation and decided to pay a visit to his old friend Ben Roberts, at Cascade. Staying with the Roberts family was an attractive girl named Nancy Cooper. Nancy was seventeen and Charlie was thirty-one, but, despite the difference in their ages, they quickly became close friends. A year later, on September 9, 1896, they were married in the Roberts' home and set up housekeeping in a small shack on the rear of the Roberts' property.

Nancy had had no more schooling than Charlie but she possessed both qualities and abilities that were to have a vast influence on her husband's career. One of these was a complete faith in Charlie's artistic talents; the other, a driving ambition to help him achieve success. Cascade was too small to offer much opportunity for an artist and within a year the couple moved to Great Falls, where they rented a small house south of Central Avenue.

As a wandering cowboy, Charlie had received considerable publicity in the numerous newspapers throughout Montana. When the roundup crew had arrived in one of the little cow towns, the local editor had usually sent a reporter to interview the "cowboy artist," and the display of his latest painting in one of the local store windows was always duly noted.

In contrast, the two Great Falls newspapers practically ignored the artist and his bride for the first three years after their arrival in that town. In 1900 Charlie received a small legacy from his mother's estate and used this fund to build a modest home adjoining the property of Mr. and Mrs. John Trigg on Fourth Avenue North. Mr. Trigg was an Englishman with considerable education and, although a saloonkeeper, was a gentleman and a man of character. The Triggs quickly took the young couple under their wing, with Nancy proving to be an apt pupil. When Charlie's picture appeared in *The Great Falls Tribune*, along with an account of the move to their new home, Nancy felt that she had broken the ice.

With a new home on the more fashionable "north side" and the sponsorship of a respected family, Nancy was ready to tackle her next objectives. These were to get Charlie to cut down on his drinking and to wean him away from his rowdy cowboy and former cowboy friends. There was no moral issue involved as far as drinking was concerned. Most of the influential citizens of Great Falls were drinking men and to refuse an invitation from friend or stranger to "have a drink" was still a breach of frontier manners.

Nancy's attitude was that they couldn't afford for Charlie to be spending his time and money in such a manner. Few of Charlie's old friends were in a position to buy his paintings, much as they might admire them. It was, therefore, a waste of Charlie's time to be hanging around saloons, drinking, spinning yarns, and talking over old times when he might be home painting.

[6] Vin Fortune, "The Cowboy Artist, Charles M. Russell," unpublished manuscript in the possession of the author.

[7] John H. Beacom, *How the Buffalo Lost His Crown* (Minneapolis: Forest and Stream Publishing Co., 1894).

Nancy succeeded to a considerable degree and under her prompting Charlie got in the habit of spending his mornings at his easel. After lunch he would usually saddle his horse and ride to town to put in a few hours with his cronies. As he left, Nancy might hold up two fingers, indicating that Charlie should have not more than that number of drinks, a precaution he usually followed. Charlie didn't give up his old friends but there is no question that under Nancy's influence he saw less of them. This was naturally resented by the many old-timers who treasured Charlie's companionship even more than they admired his art work. Some of them referred to Nancy in uncomplimentary terms and were convinced she would "ruin" Charlie as an artist. That Nancy ever had very much influence on the way Charlie painted is doubtful. There is little question that her insistence on regular hours increased his output. Nor is there any doubt that her business acumen in promoting his work was mainly responsible for Charlie's ultimate financial success.

It is probable, too, that it was Nancy's encouragement that led Charlie to try his hand at writing short stories that could be illustrated with his own paintings. Charlie could talk entertainingly and he loved to tell stories, but his first attempt at writing must have been painful. The fact that he tried it at all is a tribute to Nancy and to his own perseverance. His first story was a fictional account of a party of trappers who had pushed north to the country of the Blood Indians. Although the events described were supposed to have taken place before Charlie was born, the story was written in the first person and was obviously based on some of Charlie's own experiences. The yarn was accepted by the editor of *Recreation* and published with three of Charlie's illustrations in the April, 1897, issue of that popular magazine.

This event was Charlie's first opportunity to get any kind of professional advice and it is possible that the editor may have made some suggestions about the illustrations he had accepted. Whether because of this help or because of Charlie's own constant efforts to improve his work, a decided change in his palette took place about this time. Most of his early paintings in oils had been in dull tones of brown; he now began to use more, and lighter, colors. Where he had previously relied on meticulous draftsmanship, he now began to experiment with getting the effects he wanted with color alone. The composition of his paintings also improved. Instead of showing twenty-five cowboys spread all over the landscape—as he did in the painting shown at St. Louis—he reduced his major figures to two or three,

carefully arranging them on his canvas to achieve a more effective and unified result. The generalization that Charlie painted few top-quality paintings before 1897 and no poor ones after that date is an exaggeration, but the statement is indicative of the marked improvement in his work that was made about this period.

In 1903 Charles Schatzlein, of Butte, was acting as Charlie's agent and by the fall of that year had sold a considerable number of paintings. With a little money ahead, Charlie decided to take Nancy east for a visit. Following a reception in their honor at the Schatzlein home on October 8, Charlie and Nancy left by train for St. Louis. There were several purposes for the trip. Charlie, of course, wanted to see his father, and Nancy was anxious to pay her first visit to the Russell's ancestral home. Charlie also took several paintings with him, which he hoped to have accepted for exhibition at the World's Fair which was to open in St. Louis the following May. One of them, *Pirates of the Plains*, was accepted, and shortly after Christmas, Charlie and Nancy continued on to New York.

The trip to New York City, their first to the "Big Camp," as Charlie called it, probably would not have been made had it not been for John N. Marchand. Marchand was a Kansas boy who had spent his early life in Indian Territory among the cowboys and Indians before going to New York to become a successful illustrator. The preceding summer Marchand had been gathering material on the Coburn ranch in Montana and had met Charlie. With their similar backgrounds and interest, the two men took to each other immediately. Marchand told Charlie he ought to make a trip to New York, where he could meet some of the leading publishers interested in Western art, and promised to show him the ropes if he would do so.

The New Yorker was as good as his word and after Charlie's arrival Marchand took him around to see the art editors of *Scribner's*, *McClure's*, *Outing*, and *Leslie's* magazines, all of whom promised to use some of Charlie's work. The studio which Marchand shared with Will Crawford and Albert Levering served as Charlie's headquarters for the six weeks he was in New York. On one occasion Charlie was a guest of the three artists at a Players Club dinner. As usual, Charlie was wearing his red sash and cowboy boots and made no effort to be anyone but himself. At first the other guests looked on him as some sort of Western curiosity but after his friends drew him out, Charlie lost his shyness, telling story after story. The whole assembly was soon hanging on every word and Charlie was the hit of the evening.

In addition to Crawford and Levering, Charlie also met Charles

Schreyvogel, the painter of frontier army life, authors Ernest Thompson Seton and Alfred Henry Lewis, and a then-unknown comedian named Will Rogers. Rogers was not mentioned as one of the celebrities Charlie told his friends about when he returned to Great Falls and their meeting may have been a casual one. Rogers remembered it, however, years later writing in one of his syndicated columns, "Charlie Russell was trying to sell a few paintings and I was trying to sell a few jokes when I first met him in the east . . . That was before either of us was known much outside of his own home town. He went up the ladder of fame a lot faster than I did."

All of the celebrities Charlie met were wonderful to him and he thoroughly enjoyed that aspect of his Eastern visit. He wasn't much impressed with New York City, however. After returning to Great Falls he told his friends:

New York is all right but it is not for me. It's too big and there are too many tall tepees. I'd rather live in a place where I know somebody and where everybody is Somebody . . . And the style in those New York saloons. The bartenders won't drink with you even. Now I like to have the bartender drink with me occasionally, out of the same bottle, just to be sure I ain't gettin' poison. They won't even take your money over the bar. Instead, they give you a check with the price of your drink on it and you have to walk yourself sober trying to find the cashier to pay for it.[8]

"A woman can go farther with a lipstick than a man can with a Winchester and a side of bacon"---Charlie's rare ability to see humor in almost any situation and the pungent language he used to tell about it delighted his friends. They were also amused by the outlandish nicknames Charlie was likely to bestow on his close friends. While these were not always flattering they were rarely resented. The rotund Irvin S. Cobb was "Short Bull" and W. G. Krieghoff, a prominent portrait painter from Philadelphia, became known to Montanans as "Duck Legs." On hunting trips Charlie's companions were afraid to go to sleep before he did, fearful they might miss some of his rib-tickling observations or stories. He was invariably the center of attention wherever there was a crowd.

During Charlie's early days on the frontier, men had to make their own amusement and long evenings were passed telling stories. These might come from their own experiences or from the experiences of others they had heard about. There was one inflexible rule. The narrator might tell about his own misadventures but, unless he was willing to be nicknamed "Windy," he avoided bragging about his exploits.

Charlie's keen wit and highly original ways of expressing himself made him a masterful storyteller, but he was more than this. Both his conversation and his writings reveal a love of people, a gentle tolerance toward their faults, and a deep insight into the meaning of human relationships. As a homespun philosopher, Charlie was years ahead of his friend Will Rogers. On later occasions when the two men got together with a few friends, it was Charlie's stories, not Will's, that the crowd demanded to hear.

Despite Charlie's antipathy for the East, his trip to New York had been a productive one and in the following year he received a rush of orders. Forest and Stream Publishing Company wanted illustrations for W. T. Hamilton's *My Sixty Years on the Plains* and Street & Smith asked Charlie to illustrate B. M. Bower's *Chip of the Flying U*. In addition to the books, there were illustrations to be done for a series of stories by Stewart Edward White for *McClure's* magazine and others for *Leslie's Illustrated Weekly*. As a final fillip, the well-known Casper Whitney asked Charlie to both write and illustrate a series of short stories to be published as "Line Camp Yarns" in *Outing Magazine*. Charlie's career as one of the leading Western illustrators of his time was well on its way.

Although the demand for magazine and book illustrations continued, and even increased, Charlie was never satisfied to become a mere illustrator of the works of others. As always, most of the subjects and incidents he continued to do in oils and watercolors were drawn from his own experiences and were done for his own satisfaction, not that of some publisher.

By 1906 practically everyone in Montana was familiar with Russell's work. Since his cowboy days Charlie had made a practice of displaying his paintings in store windows throughout the state and over the years a number of prominent saloons had acquired a collection of his paintings and sculpture. Among these, the Silver Dollar and The Mint in Great Falls were outstanding.

Imagine an old-time saloon that collected works of art, issued illustrated catalogs of its paintings, closed its doors to permit special tours by feminine members of the public, and loaned works of art for display at international exhibitions. That was The Mint of Great Falls, Montana, shortly after the turn of the century.

[8] *Great Falls Tribune*, February 16, 1904, p. 8.

First opened for business in July, 1898, The Mint soon became famous as a place where a major collection of paintings and other works of art by Charles M. Russell could be seen by the public. The Mint was no ordinary saloon and for fifty years it enjoyed a position unique in the annals of American art.

For most of this period, the proprietor was Mr. S. (Sid) A. Willis, former sheriff of Valley County, Montana, and at one time deputy United States marshal. Willis had been a warm friend of Charlie Russell from the artist's early days in Montana. As a member of the State Legislature in 1927, it was Willis who introduced the bill authorizing a statue of his friend in Statuary Hall in the nation's Capitol at Washington, D. C.

The first major Russell painting in The Mint collection was *The Hold Up*, shown in Plate 140. This was acquired in 1899 and occupied the same place on the wall for half a century. It and *The Buffalo Hunt*, shown in Plate 152 were exhibited in the Montana Building at the St. Louis Exposition of 1904 and at the Alaska-Yukon-Pacific Exposition in Seattle in 1909, where both paintings attracted a great deal of attention.

Over the years Mr. Willis acquired other Russell paintings and a notable collection of the artist's original models. Some of these were obtained from the Silver Dollar when that equally famous establishment closed its doors with the coming of prohibition.

It is popularly believed that Mr. Willis refused to dispose of any of his paintings while he was the owner of The Mint. This is not quite correct, as a few were sold during the depression years of the late 1920's and early 1930's. The fact remains, however, that Mr. Willis was one of the few Montanans who assembled an important collection of Russell's works and who made strenuous efforts to keep the collection intact for the benefit of the people of Montana.

With advancing years, circumstances led Mr. Willis to the decision that his Russell collection would have to be sold. It was his hope that the collection could be kept in Great Falls as a memorial to the artist, and, if this were not possible, that it would at least stay in Montana. Mr. Willis was not in a position to make a gift of such magnitude to the public and an attempt was made to get the State Legislature to appropriate funds to purchase the collection. This attempt, as well as a variety of others, was unsuccessful. In 1948 a "Charles Russell Memorial Committee," headed by seventeen prominent sponsors, was formed "to raise enough money to purchase this collection and to present it to the State of Montana for perpetual keeping." At that time Mr. Willis offered his collection to the state for $125,000, although he had received numerous higher offers, including one for $160,000, from outside Montana.

After several years the memorial committee succeeded in raising approximately ten per cent of the necessary amount. When it became apparent that further efforts would fail, ownership of The Mint, including its art collection, passed to other parties. Shortly thereafter the works of art were purchased by M. Knoedler & Co., art dealers of New York City. In 1952 the Knoedler company sold all of the Russell works included in the Mint Collection to Mr. Amon G. Carter.

Russell's first one-man show was at the Noonan-Kocian Galleries in St. Louis in November, 1903. While no catalogue of this exhibit has been preserved, the printed invitation reveals that it included both oils and watercolors. It is probable that among them were the ones Charlie hoped to have accepted for display at the World's Fair the following year.

In the winter of 1906 Great Falls was visited by Newell Dwight Hillis, a traveling lecturer and minister of the Plymouth Church in Brooklyn, New York. The record does not reveal how Reverend Hillis happened to visit the barroom of the Park Hotel, but he did and saw there a number of Russell paintings. The minister was so impressed that he approached Charlie with a proposal for an exhibition of his paintings in the East—promising that he would arrange such a display in his own church. Charlie thought the idea a strange one, but Nancy saw the suggestion as an opportunity and readily agreed. Nine major paintings were selected, mainly from those owned by Paris Gibson, and the first exhibit of Russell's work on the eastern seaboard opened at the Plymouth Church on February 16, 1907. From all indications, it was well received.

The Brooklyn show broke the ice for Nancy and from then on she lost few opportunities to show Charlie's paintings and sculpture. Three of his bronzes and two of his paintings were displayed at the Alaska-Yukon-Pacific Exposition in Seattle in 1909 and an important group of paintings were shown the same year at the Seventh Montana State Fair.

In 1910 George W. Niedringhaus assembled a group of ten of Russell's oils and eleven of his watercolors for a special display at St. Louis. The prices of the items listed in the little printed catalog for this show are a revelation to present-day Russell collectors. *First Wagon Trail* was valued at $500, *When Blackfeet and Sioux Meet* at

19

$800, and *In without Knocking* at $900 (Plate 203). These figures indicate the prices Russell was getting for his better paintings at this period.

The following year saw Russell's first major show in New York City. The exhibition at the prominent Folsom Galleries, at 396 Fifth Avenue, included thirteen oils, twelve watercolors, and six of Russell's recently cast bronzes. The display was billed as "The West That Has Passed" and attracted a great deal of attention, both in the press and among interested New Yorkers. "Cowpunchers and redskins—lonely trails—wolves—gunplay, simple and compound—bony, wise-looking horses—gaudy trappings and blankets and feathers—buffaloes . . ." was the way the exhibition impressed *The New York Times*, which devoted almost an entire page to the "cowboy artist" in its issue of April 2, 1911.

Russell's successful show in one of the leading Eastern galleries may well have been a factor in the first public and official recognition of his abilities by his adopted state of Montana. This was the commission, awarded July 1, 1911, for a monumental painting to adorn the wall in the house of representatives in the State Capitol. The result was a magnificent scene of Lewis and Clark's historic meeting with the Ootlashoot Indians in Ross' Hole. Many critics consider this painting Russell's masterpiece and it has been called one of the truly great pictures of America.

A second showing of Charlie's work in New York City was arranged in 1912, as was his first one in Canada. The latter was at Calgary, Alberta, in connection with "The Stampede," the first major bronc-riding and roping contest to be staged by the Canadians. Present at this affair were many distinguished notables, including the Duke of Connaught, the governor-general of Canada, and Sir Henry Mill Pellat, commander of the Queen's Own Rifles. Sir Henry was so taken with Russell's paintings that he purchased five of them. Among these were *In without Knocking* and *When Horseflesh Comes High* (Plates 202, 203). Other titled Englishmen were also lavish in their praise and a number of them sought out Charlie to persuade him to arrange for a similar display in London.

The show of Russell's work at Calgary was received so enthusiastically that Charlie promised the officials of the Winnipeg Stampede they could have a similar display the next year. Accordingly, it was not until 1914 that Nancy could complete arrangements for a show in London. The exhibition of twenty-five oils and watercolors was held at the Dore Galleries on New Bond Street, and it is hard to say

whether it was the paintings or the artist himself that attracted the most interest. Charlie's cowboy boots and red sash, his unassuming Western ways, and his vast knowledge of the scenes he had shown so masterfully on canvas made him popular with everyone he met. Among the many distinguished visitors to the show were the Queen Mother Alexandra and her sister, the Dowager Empress of Russia. Before the close of the show a number of the paintings were sold to prominent Englishmen at "excellent" prices, according to the newspaper accounts.

Russell's paintings were also shown in London at the Anglo-American Exposition, which opened May 15, 1914. Authorities of the Exposition had announced that no more than two canvases by the same artist would be permitted. The interest that had been aroused by the Dore Galleries exhibit had been so great, however, that special provision was made for the showing of Russell's entire display.

In succeeding years there were one-man shows of Russell's work in Glacier and Yellowstone National Parks, in Chicago, New York, San Francisco, Pittsburgh, Saskatoon, Minneapolis, Los Angeles, Santa Barbara, and Washington, D. C., the last at the famed Corcoran Gallery in 1925, the year before the artist's death.

Some measure of Russell's success is indicated by the constantly increasing prices his work commanded. A large oil painting that was raffled off for $300 at a Great Falls Christmas party in 1899, brought $5,000 in 1915. Six years later Nancy sold a smaller painting for $10,000, which at that time was reported to have been the largest sum ever paid for the work of a living American artist. Even this amount was dwarfed by Russell's last commission.

In 1926 E. L. Doheny asked Nancy to have Charlie do two panoramic paintings of the early West for the walls of his Los Angeles home. The space to be covered consisted of two panels, each approximately thirty inches by twenty feet. For this commission Nancy demanded, and got, $30,000. After Mr. Doheny's death the paintings were presented to St. John's Seminary at Camarillo, California, and are now housed in the Edward Laurence Doheny Memorial Library of that institution.

Such prices eliminated all financial worries for the Russells and after 1919 a part of each winter was spent in California. This was partly to get away from Montana's cold winters, and partly because Nancy had discovered an excellent market for her husband's work among members of the movie colony. William S. Hart, Douglas Fairbanks, Noah Beery, Harry Carey, and Charlie's old friend Will

Rogers, were among those who purchased some of his major paintings and bronzes.

In 1923 Charlie was back in Great Falls, where he suffered his first serious illness. This was a severe attack of sciatic rheumatism, which disabled him for nearly six months. That fall he was forced to forego his annual hunting trip, the first one he had missed for many years. In November he wrote to a friend, "I am better but am still using four legs, the frunt ones are wooden."[9]

The rheumatism persisted and although a number of important paintings were completed the following year, Charlie was far from well. He was also troubled by a goiter, which was steadily growing larger, a fairly common ailment in iodine-deficient Montana. Charlie had always been fearful of surgery and it wasn't until June of 1926 that he finally agreed to submit to the doctors. The goiter was successfully removed on July 3. However, the examination indicated a weakened heart and he was told that he would probably not live more than another six months.

The end, brought on by a heart attack, came at his Great Falls home a few minutes before midnight on October 24, 1926.

Many artists have seen history in the making but few have recorded that history with the inspiration, fidelity, and wealth of material that Charles Marion Russell has left us in oils, watercolor, and bronze. His canvas was the sweep of a thousand miles of prairie and sky, back-dropped by the mighty Rockies, traversed by the Missouri and Yellowstone, and peopled by a dozen tribes of wild Indians only a generation or two from the Stone Age when he arrived in Montana Territory.

Russell saw the last of the mountain men and gold seekers. He heard the bawling longhorns coming up the trail from Texas; the beginning of a vast ranching industry was to unfold before his eyes. Eventually he saw both the Indian's and the cowman's "trails plowed under" as hordes of land-hungry settlers poured in from the East.

Russell's paintings and sculpture have a universal appeal to our eyes and emotions. Youngsters of all ages have had their blood stirred by the flashing action of Russell's art—the clash of Indian war parties, the cowboys on their wildly pitching broncos. Old-timers observing Russell's paintings note with satisfaction that every detail is "right," from the bead-work design that identifies the Indian's tribe, to the

make of the saddle that tells them where the cowboy hails from. A few errors have been noted in Russell's interpretations of historical incidents that took place many years before he reached Montana. Historians, however, rely on Russell's paintings for the way the Indian looked and dressed in that period. Naturalists consider him one of the world's pre-eminent sculptors of wild animals.

Underlying all this and giving added significance to it is the fact that Russell's works are among the few understanding records of an important part of our country's history—the winning of the West. Russell sensed that a significant era was passing during his lifetime and much of his importance as an artist is due to the fidelity and insight with which he painted that changing scene.

Within the scope of his horizon, there was no facet of this wonderful panorama that Russell missed. For the scenes of an earlier day he listened to the tales of those who had been there before him and read the journals of the few who had written about their travels. The explorers—La Vérendrye, Radisson, and Lewis and Clark—march across his canvas. The mountain men and furtraders are there—Jim Bridger, Kit Carson, Manuel Lisa, and John Colter, to mention a few of the more famous. After these were the missionaries—Father De Smet and Brother Van. Later there were prospectors, steamboaters coming up the Missouri, freighters with their bull teams, outlaws, gamblers, and all the other heterogeneous characters of the frontier. Above all of them, there were the Indians.

Few Montanans of Russell's time had any interest in the Indians— "get rid of them as quickly as possible in one way or another." Most whites looked on the Indians en masse—murdering, thieving, savages, with no rights to the lands they had inhabited for centuries. Russell had more perception. He saw them as individuals with customs and traditions that commanded his respect. He quickly learned, too, that many Indians were more truthful and had a higher code of personal honor than the more vociferous whites. Russell sought out the Indians, learned to talk with them in sign language, and stayed overnight in their camps. Whether they were Assiniboin or Cree, Blackfoot or Crow, Piegan or Sioux, Russell made friendships with the Indians that lasted throughout his life.

Russell was interested in everything about the Indians. He was especially taken with their stories of a wild, free life before the coming of the white man. Of these, their talks of the "Surround"—one of the ways the Indians of the northern plains hunted the buffalo—was particularly thrilling to him. In the "Surround" a few of the tribe's fast-

[9] Charles M. Russell, *Good Medicine: The Illustrated Letters of Charles M. Russell,* p. 54.

est ponies were trained to cut out a small band of buffalo and quickly get their masters alongside to make the kill with arrow, lance, or rifle. Russell was to illustrate the "Surround" in more than sixty paintings and drawings with always varying detail. It seems reasonable to assume that this was his favorite of all subjects. The practice known as the "Piskan" apparently had no appeal to Russell. In the "Piskan" an entire herd of buffalo was driven over a cliff to be crippled or killed. While this had been the custom in the days before the Indians had horses, it had been abandoned thirty years before Russell's time. It is probable that the cruelty of the "Piskan" repelled Russell and, as far as known, he never painted this subject.[10]

Horse-stealing expeditions and warfare between neighboring tribes were a way of life with the Indian, and Russell did many paintings of these subjects. Since most of the actual fighting between the Montana tribes had taken place before Russell's time, it is doubtful that he observed any such skirmishes. He did, however, come across the scene of such a battle shortly after two warring bands of Piegans and Crows had departed, leaving some of their dead behind them. For details of such fights he relied on the accounts of the still-living participants, some of whom described the action to him and took him to the places where the battles had been fought.

The less spectacular aspects of Indian life were of no less interest: an Indian girl waiting at the tipi for the return of her brave, the women of the tribe fleshing a buffalo hide or moving camp to new hunting grounds, or a proud warrior giving his small son his first instructions in the use of the bow. These Russell saw and he was to record all of them in his vivid paintings.

Russell's record of the cowboy and all of his kind was equally impressive. Russell worked as a cowboy for more than a decade during the open-range days before the turn of the century. At the start he was the greenest of all "pilgrims." By the time he quit the range to devote full time to his painting there wasn't much about a cowboy's life, or cows, or cow-people, that had escaped his observant eye. In later years Russell modestly disclaimed that he had ever become a top hand with a rope or as a bronc rider. The fact that he had worked year after year for some of the largest outfits in Montana is proof enough that he had all the necessary skills to do his job. Much of the time he was the horse wrangler, at other times the "nighthawk."

These highly responsible jobs, which commanded higher wages than those paid the ordinary cowboy, were seldom trusted to a greenhorn.

Every possible happening that took place around a cow camp or on the roundup can be found in Russell's paintings—branding, roping, encounters with rustlers, bucking broncos, and cows-on-the-prod. They are all there. Nor did Russell overlook the less serious incidents in the cowboy's life: the fun of dropping a loop over a running wolf, or the occasional day in town with the "hoo-rawing" of a tenderfoot and possibly a little harmless gunplay. If the latter turned into something more serious, which happened sometimes, it is certain that it, too, became the subject of a painting sooner or later.

If I seem to have overlooked some of the other frontier characters, you may be sure that Russell didn't. The traders and the trappers, the stage driver and the stage robber, the bull whacker and the mule skinner, the lawful and the lawless—all came alive under his brush.

Few American artists have received the acclaim given to Charles Marion Russell during his lifetime and since.

In 1925 the University of Montana awarded the honorary degree of Doctor of Laws to "Charles M. Russell . . . who has attained greater prominence in the field of art than any other resident of the State." This was only the fourth such degree in the history of this institution and the highest honor the University could bestow.

Two years later the Montana Legislature authorized a statue of Charles M. Russell to be placed in the nation's Capitol in Washington, D. C. Although each state is permitted such statues of two of its most illustrious citizens, at this writing Charles M. Russell is the only person to be so honored by the state of Montana.

There are Charles Marion Russell schools and city parks. A national wildlife refuge carries his name and on March 19, 1964, the United States Post Office Department commemorated the one hundredth anniversary of Charles M. Russell's birth with an official postage stamp reproducing one of his famous paintings in color.

In addition to these honors, the artist's log-cabin studio is preserved as a memorial by the city of Great Falls; a second gallery in that city houses many of his works and many others are on display in the Charles M. Russell Room of the Montana Historical Society in Helena. Other important museums have large and significant collections of his work: in Tulsa, Oklahoma; Fort Worth, Texas; Cody, Wyoming; and Shreveport, Louisiana.

Russell's admirers are legion. To the cowboys and others who really knew the old West, there has never been but one Western artist—Charlie Russell.

[10] The one known painting of the "Piskan" which has been attributed to Charles M. Russell was unsigned twenty years after the artist's death. Authorities agree that the present signature on the painting is a forgery and that the painting was not executed by Russell.

PAINTINGS 1883-1894

3. Roping 'Em

This little watercolor is among the earliest known examples of Russell's work and is believed to have been done in 1883 when the artist was nineteen years of age. Artist's materials were hard to come by on the frontier and Russell was liable to paint on anything that was handy. This picture was painted on a section of cardboard salvaged from between the layers of crackers when these staples came packed in wooden boxes. It was probably given to one of the two cowboys shown in the painting, and then was left by him in an old log cabin on the William Neill ranch at the foot of the Snowy Mountains, where it was found many years later.

Buffalo skulls were a common sight on the prairie when Russell arrived in Montana and one of these usually appears in the foreground of his earliest paintings. Repeated painting of such a skull probably gave the artist the idea of using a quick outline of one as a part of his signature, a practice he invariably followed after about 1889.

c. 1883. Watercolor, 9 1/2 × 12″. Signed lower left: CMR (skull). Ex-collection: William Neill, Carneil, Montana; Sid Willis, The Mint, Great Falls, Montana. (ACM 290.61)

4. *Crow Indians Hunting Elk*

Experts consider this painting unusually fine for Russell's early period. In comparison, some of those painted in the following year or two exhibit a much more primitive style. Here the artist has succeeded in imparting a feeling of suspense that is obviously shared by the Indians and one can almost feel the cold of a Montana winter day. The painting was done in 1887 as a wedding present for the artist's friend Johnny Sellers. Nearly thirty years later Mr. Sellers had his prized possession on display in Lewistown, Montana, and took Russell around to see it. Charlie had forgotten all about the painting and was much interested in this example of his early work. According to the local newspaper account, Charlie remarked that he was "surprised at the good work this shows."*

c. 1887. Oil on canvas, 18 × 24 1/2". Signed lower left: CM Russell (skull). Ex-collection: John Sellers, Forest Grove, Montana; John B. Ritch, Lewistown, Montana; Russell H. Bennett, Minneapolis, Minnesota. (ACM 136.61)

* Louise J. Thomas (daughter of Mr. John Sellers), from private correspondence dated December 30, 1936, in possession of the author.

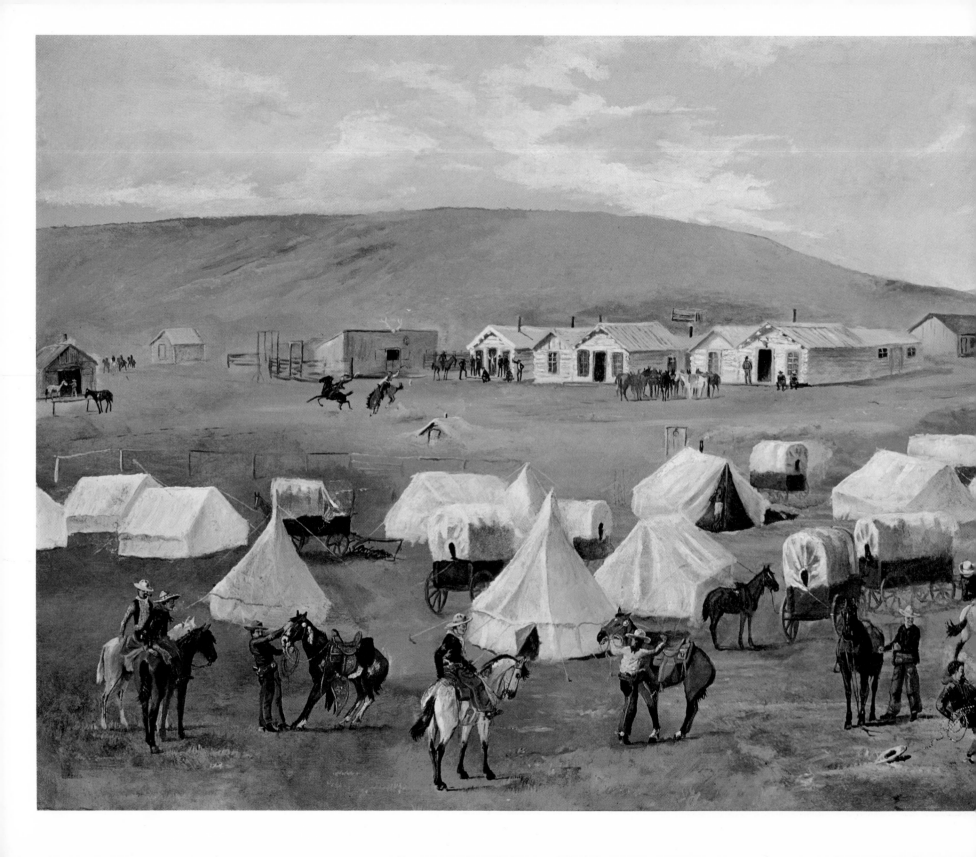

5. Cowboy Camp during the Roundup

Utica, Montana, was the headquarters for the great Judith Basin Round-up in the 1880's. On July 12, 1887, the *Fort Benton River Press* reported that "Charles M. Russell is now engaged in painting a picture for James R. Shelton in which are embraced the buildings of Old Utica, with a lively cow camp in the foreground." The account didn't mention it but Mr. Shelton owned one of the four thirst emporiums in Utica and commissioned the painting to decorate his place of business.

An art critic might call this painting primitive but the Judith Basin cowboys, who could recognize every man and horse in it, thought it wonderful. The cowboys in the foreground, from left to right, are Henry Gray, Frank Plunket, Bob Stevens, Charley Courtney, Henry Keaton, "Slack" Jackson, Pete Vann, Ed Blake, Archie Hayden (waving his hat), Kid Antelope, and Charlie Carthare. Taylor Allen and Jim Shelton are sitting at the corner of the latter's saloon in the middle distance.*

Cowboy Camp during the Roundup was one of the first examples of Russell's work to be reproduced in a Montana newspaper, appearing in the Souvenir edition of the *Helena Journal* for July, 1891. In later years the painting was acquired by Sid Willis and hung in The Mint, famous saloon and art gallery of Great Falls. As in most of the artist's early paintings, a buffalo skull appears in the foreground and the unusual monogram in the lower right is the signature Russell used from 1885 through 1887.

c. 1887. Oil on canvas, 23 3/8 × 47 1/4". Signed lower right: CMR (skull). Ex-collection: James R. Shelton, Utica, Montana; Dan Taillon, Lewistown, Montana; Sid Willis, The Mint, Great Falls, Montana. (ACM 186.61)

* S. A. Willis, Souvenir Illustrated Catalog, The Mint, Great Falls, Montana (1928), p. 10.

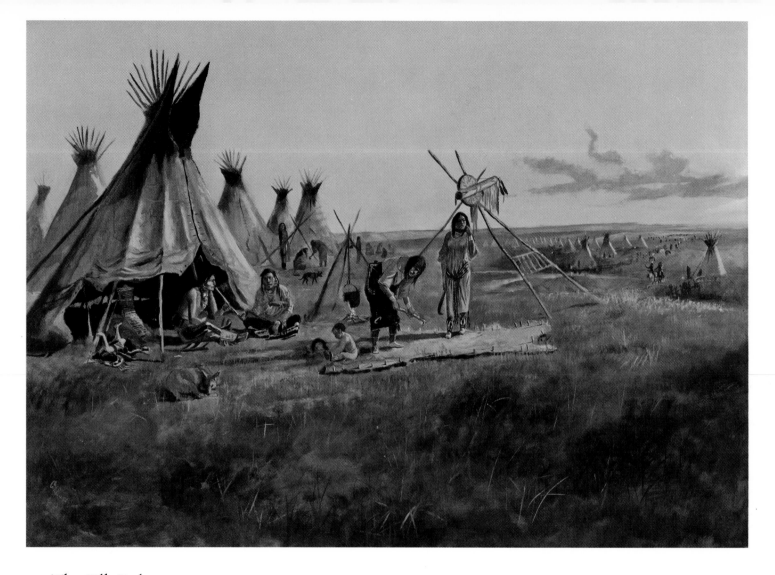

6. The Silk Robe

Russell undoubtedly saw a scene identical to this in 1888 when he spent some months with the tribe of Blood Indians in Canada. The Indian chief is sitting in the entrance to his tipi, its folds pulled up to catch the evening breeze, as he smokes and chats with one of his sub-chiefs. His two wives are "fleshing" a buffalo hide staked down on the prairie. When such a hide was especially prime and properly tanned it was called a "silk robe," the term Russell used as a title for this painting. The painting was originally purchased from the artist in 1896 by C. E. Conrad, partner in the I. G. Baker Company, famous early-day Indian traders of Fort Benton. Some years later Mr. Conrad presented the painting to his son and daughter-in-law as their wedding present.

Like many artists, Russell made use of studio "props" to give realism to his paintings. Such things as the willow backrest or the painted buffalo robe shown here might appear in several of his paintings. Most of these articles were gifts from Russell's Indian friends and many of them can still be seen at his Log Cabin Studio, now a public museum in Great Falls, Montana.

c. 1890. Oil on canvas, 28 × 39". Signed lower left: CM Russell (skull). Ex-collection: C. E. Conrad, Kalispell, Montana; C. D. Conrad, Kalispell, Montana; Mrs. Agnes Conrad, Kalispell, Montana. (ACM 135.61)

7. *Broncho Busting. Driving In. Cow Puncher*

Following the completion of the roundup in 1889, Russell spent the winter with Mr. and Mrs. Ben Roberts of Cascade, Montana. Ben Roberts was constantly encouraging Charlie to take his art more seriously and suggested that the public would be interested in a book of his paintings, promising that he would see that the book was published if Charlie would do the paintings. The idea of a saddle maker turning book publisher struck Charlie as preposterous, but after some persuasion he agreed. The series of paintings of cowboy-and-Indian life was completed that winter in the kitchen of the Roberts home and Ben promptly sent them off to New York to be reproduced by the Albertype Company.

These three paintings on a single canvas comprised a third illustra-

tion in *Studies of Western Life*, Russell's first book, published and duly copyrighted in 1890 by Ben Roberts.

In the central painting the cowboys are shown gathering wild range cattle and driving them to a branding corral on a branch of Arrow Creek, southeast of Fort Benton, with the Highwood Mountains looming in the distance. The "shot-gun" chaps and the stiff-brimmed Stetsons on the cowboys in the vignettes are typical of that period.

c. 1889. Oil on canvas, 20 × 30". Signed lower middle left: CMR (skull). Ex-collection: Monty Ellis, Great Falls, Montana. (ACM 165.65)

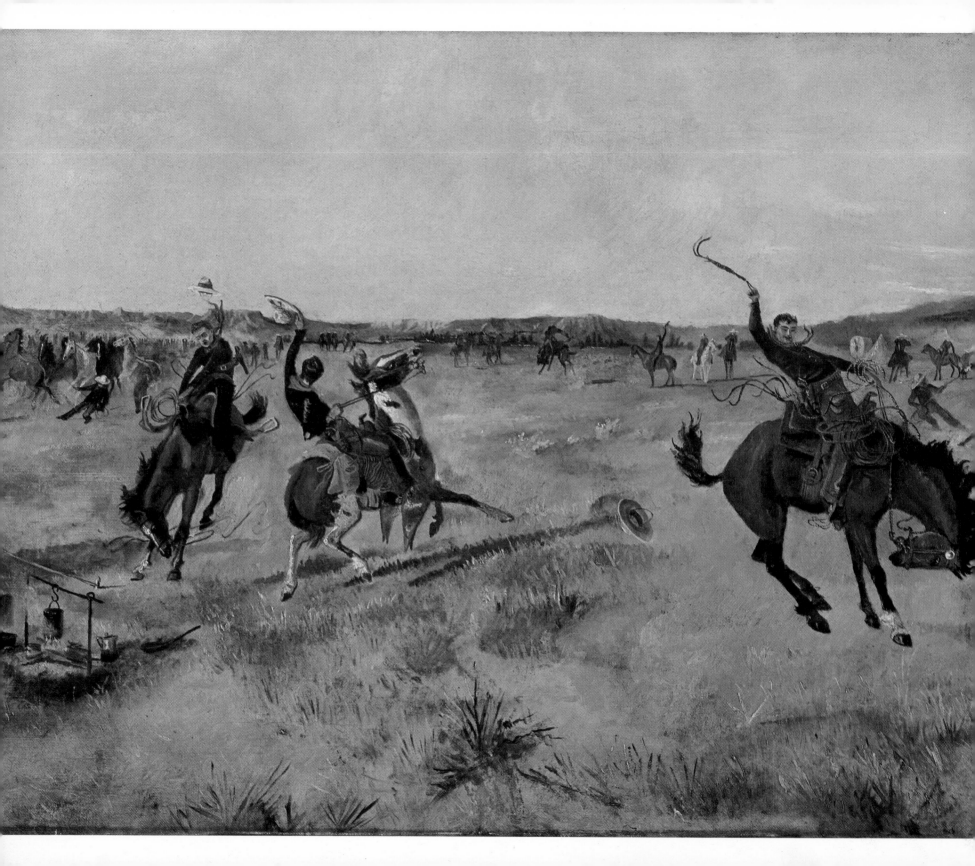

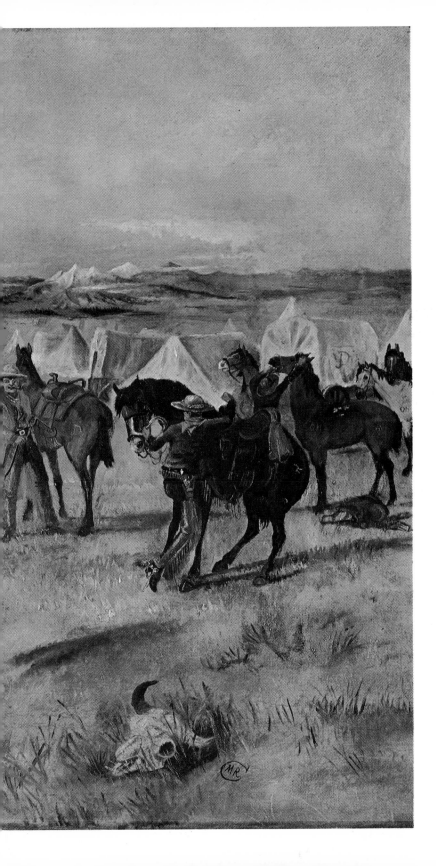

8. *Breaking Camp*

Breaking Camp was Charlie Russell's first oil painting on canvas and was completed in 1885, when the artist was only twenty-one years of age. Charlie was so pleased at getting all twenty-five cowboys of the Utica roundup crew in his painting that he sent it off to Missouri to be shown at the St. Louis Art Exposition of 1886. The label of that show is still pasted on the back of the frame. This painting and *Cowboy Camp during the Roundup*, shown in Plate 7, have sometimes been considered companion paintings from the fact that during the early days they were frequently published together. *Breaking Camp* was first owned by Jesse Phelps, the man who sent Russell's little water color sketch, *Waiting for a Chinook*, to Statler and Kaufman as his report on the terrible winter of 1885–1886. Fifty-odd years later the painting turned up in Oregon, where it was acquired by a doctor in exchange for a modest medical bill.

c. 1885. Oil on canvas, 18 1/2 × 36 1/2″. Signed lower right: CMR (skull). Ex-collection: Jesse Phelps, Utica, Montana; Dr. J. Otto George, Clatskanie, Oregon; F. G. Renner, Washington, D.C. (ACM 145.64)

9. *Lost in a Snow Storm—We Are Friends*

Being lost in a Montana blizzard at a time when there were no fences and few other landmarks was a nerve-wracking experience and these cowboys were fortunate to run into some friendly Indians who knew the country. The foremost Indian is "talking sign," telling the cowboys that the rest of their friends are "on the other side of the mountain."

Most of Russell's first paintings were in watercolor and it wasn't until about 1885 that he began to work seriously in oils. This painting, executed when the artist was twenty-four years of age, is considered unusually good for his early period. *Lost in a Snow Storm* was published as an illustration in 1894 in *Mrs. Nat Collins: The Cattle Queen of Montana*, one of the rarest of all the books illustrated by Russell.

S. lower left: CM Russell 1888. Oil on canvas. 25″×43 ½″. Ex-collections: T. W. Markley, New York City; L. H. Floyd-Jones, New York City.

1888. Oil on canvas, 25×43 1/2″. Signed lower left: CM Russell 1888 (skull). Ex-collection: T. W. Markley, New York City; L. H. Floyd-Jones, New York City. (ACM 144.61)

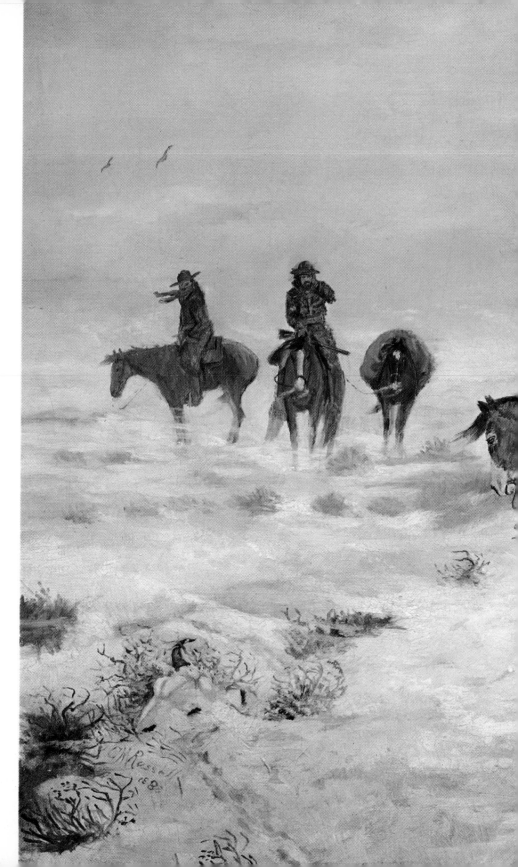

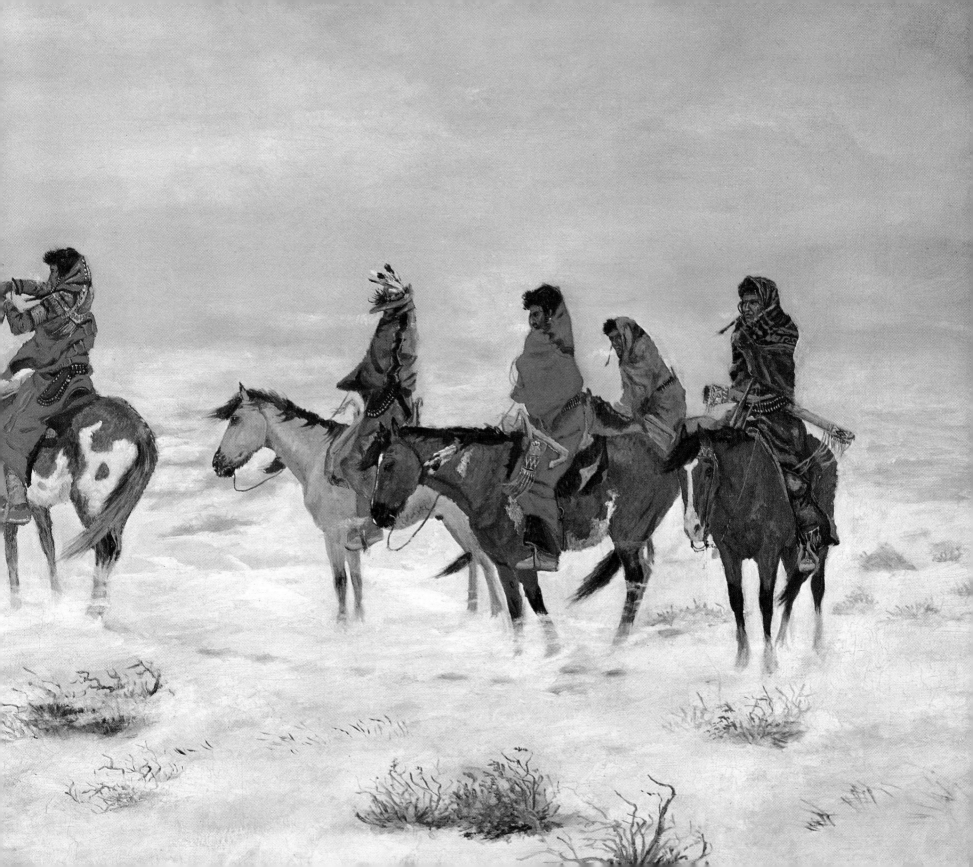

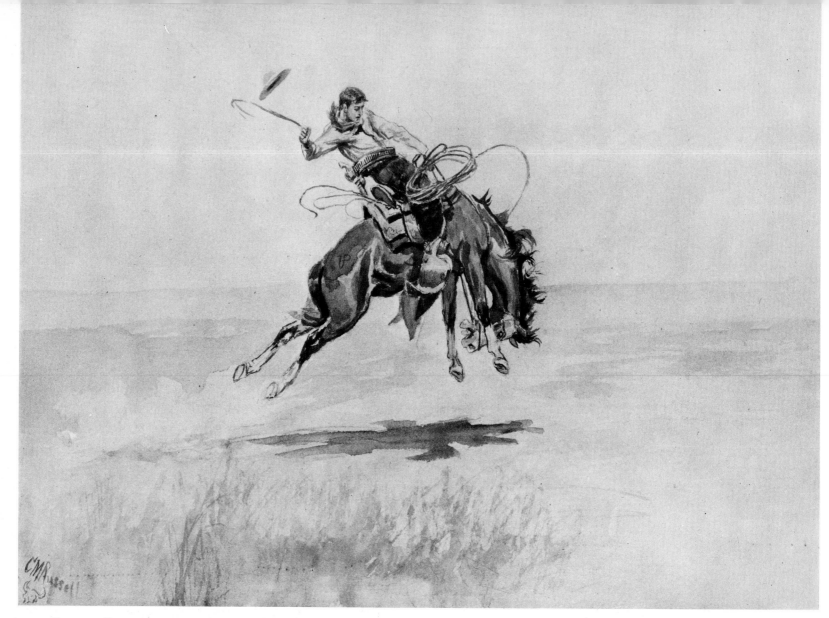

10 . *Bronco Buster*

Russell never acquired a reputation as a bronco buster, but that didn't stop him from admiring one. In the early days on the range half the horses in a cowboy's string could be expected to act snakey when a stiff saddle blanket was thrown over them on a cold morning. This was all in the day's work and usually both the man and the horse put on a good show. A horse that pitched unexpectedly when the cowboy was out on the range was a different matter. When that happened the cowboy really put on a ride, knowing that if he got thrown it meant a long walk back to camp, to say nothing of the jeers of his friends.

When Granville Stuart was manager of the Pioneer Cattle Company in

1883 two of his youngest cowboys were his nephew, Robert Stuart, and Charlie Russell. The two youngsters became boon companions and in later years were together on many of the Judith Basin roundups. Bob was known for his good looks, his ability to play the mouth harp, and the fact that he "could ride anything that wore hair." Charlie's painting of his friend was done in 1890, when Bob was "peeling broncs" for the R. W. Clifford outfit at Ubet, Montana, and Charlie was working on the same ranch as the "nighthawk."

c. 1890. Watercolor, $15 \times 21''$. Signed lower left: CM Russell (skull). (ACM 254.61)

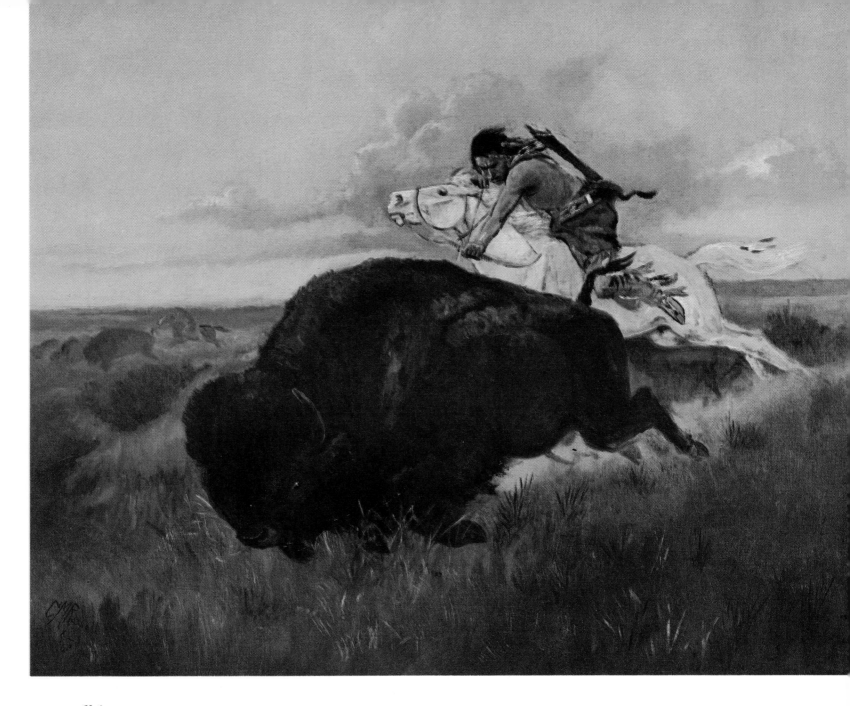

11. Buffalo Hunting

Unlike the modern hunter, who aims for the heart, the Indian directed his arrow forward and downward toward a point just ahead of the buffalo's hip bone. Here it would penetrate deeply and internal bleeding would quickly bring the animal down. If the Indian missed and hit a rib, the wounded buffalo meant trouble.

Russell's style was still somewhat primitive at this stage, emphasizing the single figure of the Indian's horse and the buffalo, both shown broadside to the observer. As he gained greater skill, Russell became more sophisticated in his compositions.

1894. Oil on canvas, 20 1/8 × 24″. Signed lower left: CM Russell (skull) 1894. Ex-collection: W. R. Coe, Southampton, New York. (ACM 211.61)

12 . *Wild Meat for Wild Men*

No one will ever know the exact number of buffalo that roamed the Great Plains but Ernest Thompson Seton's estimate of 60,000,000 is probably as authoritative as any.* These animals were still plentiful when Russell arrived in Montana, and the following year free traders described the plains in the vicinity of the Musselshell as "black with buffalo herds." The days of the buffalo were numbered, however, and the next two years saw the last of the great Indian buffalo hunts in Montana. More than a thousand Bloods, an equal number of Crees, and many Blackfeet engaged in this hunt according to James Willard Schultz. †

Russell painted every possible variation of an Indian buffalo hunt. In one interpretation the Indians might be Piegans armed with bows and arrows; in another, Indians from the same or another tribe armed with flintlocks; or, at a later date, Indians armed with repeating rifles. In each case Russell was meticulous in showing the landscape and all other details appropriate to the time, place, and participants. The scene of *Wild Meat for Wild Men* is in the general area of the Great Falls of the Missouri, near where Captain Meriwether Lewis told of seeing "a herd of at least a thousand buffaloe." ‡ "Square Butte," which was also mentioned by Captain Lewis, is looming in the left distance.

1890. Oil on canvas, 20 1/4 × 36 1/8". Signed lower left: CM Russell (skull) 1890. Ex-collection: Mrs. Florence M. N. Russell, Los Angeles, California; G. Kier Davis, Los Angeles, California; A. J. Davis, West Los Angeles, California. (ACM 182.61)

* Ernest Thompson Seton, *Lives of Game Animals* (New York: Doubleday, Doran, 1928), III, 654–657.

† James Willard Schultz, *Blackfeet and Buffalo*
(Norman: University of Oklahoma Press, 1926), p. 41.

‡ Meriwether Lewis, *The Lewis and Clark Expedition*
(New York: J. P. Lippincott and Co., 1961), I, 231.

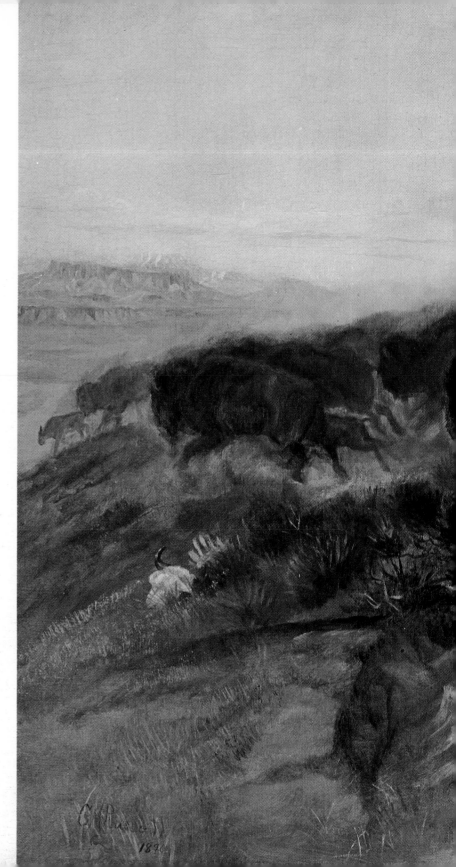

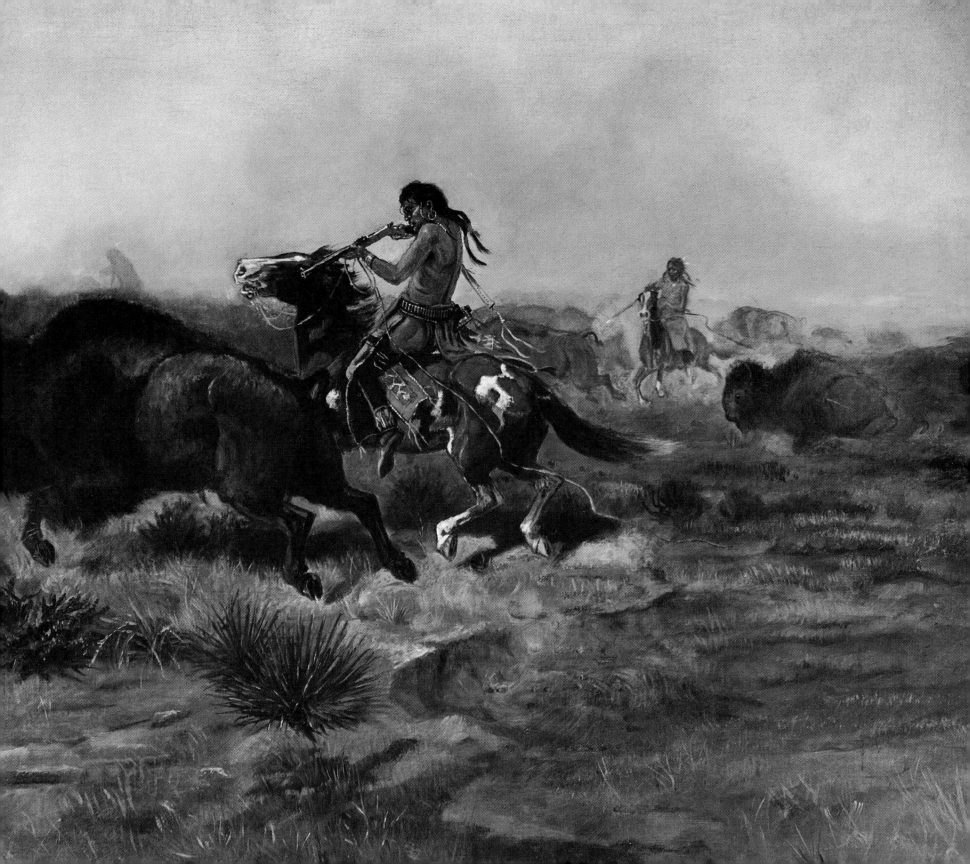

13. Bringing Home the Meat

The men of the tribe provided the meat for the family but their responsibility ended when the animal was killed. It was the women's job to follow the chase and bring the game back to camp—the carcasses of four antelope in this case. They also did the skinning, prepared the meat for cooking or for drying as "jerky," and tanned the hides. Between times they raised a family, moved camp, set up the tipi, gathered the wood, and decorated their braves' clothing with beadwork.

c. 1891. Oil on canvas, 38 1/2 × 24 1/8". Signed lower left: CM Russell (skull). Ex-collection: Sid Willis, The Mint, Great Falls, Montana. (ACM 194.61)

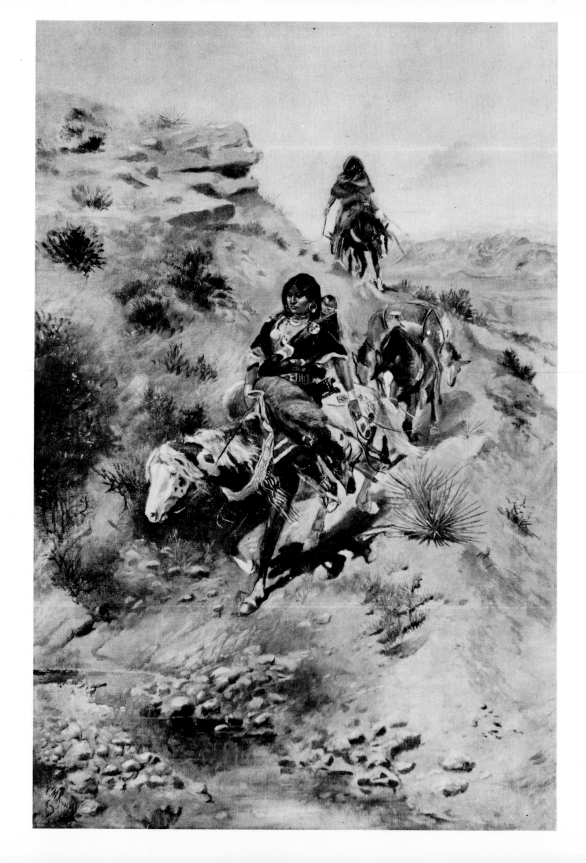

RUSSELL AS A SCULPTOR

Many admirers of Charles M. Russell have been unaware that their favorite artist was an outstanding sculptor as well as a painter, principally because until recent years relatively little publicity has been given to this phase of the artist's work. For many years not one of his models was to be seen in any public museum. Practically all of those that had been cast in bronze were in the hands of the few private collectors who could afford them and were not generally seen by the public. In contrast, literally tens of thousands of reproductions have been made of more than two hundred of Russell's paintings. Such reproductions have appeared on calendars, have been lithographed separately as colored prints, and, along with many others, have been published as illustrations in a great variety of books and magazines.

It is no reflection on Russell the painter to say that as a sculptor he was more creative. Russell was no imitator in any medium but his sculpture has a special distinction that is always the mark of a great artist. One would expect vitality in Russell's sculpture. He was a vital person, concerned with vital subjects all of his life. This vitality is in his sculpture. There is also imagination and beauty, and with them a unity that arouses and holds the undivided interest of the observer. Most important of all, Russell's fingers had an extraordinary facility for capturing the feeling that his mind sought to express. The dignity of the old Indian in *Watcher of the Plains*, the ferocity of the combat in *Counting Coup*, the playfulness of the bear cubs in *Mountain Mother*, and the exuberance of the cowboy in *A Bronc Twister* are only a few examples in which Russell displays his subtle mastery of wax and modeling clay.

The first of Russell's models to be cast in bronze was called *Smoking Up*, the subject a drunken cowboy shooting up the town. Surprisingly enough, the model for this was executed, not in Russell's Great Falls studio, but in a hotel room in New York City. The Russells made their first trip to the East in 1903, and while Nancy was making the rounds of the publishers trying to interest them in some of her husband's paintings and drawings, Charlie put in his time modeling. *Smoking Up* came to the attention of members of the Co-Operative Art Society and that organization purchased the rights to have a number of bronze castings made. Of the five in the initial order, one was presented to President Theodore Roosevelt.

During the Russells' second trip to New York City, in 1905, Charlie completed three other models which he also had cast in bronze. These were *The Buffalo Hunt, Counting Coup*, and *Scalp Dance*. The first two of these were to be among the largest and most elaborate of all of Russell's models. Present-day Russell collectors will be interested in knowing that in 1905 *The Buffalo Hunt* and *Counting Coup* were offered for sale at Tiffany's at $450 each. The *Scalp Dance* could be had for $180.

During his lifetime Russell had fifty-three of his original models cast in bronze. These castings were made from models expressly executed for this purpose and are superb examples of his work. Collectors know these as "Original Russell Bronzes"—meaning those whose casting was authorized by the artist, as distinguished from bronzes cast from other Russell models since the artist's death. All of these fifty-three bronzes are in the collection of the Amon Carter Museum, at the present time the only such complete set in existence.

14 . The Spirit of Winter

c. 1926. Bronze; height 10″, base 6 × 10″.
Signed: CM Russell (skull). Foundry unknown.
Ex-collection: C. R. Smith, New York City.
(ACM 77.61)

15. Mountain Mother

c. 1924. Bronze; height 6 3/4", base 5 × 12".
Signed: CM Russell (skull). Cast by: Cal. Br. Foundry, L.A.
Ex-collection: C. R. Smith, New York City.
(ACM 76.61)

16. Nature's Cattle

c. 1911. Bronze; height 7", base 3 1/2 × 15 1/2".
Signed: CMR (skull). Cast by: Calif. Art Bronze Fnry., L.A.
Ex-collection: C. R. Smith, New York City.
(ACM 98.61)

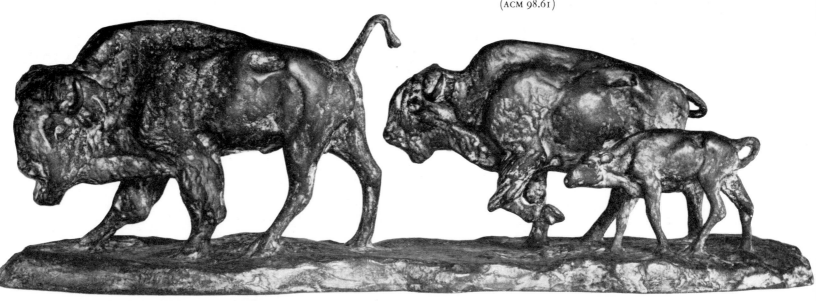

17 . *The Battle*

c. 1908. Bronze; height 6 3/4″, base 4 1/2 × 9″.
Signed: CM Russell (skull). Foundry unknown.
Ex-collection: C. R. Smith, New York City.
(ACM 82.61)

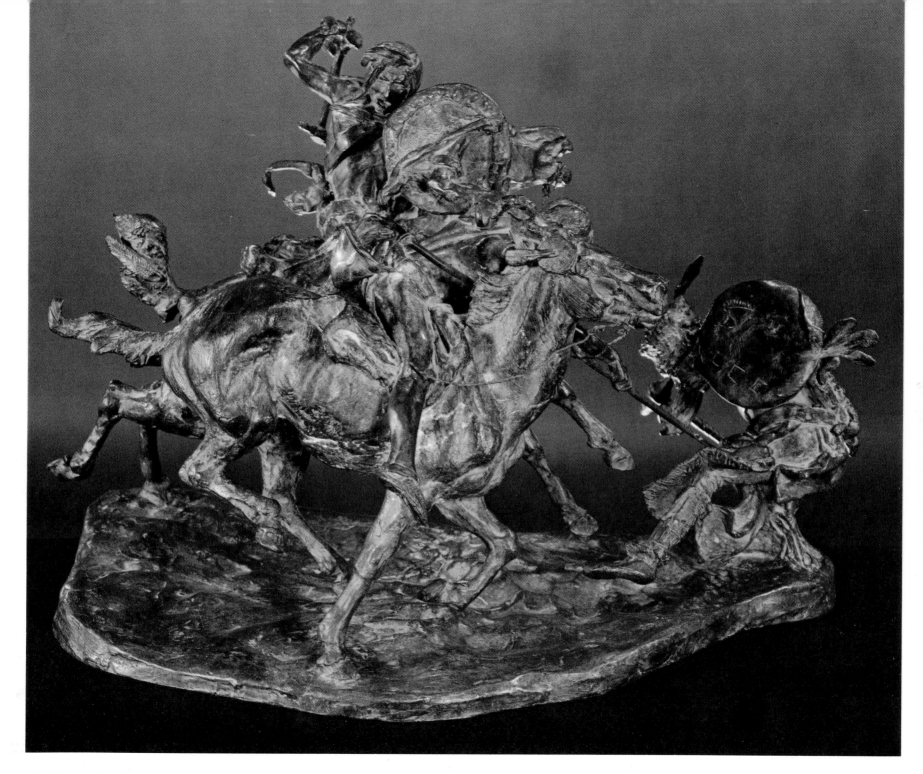

18. Counting Coup c. 1904. Bronze; height 11 1/4″, base 9 1/2 × 16 1/2″.
Signed: CM Russell (skull). Cast by: Roman Bronze Works, N.Y.
Ex-collection: C. R. Smith, New York City.
(ACM 116.61)

19. *Lone Buffalo*

n.d. Bronze; height 4 3/8″, base 4 × 7 3/8″.
Signed: CMR (skull). Cast by: R. B.W. [Roman Bronze Works, N.Y.].
Ex-collection: C. R. Smith, New York City.
(ACM 97.61)

20. *Oh! Mother, What Is It?*

c. 1914. Bronze; height 3 3/4″, base 4 1/2 × 9 1/8″.
Signed: CM Russell (skull). Cast by: Calif. Art Bronze Fnry., L.A.
Ex-collection: C. R. Smith, New York City.
(ACM 106.61)

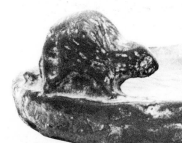

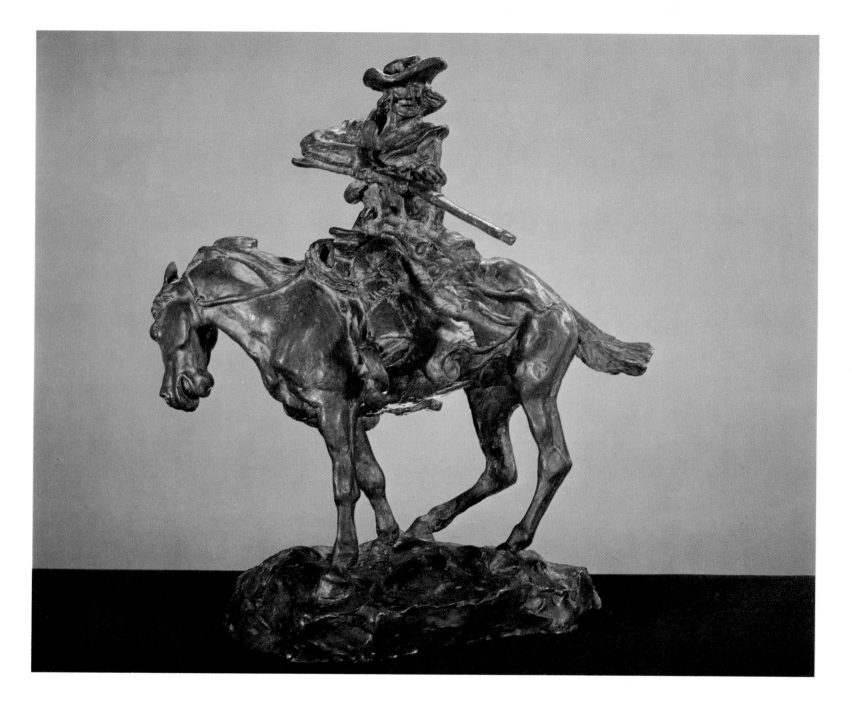

21. *Jim Bridger*

c. 1925. Bronze; height 14 3/8″, base 6 1/2 × 10 3/8″. Signed: CM Russell (skull).
Cast by: Cal. Br. Foundry, L.A. Ex-collection: C. R. Smith, New York City. (ACM 70.61)

22. The Texas Steer

c. 1925. Bronze; height 4″, base 4 × 6 3/4″.
Signed: CMR (skull). Cast by: Nelli Art Bronze Works, L.A.
Ex-collection: C. R. Smith, New York City.
(ACM 109.61)

23. The Range Father

c. 1926. Bronze; height 5 1/8″, base 5 × 14 5/8″.
Signed: CM Russell (skull). Cast by: Calif. Art Bronze Fnry., L.A.
Ex-collection: C. R. Smith, New York City.
(ACM 95.61)

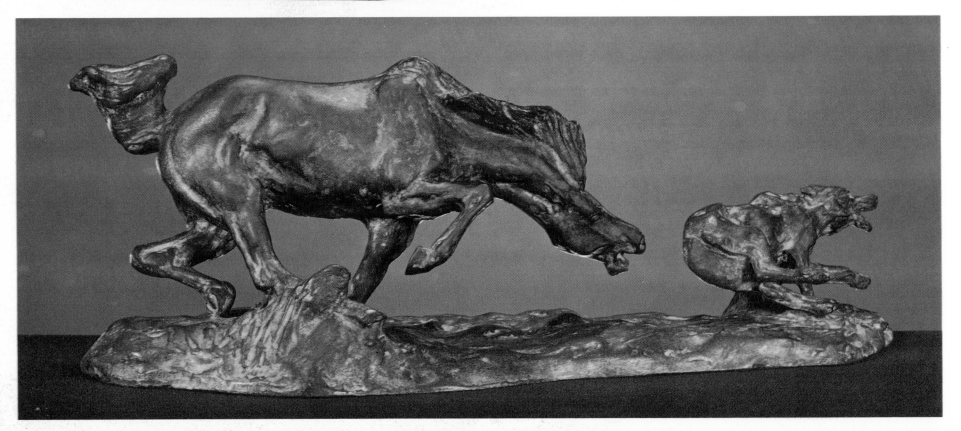

24. *Where the Best of Riders Quit*

c. 1920. Bronze; height 14 3/8″, base 6 1/2 ×
10 1/8″. Signed: CM Russell (skull). Cast by:
Calif. Art Bronze Fnry., L.A.
Ex-collection: C. R. Smith, New York City.
(ACM 29.61)

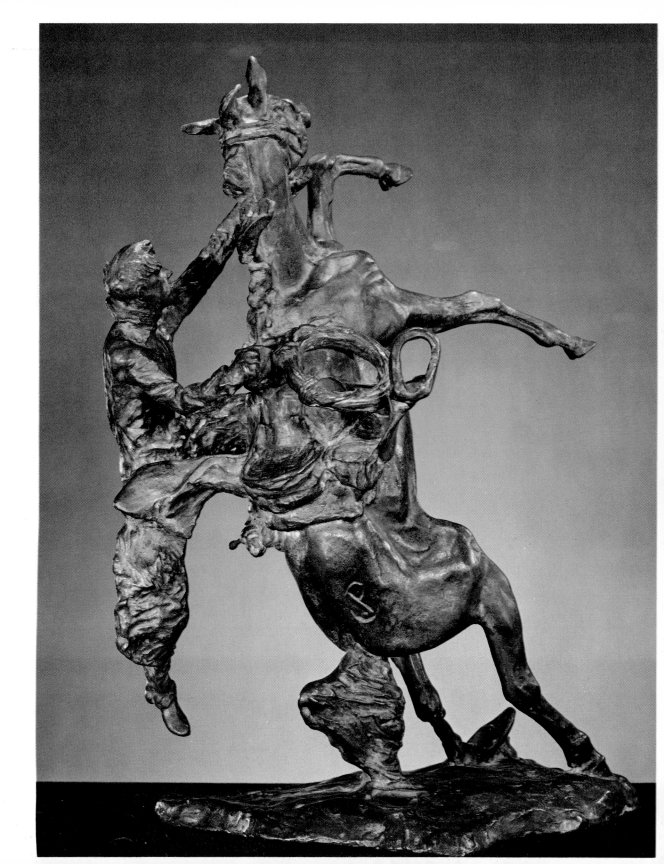

25. Smoking Up

c. 1904. Bronze; height 12 5/8″, base 5 × 8 1/4″.
Signed: CM Russell (skull). Cast by: Roman Bronze Works, N.Y.
Ex-collection: C. R. Smith, New York City.
(ACM 83.61)

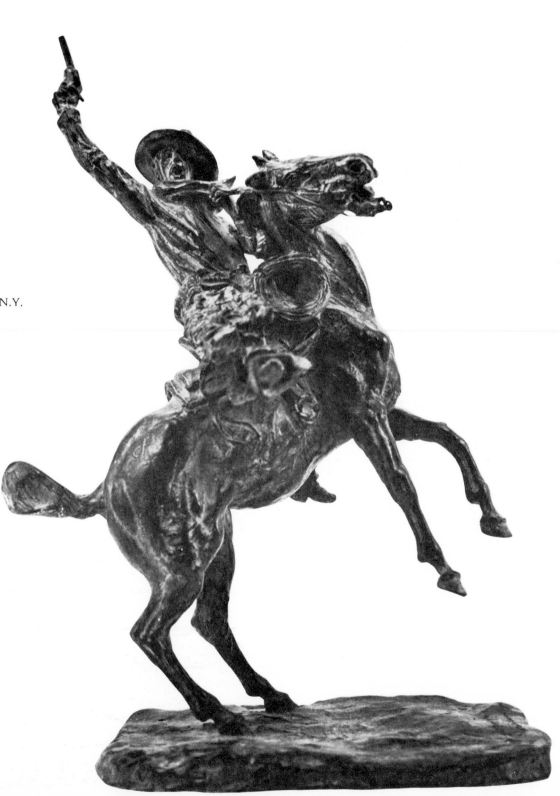

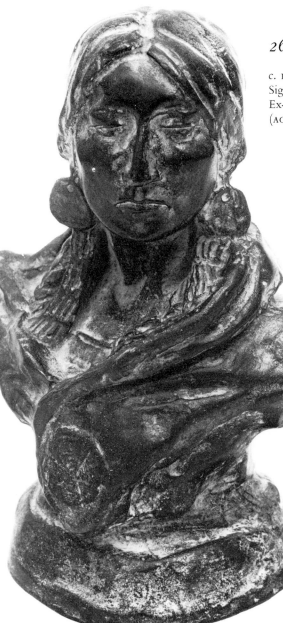

26. Piegan Squaw

c. 1902. Bronze; height 6 1/2″, base 3 1/2 × 4 3/4″.
Signed: CM Russell (skull). Cast by: Cal. Br. Foundry, L.A.
Ex-collection: C. R. Smith, New York City.
(ACM 103. 61)

27. Sleeping Thunder

c. 1902. Bronze; height 6 7/8″, base 3 3/4 × 6 7/8″.
Signed: CM Russell (skull). Cast by: Cal. Br. Foundry, L.A.
Ex-collection: C. R. Smith, New York City.
(ACM 105.61)

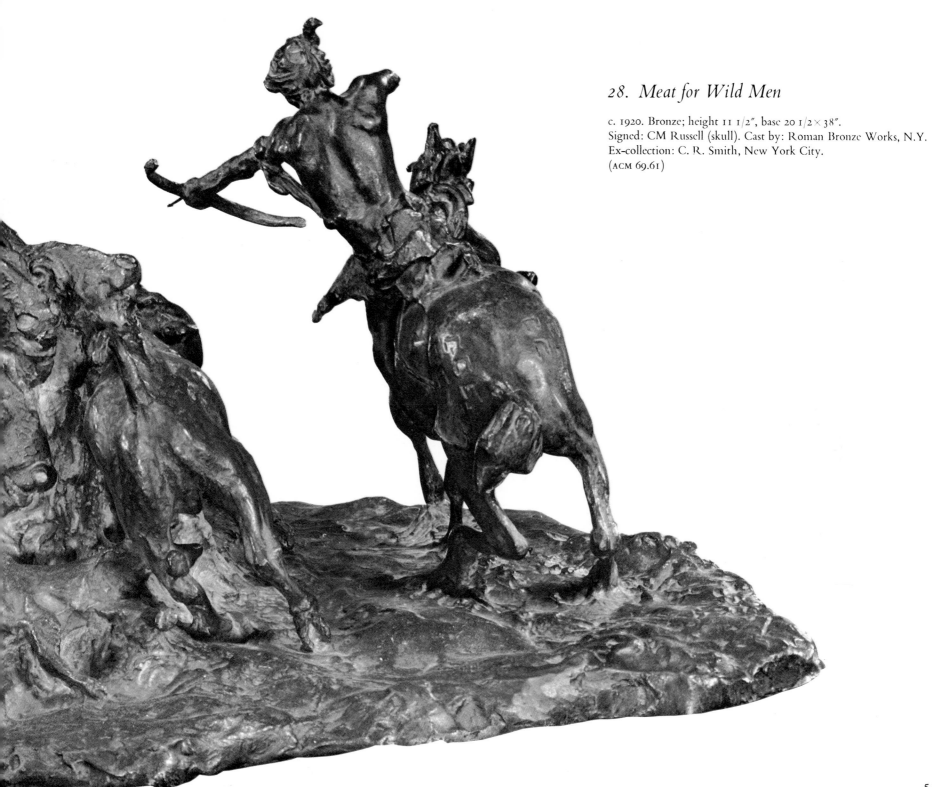

28. Meat for Wild Men

c. 1920. Bronze; height 11 1/2″, base 20 1/2 × 38″.
Signed: CM Russell (skull). Cast by: Roman Bronze Works, N.Y.
Ex-collection: C. R. Smith, New York City.
(ACM 69.61)

29. Will Rogers

n.d. Bronze; height 11 1/4″, base 5 × 9 7/8″.
Signed: CM Russell (skull). Cast by: Nelli Art Bronze Works, L.A.
Ex-collection: C. R. Smith, New York City.
(ACM 28.61)

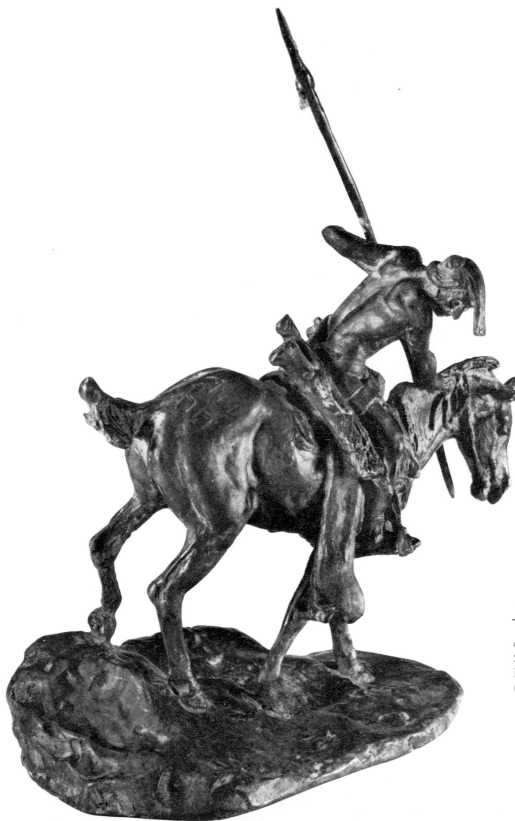

30. The Enemy's Tracks

c. 1920. Bronze; height 12 3/4″, base 6 × 8 3/4″.
Signed: CM Russell (skull). Cast by: Roman Bronze Works, N.Y.
Ex-collection: C. R. Smith, New York City.
(ACM 75.61)

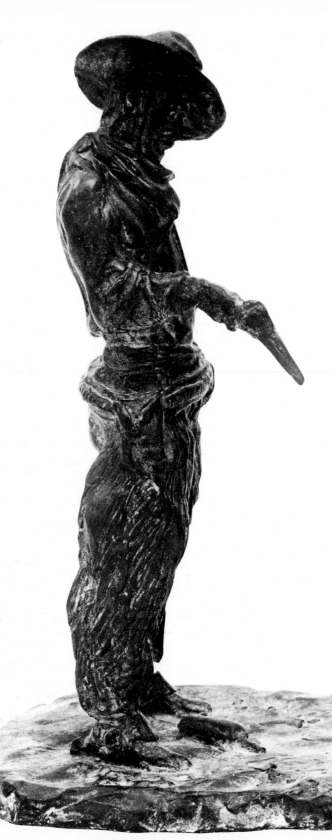

31. Painting the Town

n.d. Bronze; height 11″, base 6 × 13″.
Signed: CM Russell (skull). Cast by: Nelli Art Bronze Works, L.A.
Ex-collection: C. R. Smith, New York City.
(ACM 99.61)

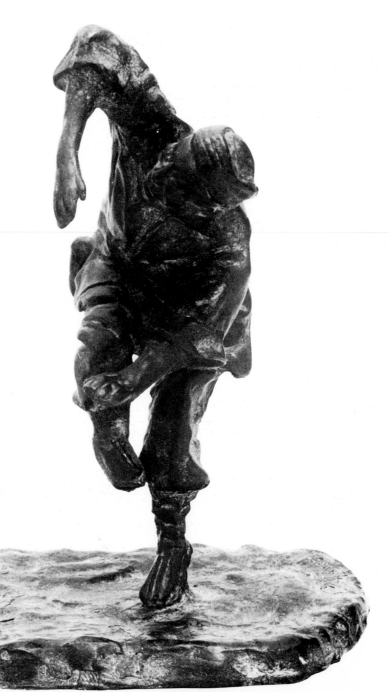

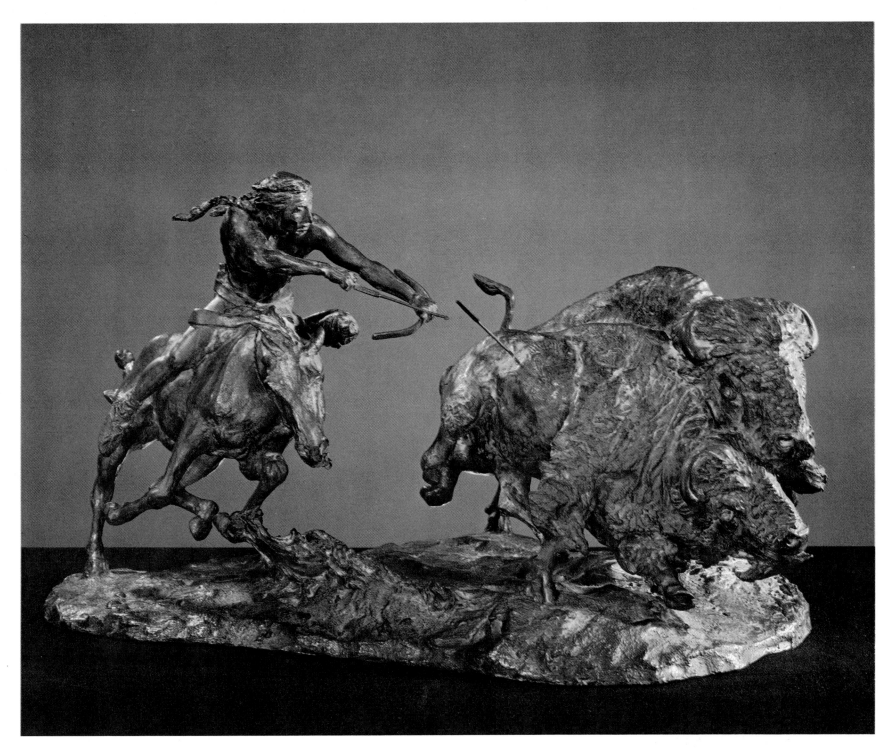

32. Buffalo Hunt

c. 1904. Bronze; height 10″, base 13 × 17 3/4″. Signed: CM Russell (skull). Cast by: Roman Bronze Works, N.Y.
Ex-collection: C. R. Smith, New York City. (ACM 121.61)

33. Medicine Whip

1911. Bronze; height 9 1/2″, base 4 × 9 7/8″.
Signed: CMR (skull) 1911. Cast by: Cal. Art Bronze Foundry, L.A.
Ex-collection: C. R. Smith, New York City.
(ACM 96.61)

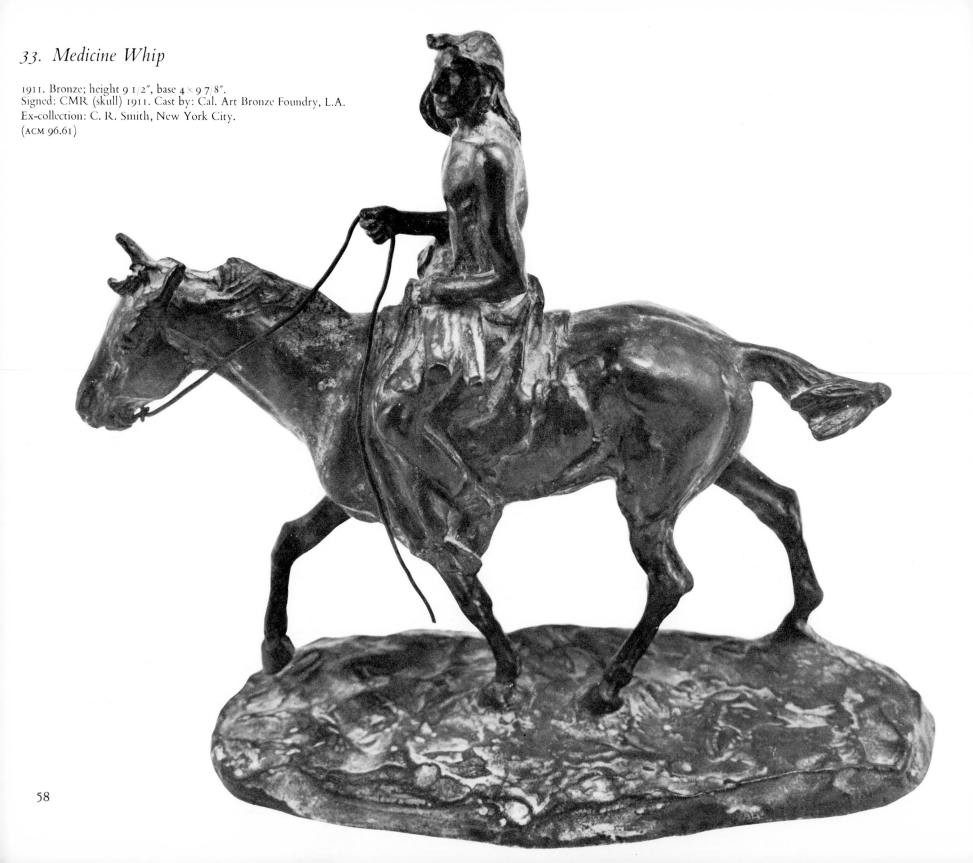

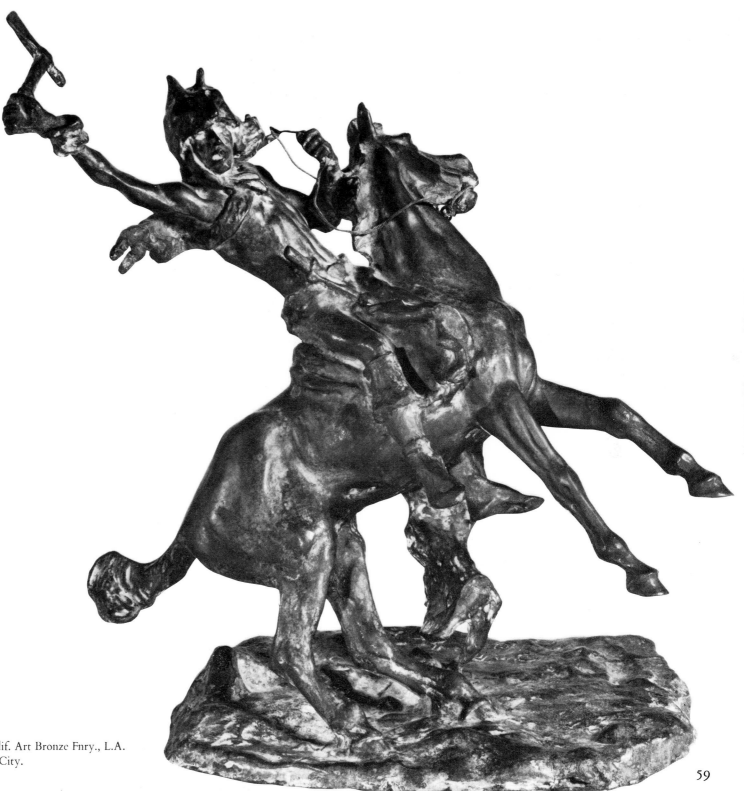

34. *The Cryer*

n.d. Bronze; height 11 1/2″, base 6×8″.
Signed: CM Russell (skull). Cast by: Calif. Art Bronze Fnry., L.A.
Ex-collection: C. R. Smith, New York City.
(ACM 81.61)

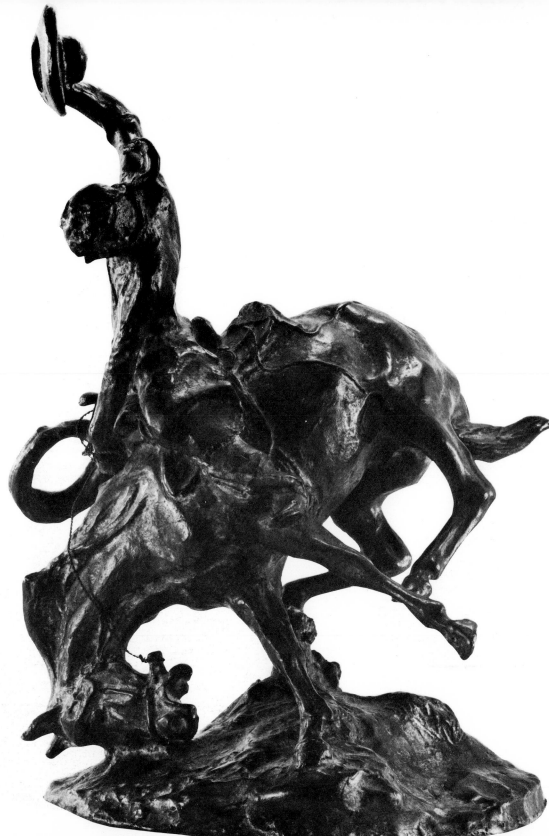

35. The Weaver

c. 1911. Bronze; height 15″, base 7 3/4 × 10″.
Signed: CM Russell (skull). Foundry unknown.
Ex-collection: C. R. Smith, New York City.
(ACM 32.61)

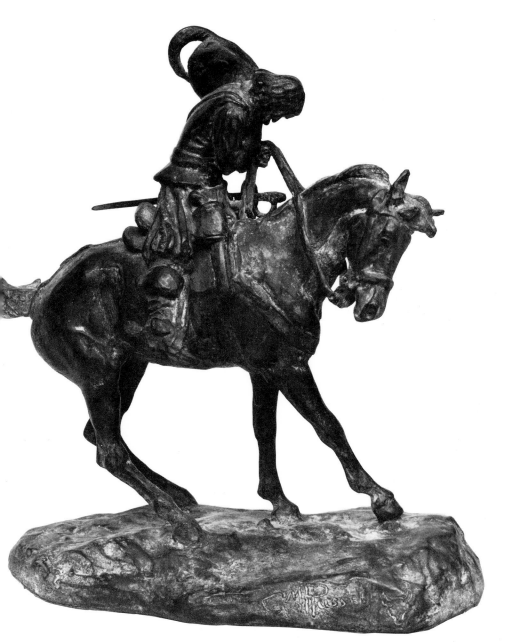

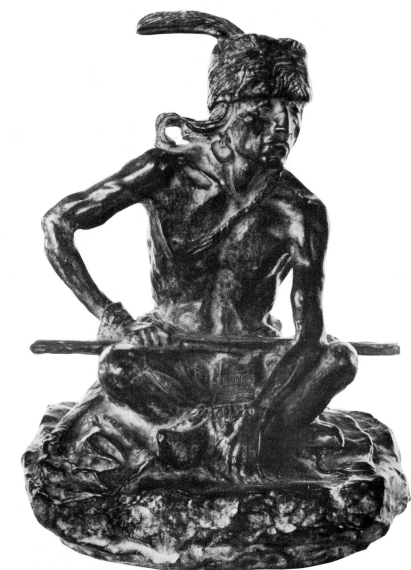

37. *Watcher of the Plains*

c. 1902. Bronze; height 11″, base 7 × 9″.
Signed: CM Russell (skull). Cast by: Calif. Art Bronze Fnry., L.A.
Ex-collection: C. R. Smith, New York City.
(ACM 88.61)

36. *Fairbanks as D'Artagnan*

c. 1924. Bronze; height 11 1/4″, base 5 1/4 × 9 7/8″.
Signed: CM Russell (skull). Cast by: Nelli Art Bronze Works, L.A.
Ex-collection: C. R. Smith, New York City.
(ACM 80.61)

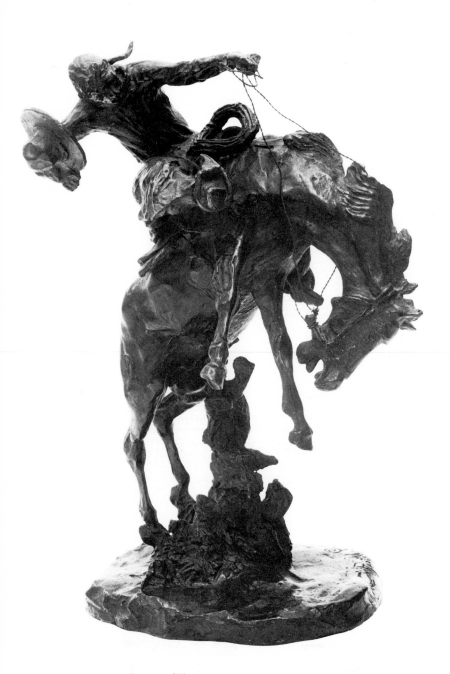

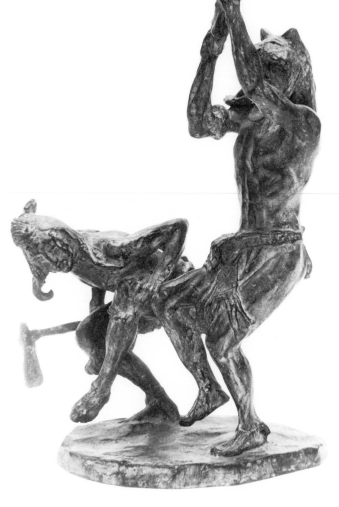

38. *A Bronc Twister*

n.d. Bronze; height 17 7/8″, base 12 3/8 × 8 1/4″.
Signed: CM Russell (skull). Cast by: Calif. Art Bronze Fnry., L.A.
Ex-collection: C. R. Smith, New York City.
(ACM 31.61)

39. *Scalp Dance*

c. 1904. Bronze; height 13 1/2″, base 5 1/2 × 6 3/4″.
Signed: CM Russell (skull). Cast by: Calif. Art Bronze Fnry., L.A.
Ex-collection: C. R. Smith, New York City.
(ACM 78.61)

PAINTINGS 1895-1898

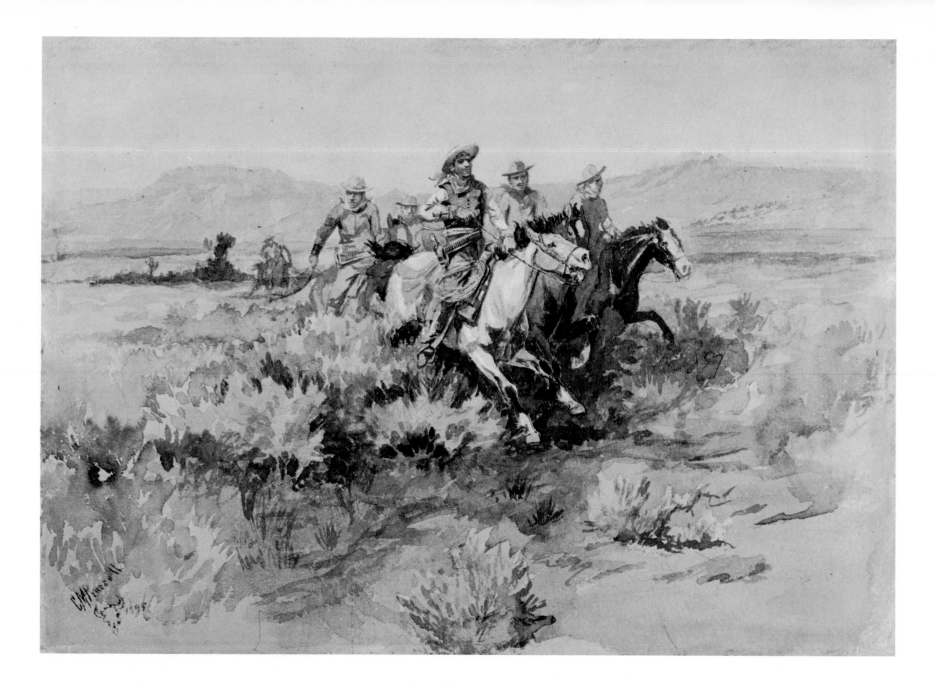

40. The Posse

The usual practice of Montana rustlers in the 1880's was to run stolen horses north to Canada, where they were sold to ranchers. The more efficient rustlers then stole some Canadian horses, which they brought back across the line to be sold around Fort Benton. Their depredations finally became so open and the losses so great that honest ranchers determined to hunt down the outlaws and to "persuade them to stop these nefarious activities." The persuasion was usually a rope thrown over the limb of the nearest tree.

1895. Watercolor, 14 × 20″. Signed lower left: CM Russell (skull) 1895. Ex-collection: Mrs. Bradon, New York City. (ACM 255.61)

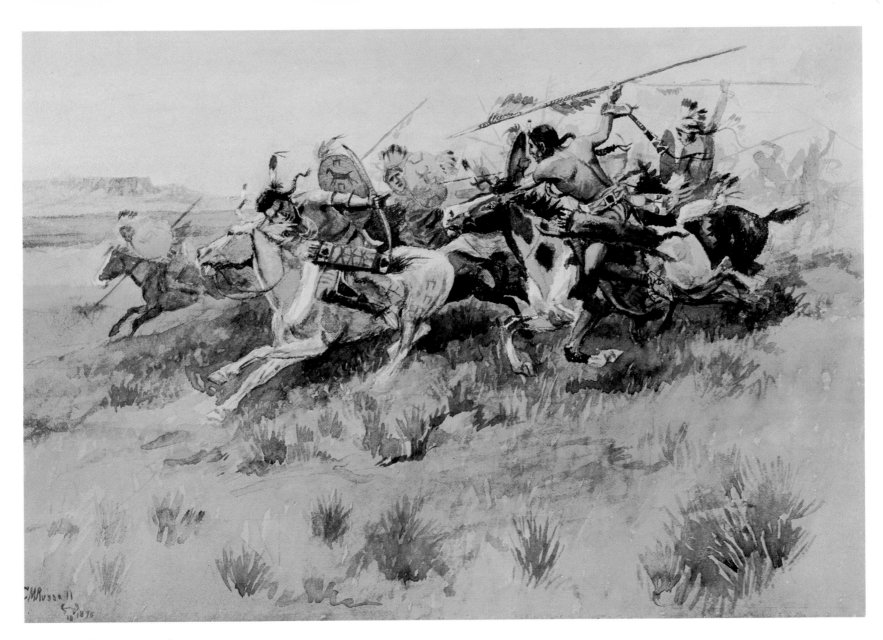

41. Indians Attacking

In his book *Trails Plowed Under* Russell told of a battle between parties of Sioux and Blood Indians, which was similar to the combat pictured here. After the Sioux had burned the northern buffalo range the hungry Bloods had taken their trail and finally caught up with them. The first part of the battle was a standoff and the Sioux had started to taunt the Bloods, telling them, "it ain't no credit to the Sioux to take the hair of a Blood, these trophies are only good to trim squaw leggin's with." This insult so infuriated one of the Bloods that he threw down his bow and empty quiver and charged the enemy with only his lance and quirt. As Russell told it:

The last he remembers he is lashin' the medicine man across the back and shoulders with his quirt. He's so fightin' mad he don't feel the arrows that are piercin' his legs and thighs. This charge of his rallies and nerves up his own men so they're right on his ponies tail when he hits the Sioux bunch, who are so busy dodgin' . . . they're all killed before they come to.*

1895. Watercolor, 13 7/8 × 19 3/4". Signed lower left: CM Russell (skull) 1895. Ex-collection: George W. Niedringhaus, St. Louis, Missouri. (ACM 174.61)

* Charles M. Russell, *Trails Plowed Under*, p. 186.

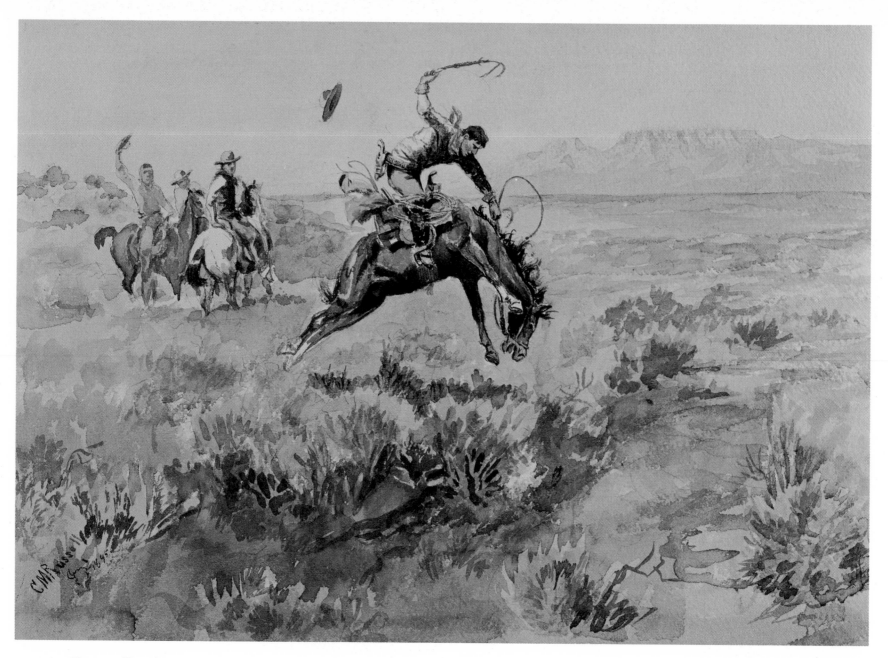

42. Bronco Busting

Men who made a specialty of riding outlaw horses had a language all their own. Such cowboys were bronco busters, twisters, peelers, or bronc stompers, men who scorned to pull leather as their horse bucked, crawfished, came apart, jackknifed, pitched, rainbowed, sunfished, or tried to chin the moon. Bob Thoroughman, the rider in this painting, embodied both the experiences and the skills Russell most admired. Thoroughman had crossed the plains with an ox team in 1865, at the age of fifteen. After working as a cowboy for a number of years, he established his own ranch in the Chestnut Valley. Widely known to be a top hand as a roper and bronc rider, Thoroughman's likeness appears in a number of Russell's paintings of cowboy life.

1895. Watercolor, 14×20″. Signed lower left: CM Russell (skull) 1895. Ex-collection: George W. Niedringhaus, St. Louis, Missouri. (ACM 270.61)

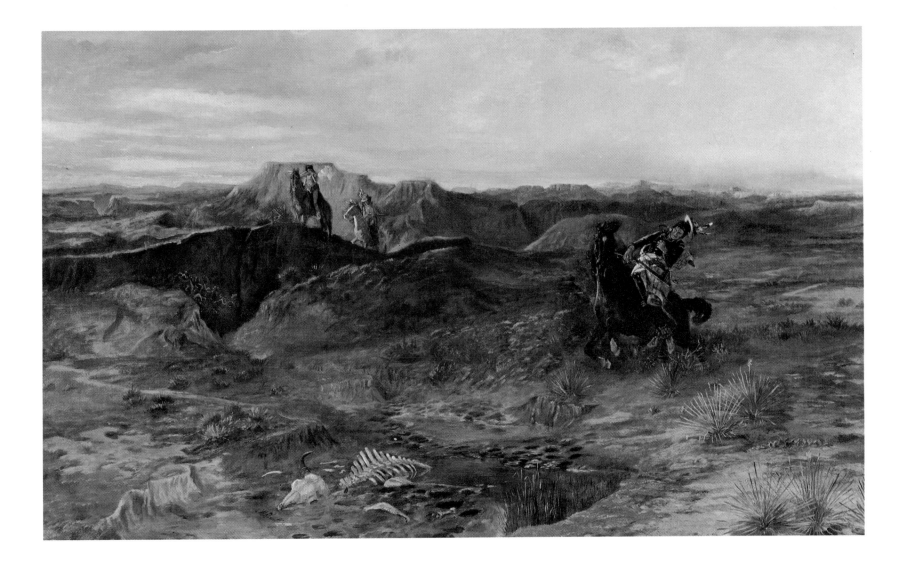

43. *Shooting a Spy*

This is the only painting Russell ever permitted to be reproduced in an unfinished state. When Mrs. Nat Collins, "The Cattle Queen of Montana," was writing the story of her life, she asked Russell to do some of the illustrations for her book. Always willing to help out a friend, Russell furnished Mrs. Collins with two paintings and advised her he was working on a third one. *Shooting a Spy* had been started sometime earlier and had been laid aside with only the landscape completed. Mrs. Collins insisted that the painting would suit her purpose just as it was. Russell reluctantly gave in and the unfinished painting was reproduced under the title *A View of the Badlands*.

The accompanying photograph shows how the illustration appeared in the book. The figures of the three Indians were added later.

c. 1888. Oil on canvas, 28 1/2 × 48″. Signed lower left center: CM Russell (skull). Ex-collection: The Loeb Family, New York City. (ACM 160.61)

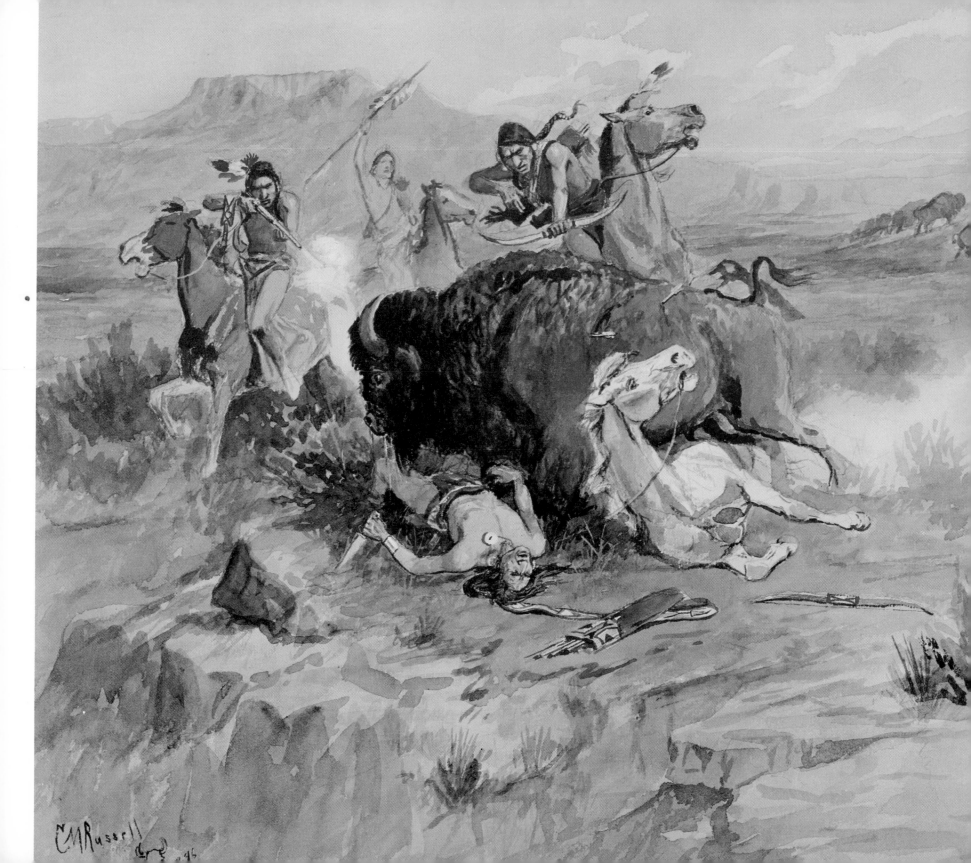

44. Buffalo Hunt No. 15

Russell had a number of favorite subjects, variations of which he was to paint time and time again. His favorite of them all was a small group of Indians hunting buffalo. So many of these are called simply *Buffalo Hunt* or *The Buffalo Hunt* that Russell iconographers have given each of them a number as a means of identification. In 1896 when this one was executed, Russell had already completed fourteen such paintings and more than twice that number were still to come from his brush. These are in addition to paintings of this subject known under such distinctive titles as *The Buffalo Runners*, *Wild Meat for Wild Men*, *Meat for the Tribe*, and many others.

1896. Watercolor, 14×20″. Signed lower left: CM Russell (skull) 1896. Ex-collection: George W. Niedringhaus, St. Louis, Missouri. (ACM 153.61)

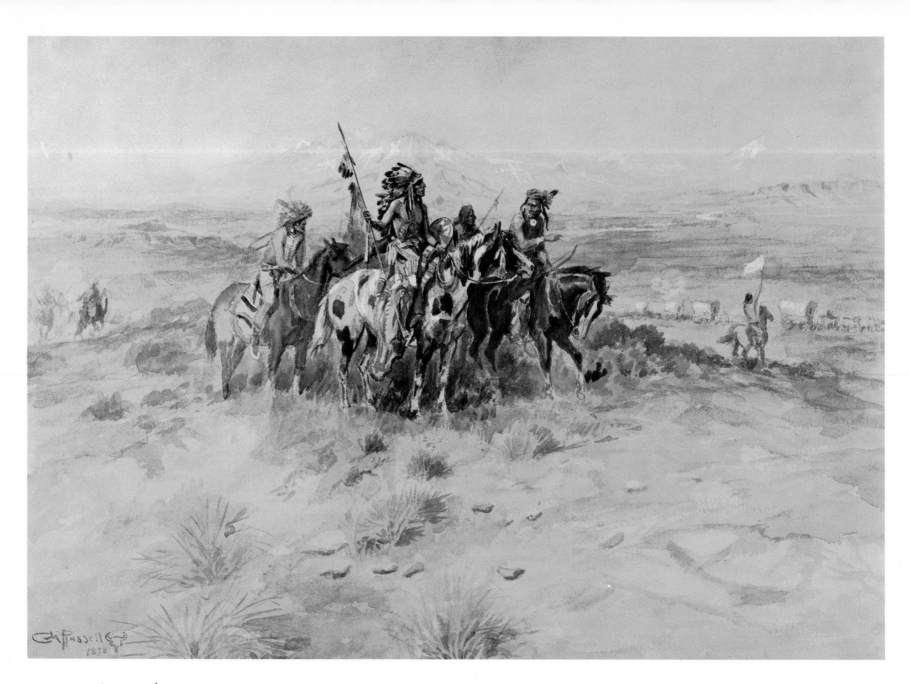

45. Intercepted Wagon Train

After many of the smaller parties of immigrants were lost, the whites found it necessary to organize large wagon trains as a matter of safety. Such a strong force was heavily armed with long-range weapons—a fact the Indians quickly learned to respect. With these larger trains the Indians employed a different strategy, which involved sending an emissary to parley and demand a "toll" of a number of oxen, or gifts of tobacco or other goods, as the price for crossing the Indians' lands. The wagon master usually decided that this was a small price to pay for permission to proceed unmolested.

1898. Watercolor, 14 3/4 × 27 3/4″. Signed lower left: CM Russell (skull) 1898
Ex-collection: Sid Willis, The Mint, Great Falls, Montana. (ACM 165.61)

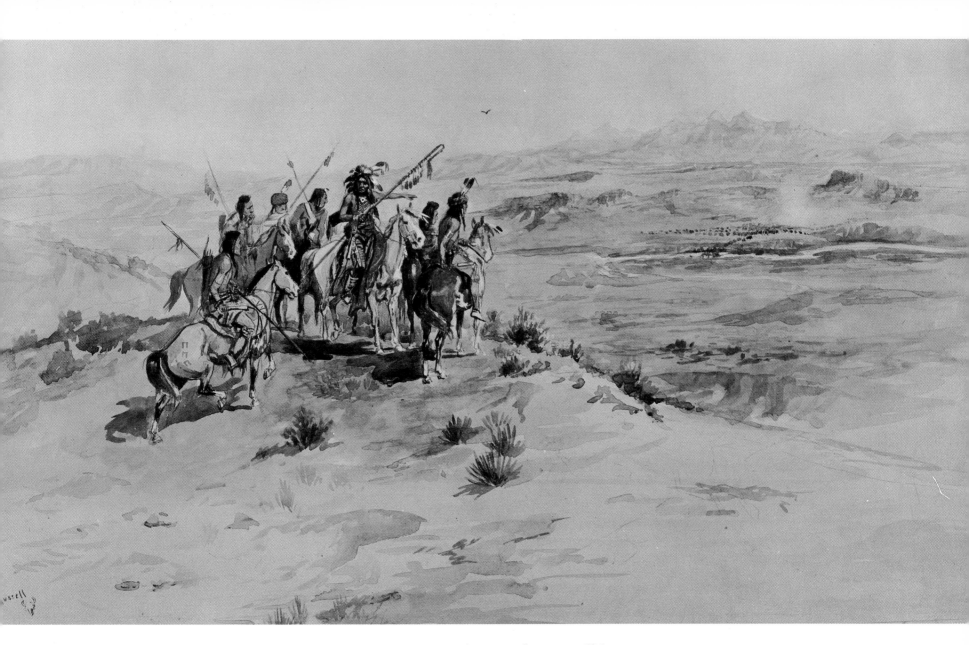

46. *Indians Sighting Buffalo*

The return of the buffalo herds in the spring of the year was an important event in the life of the tribe. More often than not, rations grew short during the long cold winters and sometimes there was even starvation if the snows were deep and game was hard to find. All this changed with the coming of spring. As soon as the scouts had located the advance guard of the returning buffalo there would be the excitement of a hunt, followed by several days of feasting by the whole tribe.

c. 1896. Watercolor, 13 3/8 × 23 1/4″. Signed lower left: CM Russell (skull). Ex-collection: George W. Niedringhaus, St. Louis, Missouri. (ACM 166.61)

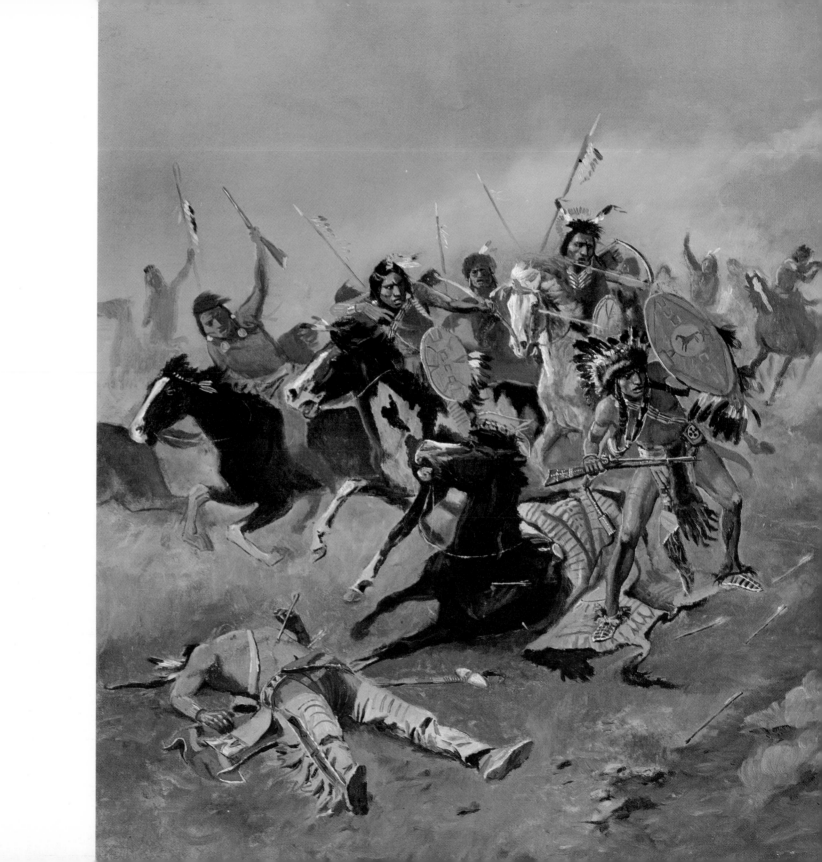

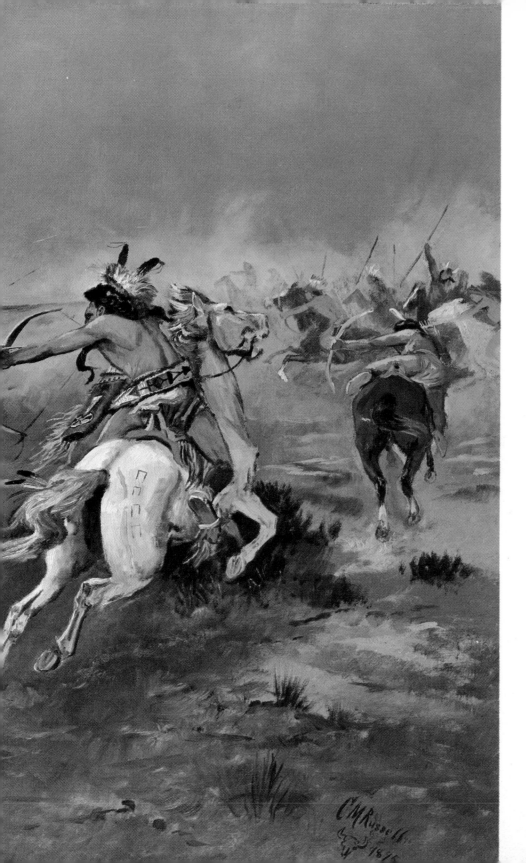

47. For Supremacy

Russell's inspiration for this painting was undoubtedly the great battle between the Piegans and the Crows around 1830. Details of this affair were reported in the *Sun River Sun*, December 25, 1884, by Little Plume, chief of the Piegans, who had been a small boy at the time of the encounter. The chiefs of the two tribes had met in council to negotiate a treaty of peace, but fighting started after it was discovered that the Crows had killed a Piegan medicine man on his way to the council. This ended the negotiations and the ensuing battle took place about two miles below the present town of Sun River. According to Little Plume's story, which may well have been exaggerated by the reporter, there were more than five thousand warriors on each side in the three-day battle and five hundred of the Piegans were killed before the Crows were driven across the Missouri. Father DeSmet's journals also tell of this great battle, although his figures of the number of Indians participating are considerably more modest.*

1895. Oil on canvas, 23 × 35″. Signed lower right: CM Russell (skull) 1895. Ex-collection: Sid Willis, The Mint, Great Falls, Montana. (ACM 170.61)

* John C. Ewers, *The Blackfeet* (Norman: University of Oklahoma Press, 1958), p. 143.

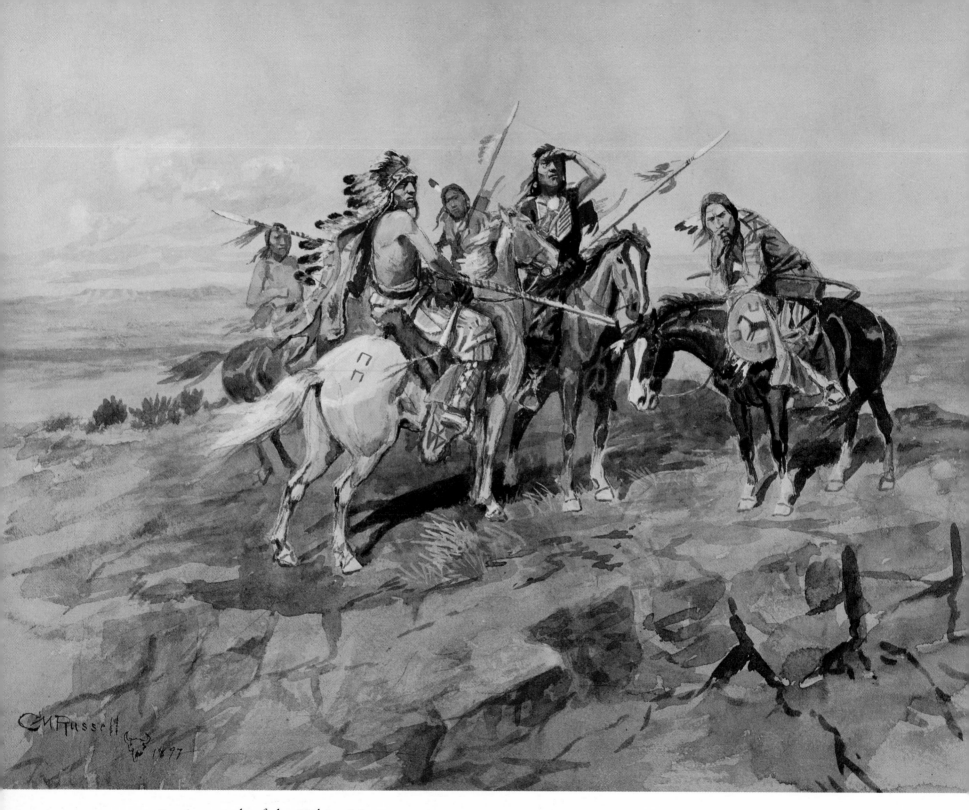

48. *Approach of the White Men* 1897. Watercolor, 18 1/4 × 24 1/2″. Signed lower left: CM Russell (skull) 1897. (ACM 152.61)

49. *Indians on Horseback*

As it is doubtful that Russell would give one of his paintings such an unimaginative title, this one was probably named by some owner through whose hands it passed. The Indians appear to be Crees and the scout in the lead is signaling "caution," having seen what may be the tracks of an enemy war party. The "point" blanket thrown across his saddle was no doubt obtained in trade from one of the Hudson's Bay trading posts far to the north.

1898. Oil on board, 13 3/4 × 10 1/2″. Signed lower left: CM Russell (skull) 1898. (ACM 159.61)

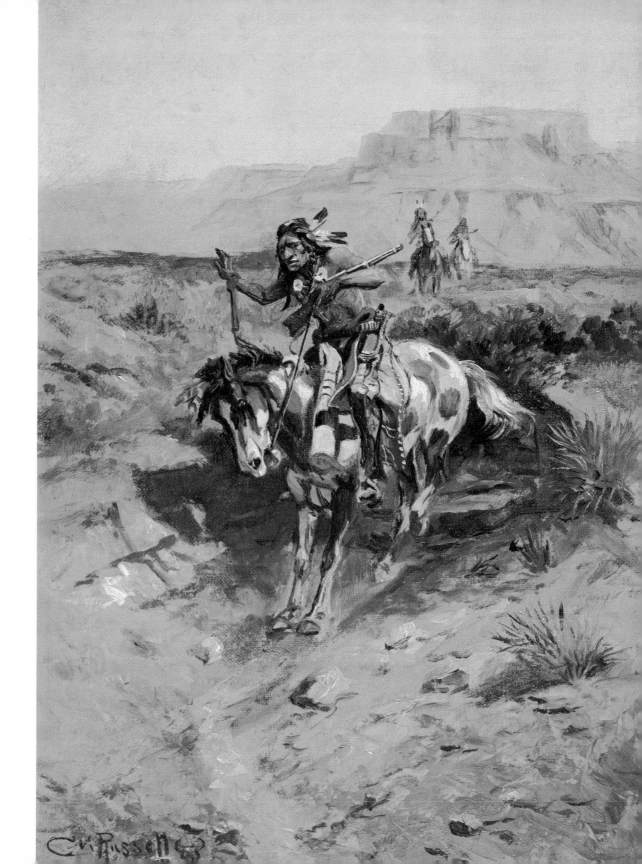

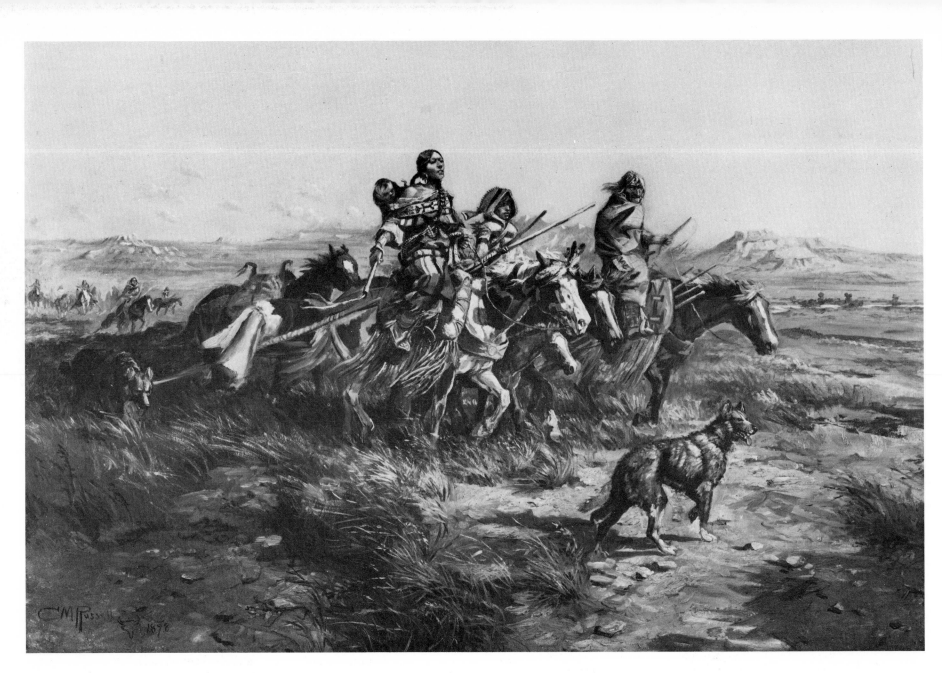

50. *Indian Women Moving*

1898. Oil on canvas, 24 × 36″. Signed lower left: CM Russell (skull) 1898.
Ex-collection: Sid Willis, The Mint, Great Falls, Montana. (ACM 147.61)

51. Squaws with Travois

Camp movements were frequent with the Plains Indians, except during the winter period, and when moving day arrived the scene was one of bustling excitement. The night before, the chief had sent the "cryer" around the camp to tell the people to get ready. By daylight the next morning the tipis would be coming down and belongings assembled and packed in parfleche bags. Within an hour or two the travois would be loaded, small youngsters would be strapped to cradleboards, and the entire tribe would be on the move. This picturesque scene must have had a great appeal to Russell, as the paintings shown here are only a few of the many variations he did of this subject.

1897. Watercolor, 13 3/4 × 22 3/4″. Signed lower left: CM Russell (skull) 1897. Ex-collection: Will Rogers, Beverly Hills, California; Will Rogers, Jr., Beverly Hills, California. (ACM 141.61)

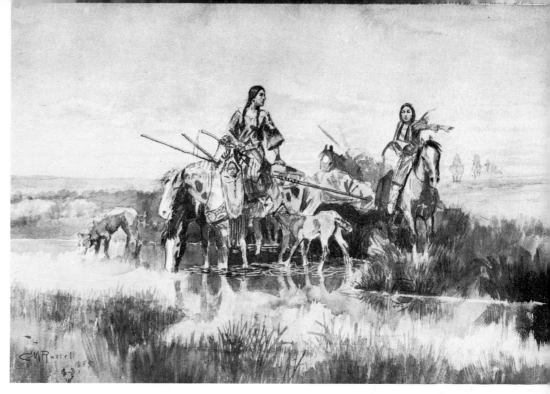

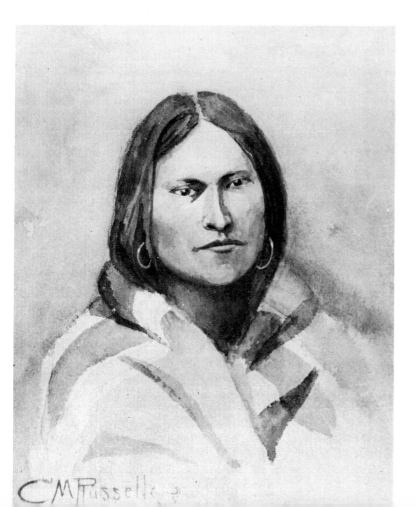

52. Indian Maiden

Russell's great action paintings of incidents on the roundup, of Indian battles, and of buffalo hunts have been so widely reproduced that some of his admirers have been led to claim that "Russell never painted a woman, white or red." It is true there are comparatively few Russell paintings depicting white women, probably for the simple reason that there were few white women to be seen during Russell's early years in Montana. This claim, however, was far from the truth concerning the Indians. Russell was interested in all aspects of Indian life and he has left us a faithful record of the activities of the Indian women, from their courtship to their old age. Russell may have been influenced by the Indians' belief that the men were the more important members of the tribe and Russell portraits of individual women or girls are comparatively rare, this being one of the relatively few examples of such a painting.

1898. Watercolor, 13 1/2 × 10 1/4″. Signed lower left: CM Russell (skull) 1898. Ex-collection: Sid Willis, The Mint, Great Falls, Montana. (ACM 140.61)

53.

The artist's wife, Nancy, posing
for the painting *Keeoma*.
Courtesy Mrs. Eula Thoroughman,
Fort Shaw, Montana.

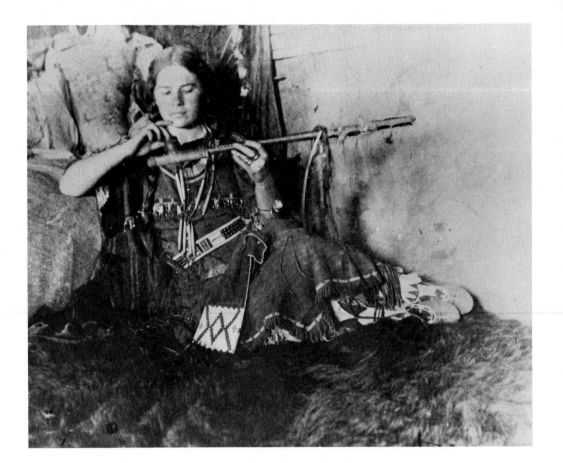

54. *Keeoma*

The figure of a voluptuous female reclining in the luxurious surround-
ings of a Far Eastern harem has been a subject that has attracted many
famous artists. Russell had probably seen a number of such paintings
and couldn't resist the temptation to do one, Indian style.

Popular legend has it that this is a portrait of the beautiful Indian girl
Russell fell in love with during the months he spent with the Blood In-
dians in Canada. One of Russell's biographers even has Sleeping Thun-
der, a chief of the Bloods, urging Russell to marry one of their women
and it has been assumed that Keeoma was the girl involved.* It may be
disappointing to those romantically inclined but there appears to be
little to support this popular fantasy. The facts are the Bloods never
had a chief named Sleeping Thunder and even the word Keeoma was
unknown to them.† The legend probably got its start when William
Bleasdell Cameron published a story called "Keeoma's Wooing" in
the July, 1897, issue of *Western Field and Stream* magazine. Russell's

painting was used to illustrate the story and has become known as
Keeoma from one of Cameron's fictional characters. The accompany-
ing photograph suggests that it was Russell's own lovely wife, Nancy,
who served as his model, rather than an Indian girl.

1896. Oil on board, 18×24 1/2″. Signed lower left: CM Russell (skull) 1896.
Ex-collection: C. E. Conrad, Kalispell, Montana; C. D. Conrad, Kalispell,
Montana; Mrs. Agnes Conrad, Kalispell, Montana. (ACM 148.61)

* Ramon F. Adams and Homer E. Britzman, *Charles M. Russell, the Cowboy
Artist: A Biography*, p. 96.

† The names "Sleeping Thunder" and "Keeoma" have never been known to
the Blood Indians of Canada. There is a small post office in Alberta called
"Keeoma," but this is an American word derived from a Blackfoot term
meaning "over there." Such a term was never used as a person's name. From
information supplied to the author by Mr. Hugh A. Dempsey, archivist for
the authoritative Glenbow Foundation, Calgary, Alberta.

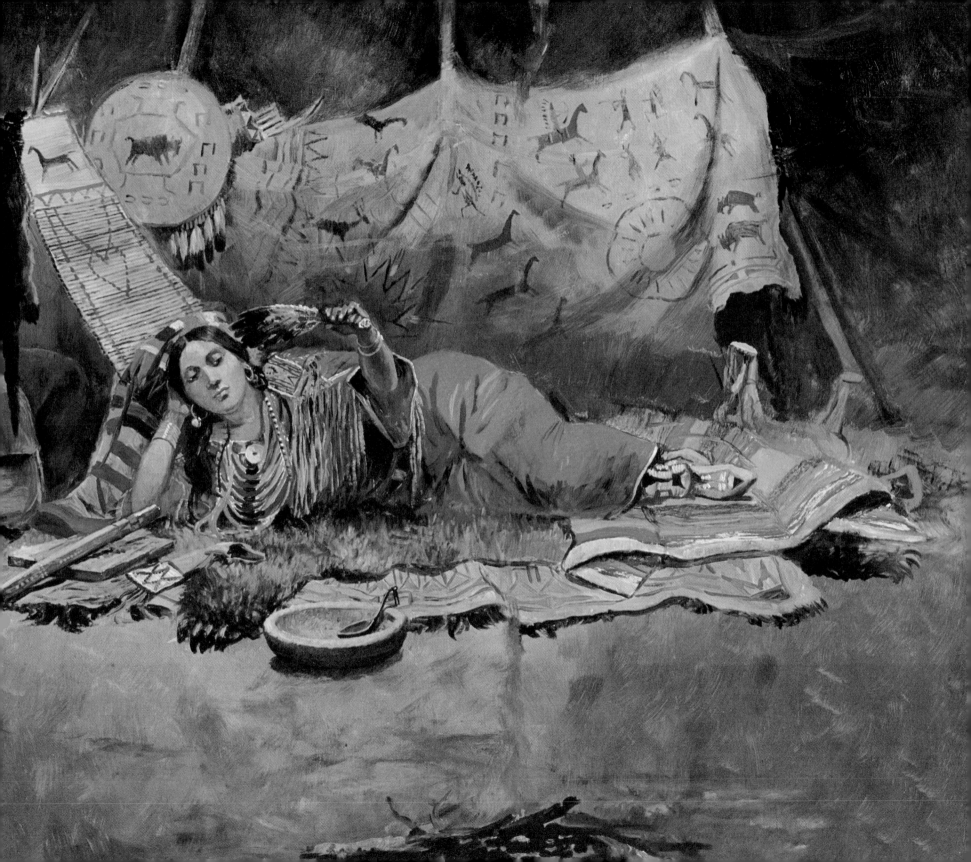

55. Bested

When early Montana horse thieves were captured they were either shot or hanged on the spot. If they were cornered they might be expected to give up only if their ammunition gave out. One such outlaw band, under the leadership of a notorious character called Stringer Jack, was corralled in a secret hide-out below the mouth of the Musselshell on July 8, 1883. Only three of the eleven outlaws escaped from that encounter and two of these were caught and hanged a few days later.* The leader of the vigilantes on that occasion was Granville Stuart, later the United States minister to Uruguay and Paraguay. The unlikely title of this painting was given to it by the editor of *Western Field and Stream*, who used it as an illustration in the September, 1897, issue of that magazine.

1895. Oil on canvas, 22 7/8 × 34 7/8″. Signed lower left: CM Russell (skull) 1895. Ex-collection: Sid Willis, The Mint, Great Falls, Montana. (ACM 189.61)

* Granville Stuart, *Forty Years on the Frontier* (Cleveland: The Arthur H. Clark Co., 1925), pp. 207–208.

56. A Doubtful Guest

After leaving his first job as a sheepherder, the youthful Charlie Russell spent most of his first two years in Montana with Jake Hoover, an old-timer who had arrived in the early 1860's. Hoover had been a prospector, but when he took Charlie under his wing he was supplying meat to the settlers in the Judith Basin and selling his hides and furs at Fort Benton. Jake Hoover was a wonderful teacher for the impressionable youngster and Charlie never forgot their times together. When Russell did this watercolor of the two

of them in camp he was remembering with nostalgia their life together fourteen years earlier. Many of the details of those days in camp are in the painting—their traps and saddles, a beaver pelt staked out to dry, even the visit from a passing band of friendly Indians.

1896. Watercolor, 18 5/8 × 22 5/8". Signed lower left: CM Russell (skull) 1896. Ex-collection: Dr. John A. Sweat, Great Falls, Montana; Miss Mary Sweat, Prescott, Arizona. (ACM 139.61)

57. Caught Napping

By 1897 Russell's work was coming to the attention of Eastern publishers. One of his first commissions for illustrations was a series of twelve to be published in *Field and Stream*. This painting depicting a white hunter with his Indian guide on a moose hunt was one of these and appeared in the January, 1901, issue of this magazine. The subject is an unusual one for Russell in that this is one of the rare paintings in which he has shown a birch-bark canoe.

Caught Napping also illustrates the considerable confusion that ex-

ists in connection with the titles of some of Russell's work. Publishers and authors unfamiliar with Russell's titles have frequently invented new ones. When this painting was published the second time, in 1907, the editor called it *At the Turn of the Stream*. Its third published appearance, in 1961, was under the title *Moose Hunt*.

1898. Watercolor, 13 1/2 × 17 1/4″. Signed lower left: CM Russell (skull) 1898. Ex-collection: Sid Willis. The Mint, Great Falls, Montana. (ACM 134.61)

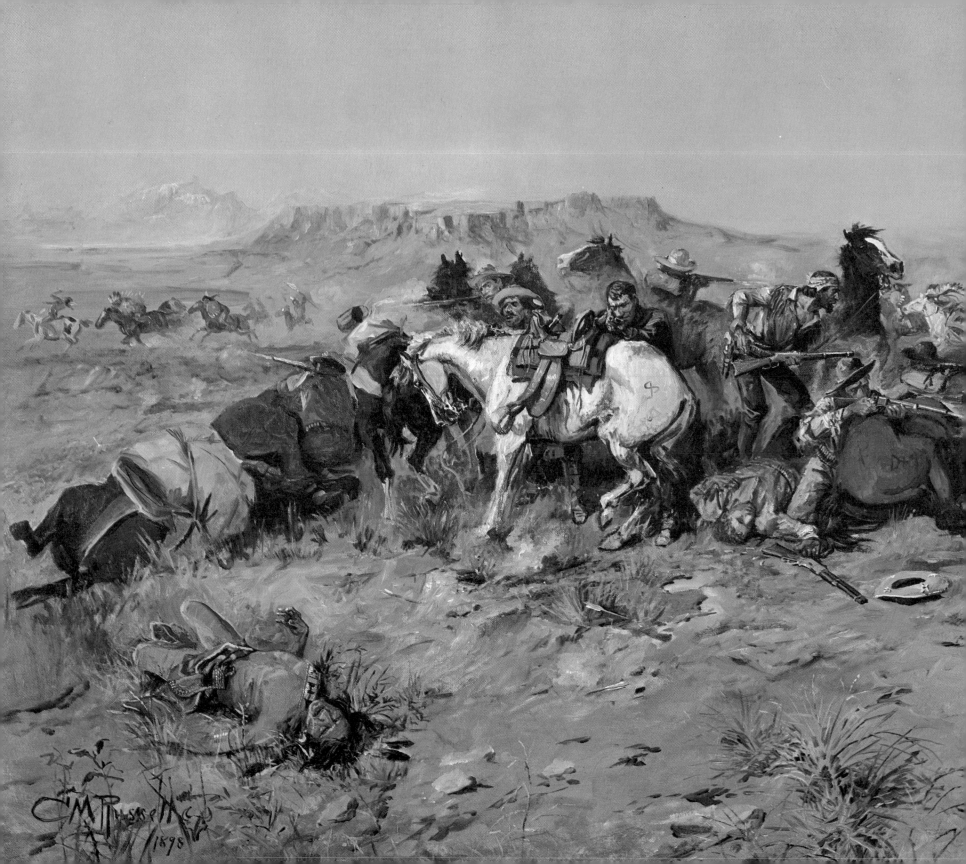

58. A Desperate Stand

The welcome that the Indians extended to the early explorers and traders eventually wore thin as more and more whites invaded the Indians' lands. The first big influx followed the creation of the great fur companies, whose employees and the free trappers who traded with them sought a fortune in beaver and other valuable furs. Even a heavily armed party of these resolute characters found it hazardous to get caught in the dreaded country of the Blackfoot—as Russell has shown in this dramatic painting.

This is one of four major oil paintings by Russell of a party of frontiersmen holding off a band of hostile Indians. The others in the series are *Caught in the Circle* in the collection of the late Sid W. Richardson of Fort Worth; *Corralled*, which is on exhibit at the Lovelace Foundation of Albuquerque, New Mexico; and *Trappers' Last Stand* owned by the R. W. Norton Art Foundation of Shreveport, Louisiana.

1898. Oil on canvas, 24 × 36″. Signed lower left: CM Russell (skull) 1898. Ex-collection: Sid Willis, The Mint, Great Falls, Montana. (ACM 158.61)

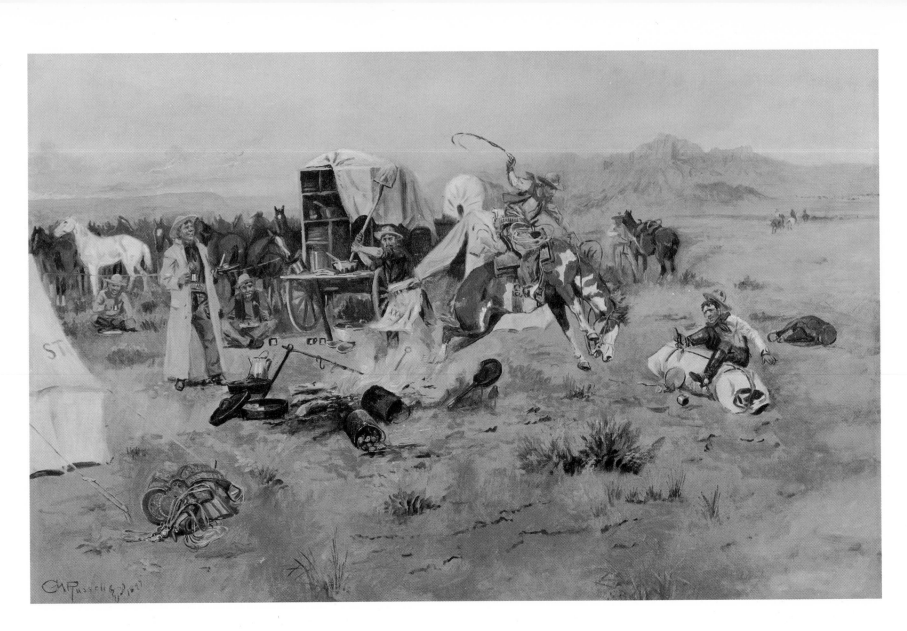

59. Bronc in Cow Camp

A bronco bucking through camp and scattering the cook's pots and pans was probably a fairly common occurrence during Russell's early days on the range, as he did several paintings of this subject. Other known ones include *Kickover of Morning Coffee Pot*, *Bronc to Breakfast*, and *The Camp Cook's Trouble*. The rider in *Bronc in Cow Camp* is Bob Thoroughman and his mount is a famous outlaw called "The Pinto." Bob was riding for the McNamara and Marlow outfit, owners of the ST brand, when this inci-

dent occurred. The home range of the ST ranch was near Big Sandy, Montana, the locale of many of B. M. Bower's early Western stories, including her most famous one, *Chip of the Flying U*.

1897. Oil on canvas, 20×31″. Signed lower left: CM Russell (skull)
1897. Ex-collection: J. P. Thoroughman, Simms, Montana; Mrs. Eula Thoroughman, Fort Shaw, Montana; F. G. Renner, Washington, D. C. (ACM 144.64)

ORIGINAL MODELS

Russell was a prolific sculptor and during his lifetime modeled hundreds of individual pieces of statuary. The artist constantly carried a ball of beeswax in his pocket for this purpose. Sitting at a table with his hands out of sight, he would suddenly produce a perfectly modeled animal or some other small figure. He even did them with his hands behind his back. When Charlie and his cronies gathered at the Silver Dollar the one who failed to guess what the artist would bring forth next paid for a round of drinks. Most of the models of this kind were done on the spur of the moment to amuse his friends and were as quickly destroyed. On one occasion one of his models had most of Great Falls in an uproar.

Charlie had seen a Gila monster on a trip to Arizona and when he returned home modeled one in clay, painting the characteristic black-and-yellow markings so realistically that his creation appeared completely lifelike. He then put his lizard in a glass-topped case and had it displayed at the Silver Dollar.

Few Montanans knew much about a Gila monster in those days and Charlie gave his imagination a free rein. His story was that the thing's breath carried a fatal poison, so all viewers were warned to approach the box with great care and always with handkerchiefs over their faces to avoid the deadly fumes. The few of Charlie's friends who were in on the joke had trouble suppressing their hilarity as they watched most of the prominent citizens of Great Falls risk their lives to see the strange reptile. Word of the affair finally reached the City Council and word was sent to Charlie to destroy the creature before there was a serious accident. Charlie said, "All right, you bring the City Council down here in an hour and I will let them see me kill the poor thing." The whole town turned out for the execution. When the councilmen arrived Charlie took his Gila monster out of the box and, walking over to the mayor, broke it in two and handed one piece to "his honor." That night, according to the report, Bill Rance took in more than $800 from the sheepish but hilarious patrons of his Silver Dollar.

Many other original models, some of them important, were gifts to close friends. A model of a longhorn steer carrying the recipient's own brand was a gift to an old-time cowman. Another friend received as a wedding gift a beautiful little antelope startled by a sage hen. There were caricatures, table decorations, and on one occasion an elaborate tableau for the Valentine party of some of the artist's younger friends. Mr. and Mrs. John Trigg, next-door neighbors of the Russells, received many unusual and interesting models of this character. The Trigg Collection is now in the C. M. Russell Gallery of Great Falls. The original models in the Amon Carter Museum Collection were mainly gifts to the artist's long-time friend Sid Willis.

60. *Charlie Himself*

This model was a 1915 birthday gift to the artist's friend William H. Rance, proprietor of the Silver Dollar. Describing the gift in the local newspaper, a reporter wrote, "Russ is all there, even to his sash and the cigar [*sic*] held between the second and third finger of his right hand. The expression is perfect; the hat sits just as the artist wears it; the coat and tie appear most natural and the sash hangs true to the artist's everyday custom" (*Great Falls Tribune*, May 19, 1915).

c. 1915. Wax and cloth, 11 3/4 × 5 1/4". Unsigned. Ex-collection: William H. Rance, The Silver Dollar, Great Falls, Montana; Sid Willis, The Mint, Great Falls, Montana. (ACM 58.61)

Russell made countless humorous models for the amusement of his friends, young and old. There were dolls with dresses of colored leaves for the girls, jesters and knights in armor for the boys, tiny turkeys to grace a Thanksgiving table, and every imaginable animal from antelope to zebra. No small part of their appeal was in the materials that Russell used. These might be a scrap of colored cloth for an Indian's blanket, a shriveled apple for a face, rooster spurs for the horns on a steer, or a piece of birch bark used for its ornamental pattern. Few of these models have survived the ravages of time. This pair of old Indians was carefully preserved by Sid Willis, who kept them in a glass case in his famous bar for more than thirty years.

61a. *Indian Squaw and Papoose*

n.d. Wax, wood, and cloth on wood base; height 16″, base 3 7/8″ diameter. Unsigned. Ex-collection: Sid Willis, The Mint, Great Falls, Montana. (ACM 59.61)

61b. *Indian Brave*

n.d. Wax, wood, and cloth on wood base; height 16 3/8″, base 4 5/8″ diameter. Unsigned. Ex-collection: Sid Willis, The Mint, Great Falls, Montana. (ACM 60.61)

62. *Grizzly*

Marked by a hump on his shoulders and by his coat with the white-tipped hairs which give him his name, the grizzly was usually given a wide berth by both Indians and early whites.

1915. Wax on plaster base; height 5 3/8″, base 4 1/2 × 7 7/8″. Signed inside base in ink: CM Russell (skull), signed on top of base in the plaster: CMR (skull) 1915. Ex-collection: Sid Willis, The Mint, Great Falls, Montana. (ACM 49.61)

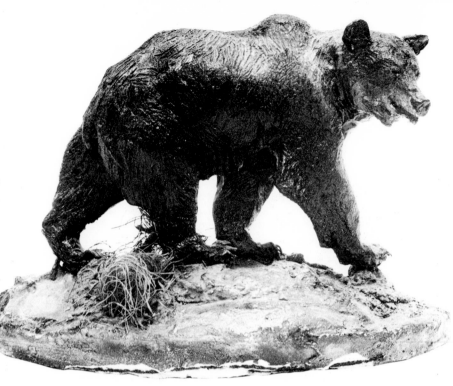

63. *Grizzly on Log*

This model is inscribed "To Bill Rance," Russell's friend and the owner of the Silver Dollar saloon in Great Falls. As young men, Russell and Rance roomed together one winter and Bill used to tell how Charlie kept him awake half the night talking and modeling small animals, which would be perched on the bedpost the next morning.

1913. Wax on wood base; height 7 1/8″, length 8 1/4″. Signed and inscribed on wood: To Bill Rance from His Friend CM Russell 1913. Ex-collection: Sid Willis, The Mint, Great Falls, Montana. (ACM 47.61)

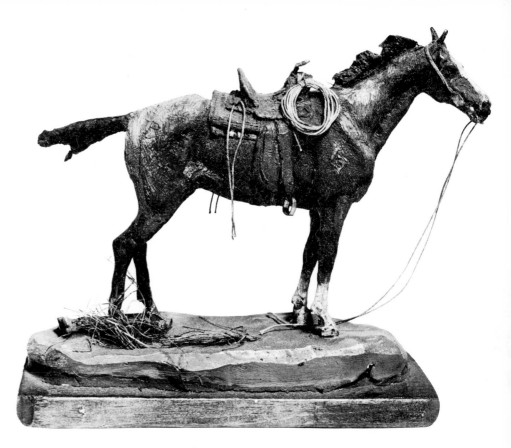

64. Horse, Saddled

Russell loved horses and, whether using paints or modeling clay, had an uncanny talent for catching their personality. A friend once remarked, "The ears on Charlie's horses express more to an old-time cowman than all the other more famous daubs put together."

n.d. Plaster; height 4 3/8", base 2 1/4 × 4 3/4". Unsigned. Ex-collection: Sid Willis, The Mint, Great Falls, Montana. (ACM 44.61)

65. Horse, Saddled

114. *Horse, Saddled*
n.d. Bronze; height 4 1/4", including artist's base 3/8 × 4 3/4 × 2 1/4". Unsigned. Cast by: Roman Bronze Works, Inc., Corona, N.Y., May, 1965, from ACM 44.61 (wax). (ACM 170.65)

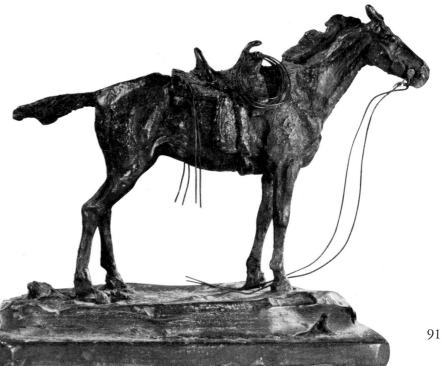

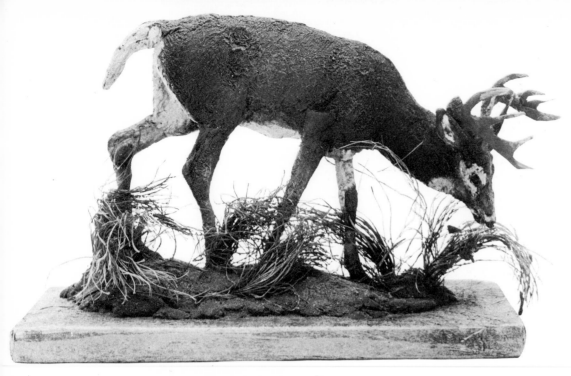

66. White Tailed Deer

The "white-tail" is still one of the most abundant of all Montana's big-game animals. Now found mostly in the mountains and foothills, these deer in Russell's time were plentiful along the "breaks" of the prairie streams far east of the mountains.

n.d. Wax on wood base; height 4″, base 2 7/8 × 6 5/8″. Unsigned. Ex-collection: Sid Willis, The Mint, Great Falls, Montana. (ACM 50.61)

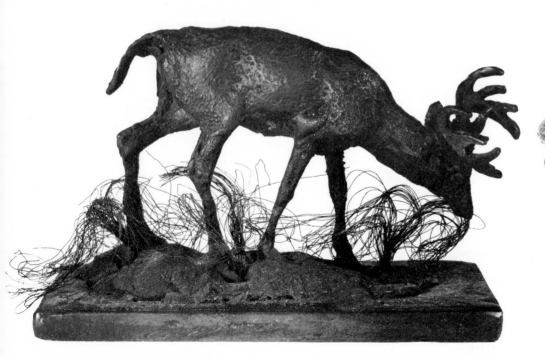

67. White Tailed Deer

119. *White Tailed Deer*
n.d. Bronze; height 3 3/4″, including artist's base 3/8 × 5 7/8 × 2 7/8″. Unsigned. Cast by: Roman Bronze Works, Inc., Corona, N.Y., May, 1965, from ACM 50.61 (wax). (ACM 171.65)

68. Wolf

Russell called wolves "meat-eaters" and once told a story about a cowboy foolish enough to catch two of them on the same rope.*

n.d. Wax; height 5 1/2″, base 3 7/8 × 7 3/8″. Unsigned. Ex-collection: Sid Willis, The Mint, Great Falls, Montana. (ACM 52.61)

* Charles M. Russell, *More Rawhides*, p. 5.

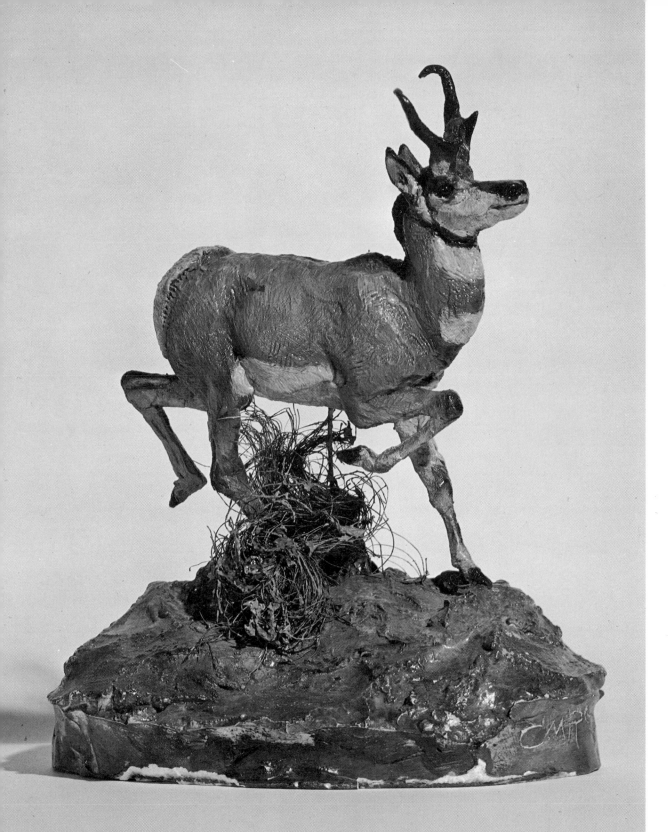

69. Antelope

At the time of Russell's visit to the Blood Indians in 1888 he was wearing a pair of pants reinforced in the seat with buckskin, a common practice in those days. His appearance from the rear reminded the Indians of the white rump of an antelope and they promptly called Russell "Ah Wah Cous," their name for this animal. The artist occasionally signed his letters with his Indian name.

1915. Wax on plaster base; height 7 5/8", base 4 × 6 5/8". Signed inside base in ink: CM Russell (skull); signed on top of base in the plaster: CMR (skull) 1915. Ex-collection: Sid Willis, The Mint, Great Falls, Montana. (ACM 51.61)

70. Bauer's Beer Advertisement

c. 1900. Colored lithograph, 16 3/4 × 23 3/8″. Lower left: Copyrighted.
The Originals in Possession of Mr. A. Bauer, Chicago, Ill. The Clinton Co.
Litho. Chicago, Ill. Lower right: Compliments of A. Bauer Dist. & Imp. Co.
Chicago, U.S.A. (ACM 215.67)

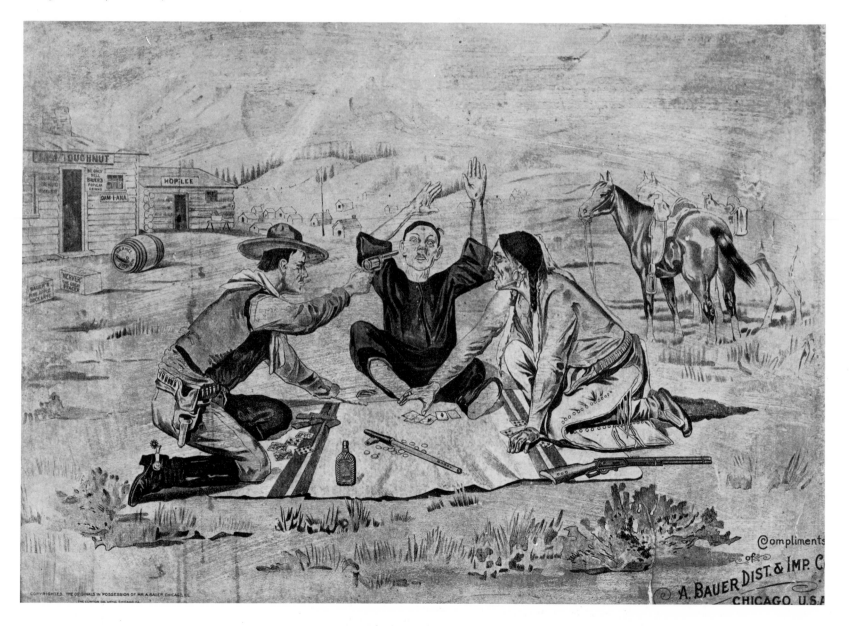

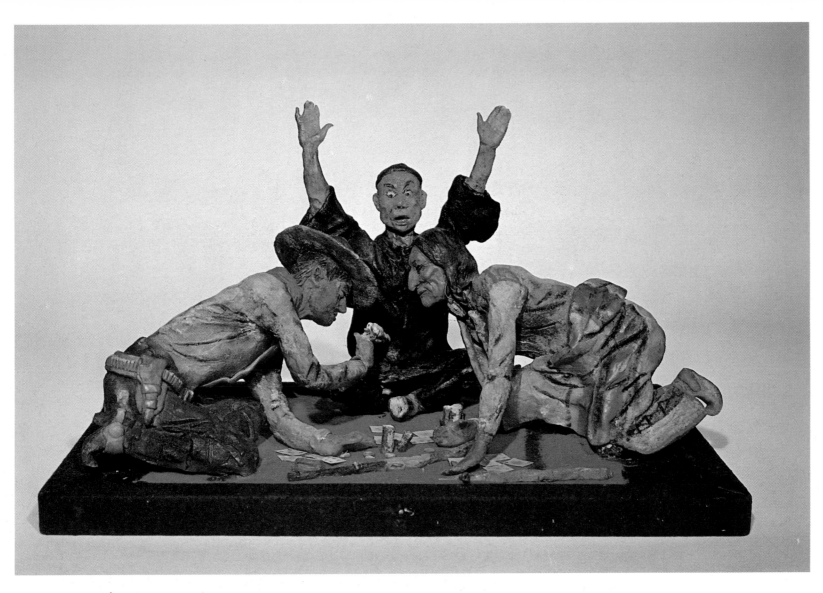

71. *Not a Chinaman's Chance* c. 1893. Wax on wood and cloth base; height 10 3/4″, base 12 × 19″. Unsigned. Ex-collection: Sid Willis, The Mint, Great Falls, Montana. (ACM 62.61)

Describing *The Poker Game*, the *Helena Montana Weekly Herald* of December 28, 1893, reported:

C. M. Russell, the cowboy artist, has just completed a fine piece of artistic work in wax. The scene represents a cowboy, an Indian, and a Chinaman playing cards. They are sitting in their accustomed way on the grass with a blanket before them. Each has cards in his hands but the Chinaman has the best of the layout as far as the game has progressed. The Chinaman has a smile on his face while the cowboy's and Indian's faces wear a scornful look. The men are colored up true to life and the whole scene is picturesque and life-like.

The sculpture attracted so much favorable attention that Russell followed it with a companion piece showing the end of the game. The observer can only conjecture whether the wily Oriental was caught dealing from the bottom of the deck or had an ace up his sleeve, but it is obvious that "he didn't have a Chinaman's chance" against two such adversaries.

Russell also did these subjects in oil paintings but it is not known whether they were done before or after the sculpture.

72. *Swipes*

In his later years Swipes was a hanger-on around the Mint Saloon and became known for his fondness for beer. Earlier he had been a hero, having made his way to town to bring word of a stage coach and its passengers stranded in a blizzard. It may have been shortly after this exploit that Russell caught and preserved the dog's self-satisfied look in this wax model.

n.d. Wax on wood base; height 6 5/8″, base 4 5/8 × 7 3/4″. Unsigned. Word "Swipes" carved into base. Ex-collection: Sid Willis, The Mint, Great Falls, Montana. (ACM 48.61)

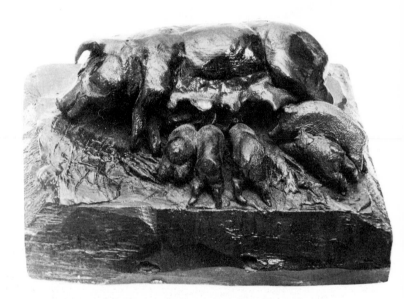

74. *Dinner Time*

Russell's models were frequently done on the spur of the moment to amuse his friends or to illustrate some point in their conversation. This one suggests the action of a bunch of cowboys when the cook yells, "Grub-pile."

n.d. Wax on wood base; height 2 3/8″, base 3 3/4 × 5″. Unsigned. In pencil, partly obliterated, on bottom of base, "Remodeled by Bill Arnold." Ex-collection: Sid Willis, The Mint, Great Falls, Montana. (ACM 45.61)

73. *Rattlesnake*

Carrie Nation got a convert and the boys a good laugh when the town drunk caught a glimpse of the figure Charlie had surreptitiously placed beside him on the bar.

n.d. Wax; height 3 3/4″, length 6 3/8″. Unsigned. Ex-collection: Sid Willis, The Mint, Great Falls, Montana. (ACM 42.61)

PAINTINGS
1899-1906

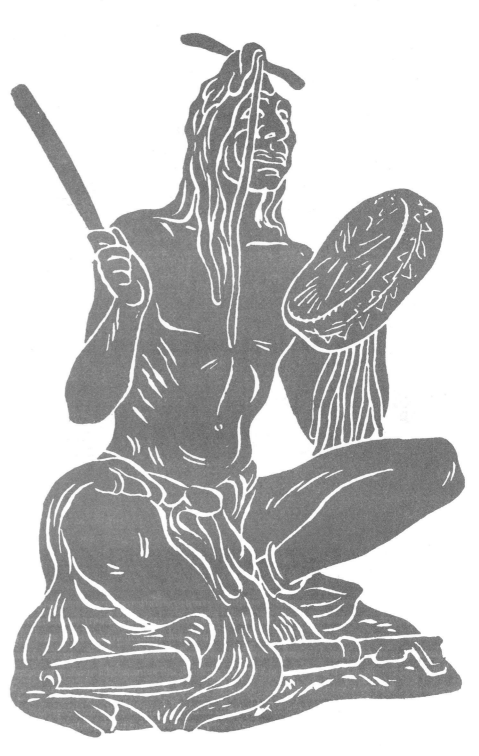

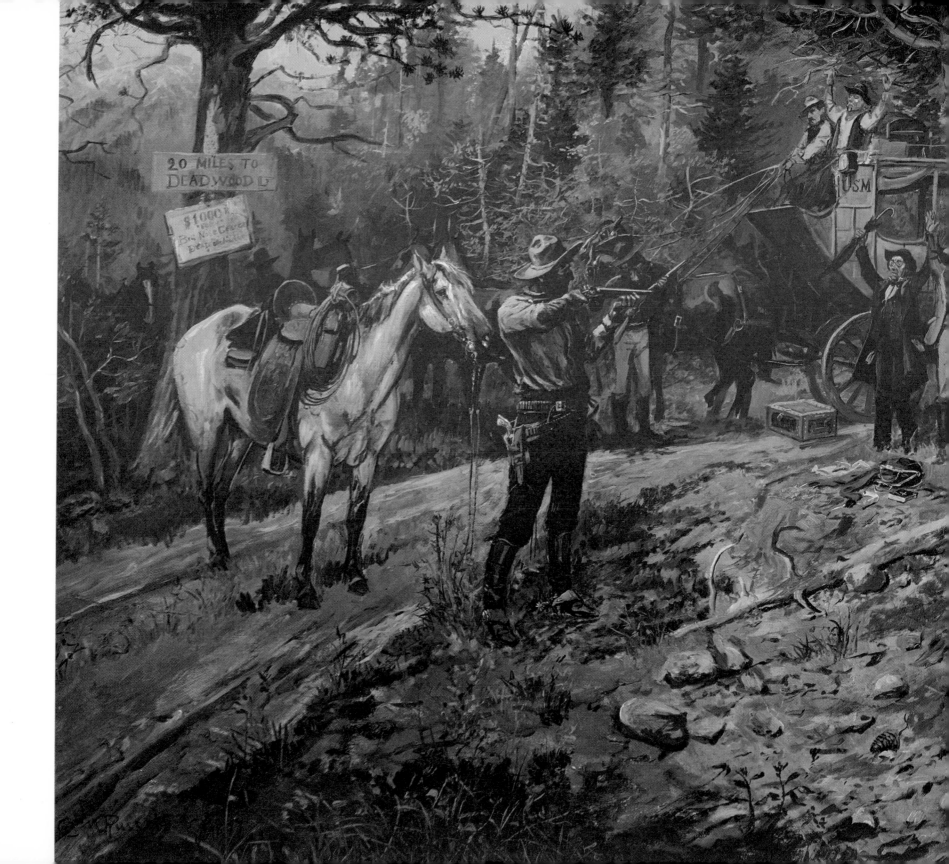

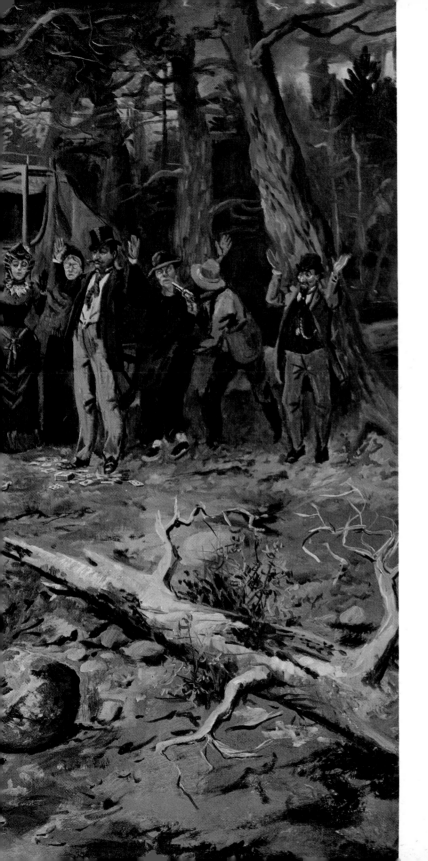

75. *The Hold Up*

Big Nose George was a notorious outlaw in the Black Hills country in the early 1880's and his last crime was to hold up the stage operating between Miles City and Bismarck. Russell wasn't a passenger on this trip but he knew some of those that were and *The Hold Up* depicts the actual incident. The passengers were the usual cross section of frontier characters—a sky pilot, a prospector, a school ma'am, the widow Flannagan who ran the Miles City boarding house, a gambler, a Chinaman, and one Isaac Katz. Ikey, as he was known to the residents of Miles, was a recent arrival from New York City who had come West to open a "gent's clothing store." While waiting for his stock of goods to arrive, Mr. Katz had tried his luck at faro and had several thousand dollars sewn in his clothes at the time of the holdup. A confederate had tipped off the outlaws to this fact and Ikey was promptly relieved of his winnings.*

Big Nose George was eventually arrested in Miles City and taken to Rawlins, Wyoming, to be tried for murder. Indignant citizens broke into the jail, removed Big Nose George, and hanged him to a telegraph pole.† That night the outlaw was skinned by a local doctor and part of his hide was used to make a quirt and a pair of lady's shoes. These gruesome relics were prominently displayed in the window of one of the Rawlins banks until recent years.

1899. Oil on canvas, 30 × 48″. Signed lower left: CM Russell (skull) 1899. Ex-collection: Sid Willis, The Mint, Great Falls, Montana. (ACM 212.61)

* *Great Falls Tribune*, June 30, 1901, p. 10.
† Velma Linford, *Wyoming Frontier State*
(Denver: The Old West Press, 1947), p. 270.

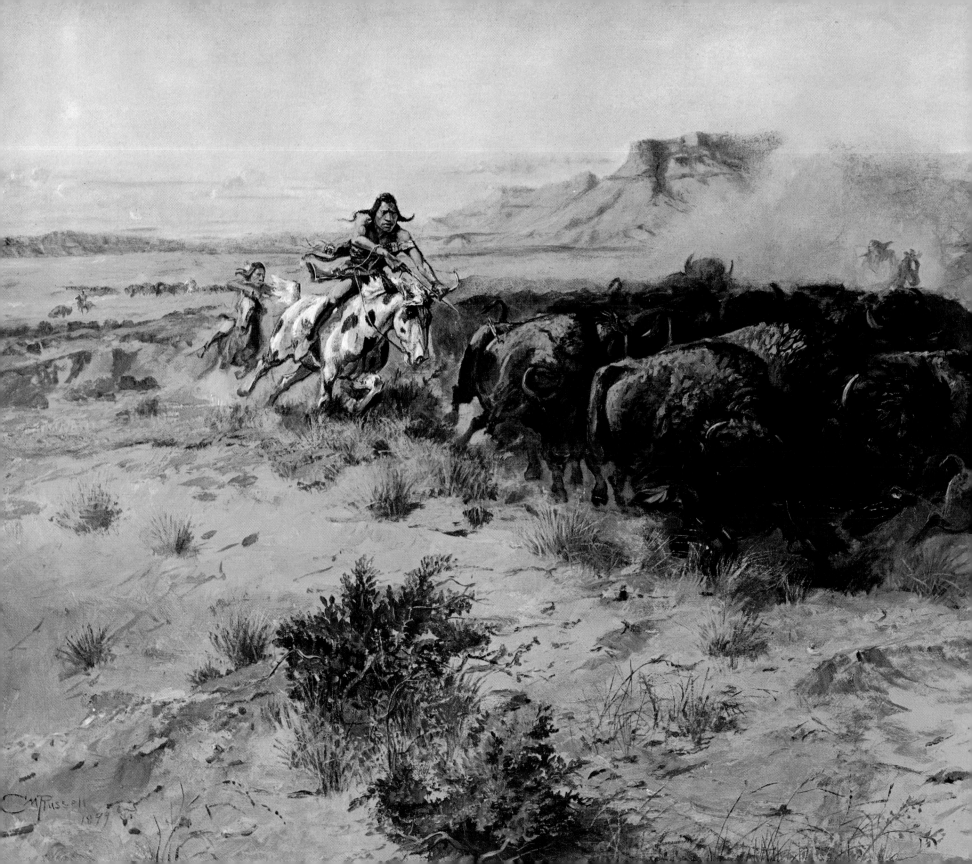

76. The Buffalo Hunt No. 26

Acquisition of the horse, which in the case of the Blackfeet was shortly before 1750, made a tremendous difference in the life of these nomadic Indians. Prior to that time their only beasts of burden were their half-wild dogs. The larger of these animals could carry up to fifty pounds, or perhaps twice that weight when travois were used. This limited the size of the Indians' lodges, kept their possessions to a minimum, and, most important of all, restricted their movement in the ever-present search for food. The horse changed all this. Without the horse the Indian faced starvation when game was scarce. With the horse the Indian was able to move hundreds of miles, if necessary, to where buffalo could be found in abundance. Even after they acquired firearms, the Blackfeet preferred their traditional weapons. With a spare arrow in his teeth and a full quiver slung across his back, a skilled hunter on a trained buffalo horse had little trouble getting his family's meat supply.

This is probably the best known of all Russell paintings of this subject. For nearly fifty years it was the principal painting in The Mint collection in Great Falls and was seen by all of the many visitors to that famed establishment. Literally tens of thousands of reproductions of this painting have been made in the form of lithographic colored prints, and it has appeared as an illustration in encyclopedias, on the menus of a transcontinental railroad, and elsewhere.*

Russell frequently painted a rabbit, a grouse, or some other small creature half-hidden in the foreground of one of his paintings. To his amusement, these usually escaped the notice of the casual observer. In this one a rattlesnake is coiled under the sagebrush at the left.

1899. Oil on canvas, 30 × 48". Signed lower left: CM Russell (skull) 1899. Ex-collection: Sid Willis, The Mint, Great Falls, Montana. (ACM 206.61)

* Menu of the "Empire Builder" of the Great Northern Railway, St. Paul, 1948. Also *New Standard Encyclopedia* (Chicago: Standard Education Society, 1957), Vol. B, p. 267.

77. Powder Face

History has left us few facts about the subject of this watercolor by Russell. Many Indian tribes had numerous secret societies, each with its own ritual, dances, and sometimes special tribal responsibilities. The headpiece on Powder Face indicates that he was a member of the Ravens. It is known that Powder Face was a northern Arapaho and that he was married to a Gros Ventre woman. In 1870 Powder Face and his family were living in Indian Territory. Later he moved to Montana where Russell probably first saw him. Powder Face died at Fort Belknap, Montana, about 1909. The dress and accouterments in a photograph taken at Fort Supply, Indian Territory, in 1870 suggest that he was a warrior of considerable importance.*

1903. Watercolor, 12×9″. Signed lower left: CM Russell (skull) 1903. (ACM 161.61)

* Bureau of American Ethnology, Smithsonian Institution, Photograph No. 180–2–1, 1870.

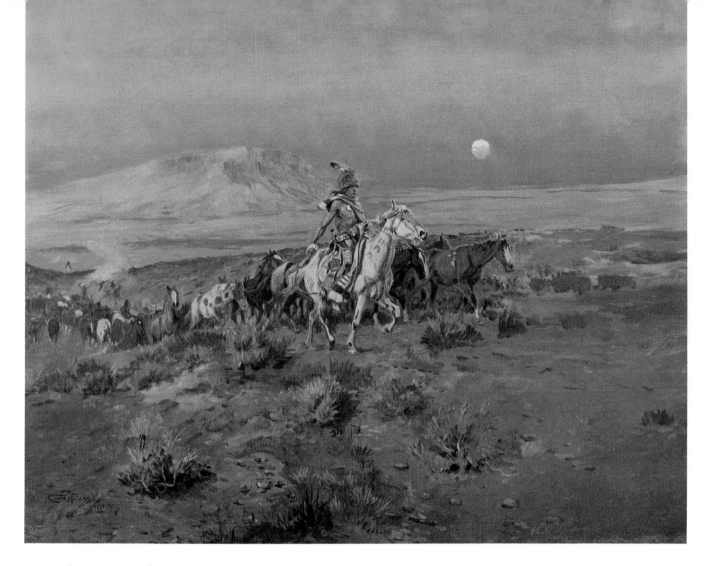

78. The Horse Thieves

This is one of Russell's relatively few night scenes. The painting depicts White Quiver, famed Piegan horse raider, returning to the Teton River country after a successful horse-stealing expedition against the Crows. White Quiver made many such forays during his time and on one occasion made off with fifty ponies, including the favorite buffalo horse of Plenty Coups, the Crow chief.* Apprehended by authorities near Fort Benton, White Quiver was jailed and the horses were taken from him. A day or so later he escaped, again stole the horses, and made his way to Canada. Arrested again, this time by the Royal Canadian "Mounties," White Quiver escaped the second time. He stole the horses for the third time and got safely back to the Blackfoot Reservation on the Montana side of the line. Among the ponies was a pinto which White Quiver traded to Bad Wound, who later sold the horse to Charles M. Russell. This was the horse called "Monte," which Russell was to ride for nearly twenty-five years.

The painted "brands" on the neck of White Quiver's pony in the painting are "raid marks," each of which indicated its owner had carried out a successful raid against an enemy tribe.

1901. Oil on canvas, 24 1/8 × 30 1/8". Signed lower left: CM Russell (skull) 1901. Ex-collection: Mrs. Mary Barworth, Helena, Montana; The Moody Estate, Galveston, Texas. (ACM 155.61)

* *Great Falls Tribune*, April 13, 1911, p. 9.

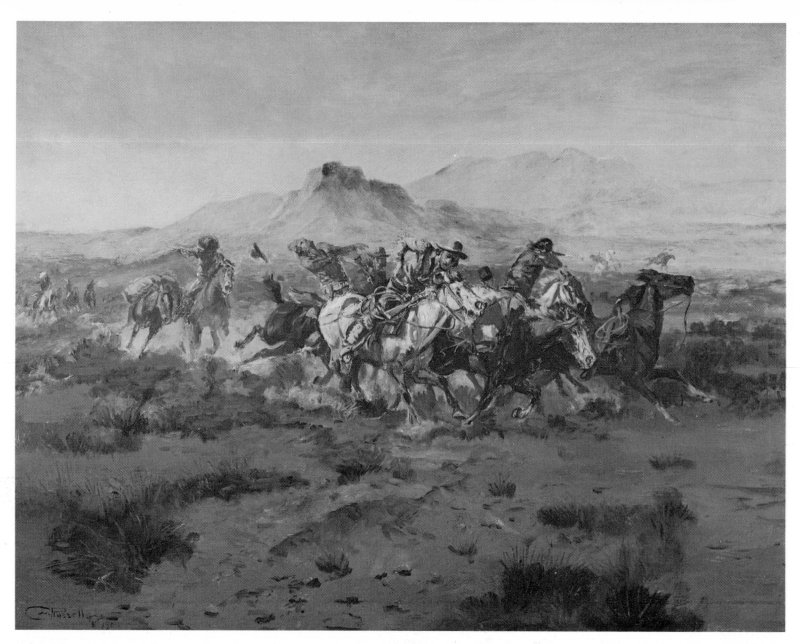

79. The Attack

Free trappers with covetous eyes on beaver in the Blackfoot country employed either of two stratagems for safety. One was to go alone or with a trusted companion, travel at night, and try to avoid being seen by the hostile Indians in the daytime. The other was to form a larger party of heavily armed men and depend on sheer numbers and fire power to withstand attack from any wandering war party. There was danger in both methods. Even the larger parties usually had to make a run for it if they were caught in open country. If they could reach the timber, where they could fort up and hold off the attack, some of them might live to tell of their experiences.

1900. Oil on board, 18 1/2 × 24 3/8″. Signed lower left: CM Russell (skull) 1900. Ex-collection: Mrs. Mary Barworth, Helena, Montana. (ACM 203.61)

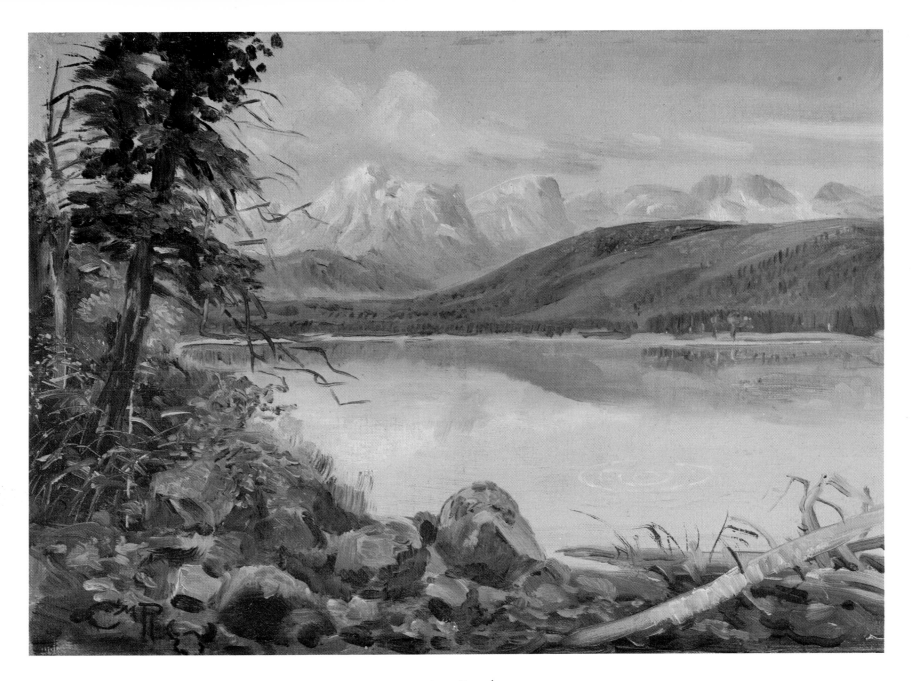

80. Landscape

Russell never tired of the view from the summer home he called "Bull Head Lodge" in Glacier National Park, and this view of Lake McDonald appears in the background of a number of his paintings. As Russell was not a landscape artist, this is one of the exceedingly rare examples of his work without a cowboy, an Indian, a horse, or some form of wildlife.

c. 1901. Oil on board, 10 × 14″. Signed lower left: CMR (skull). (ACM 419.61)

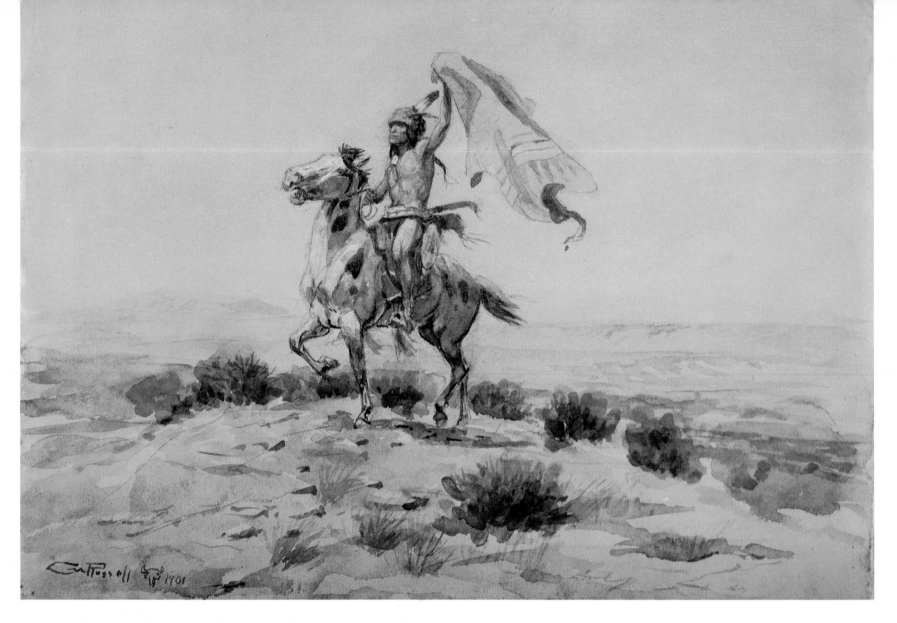

81. Indian Signalling

The great mobility of the Plains Indians was one of the reasons why the United States Army needed twenty-five years and over a thousand separate battles to subdue them. General Crook once noted in an official report that a band of Sioux Indians with their families could travel fifty miles a day, living off the country and keeping scouts advanced from twenty to fifty miles in all directions.* With the Indian leaders fully informed of the movements and strength of the army forces, they were able to avoid a conflict or to pick the time and place of battle.

The scout in Russell's watercolor may have come across the tracks of an enemy column and is sending a message back to his companions. The fact that he is making no attempt at concealment suggests the enemy is not in sight.

1901. Watercolor, 10×14″. Signed lower left: CM Russell (skull) 1901. Ex-collection: Oliver F. Wadsworth, Great Falls, Montana. (ACM 173.61)

* General George Crook's report in the Secretary of War's report, 1876, I, 500.

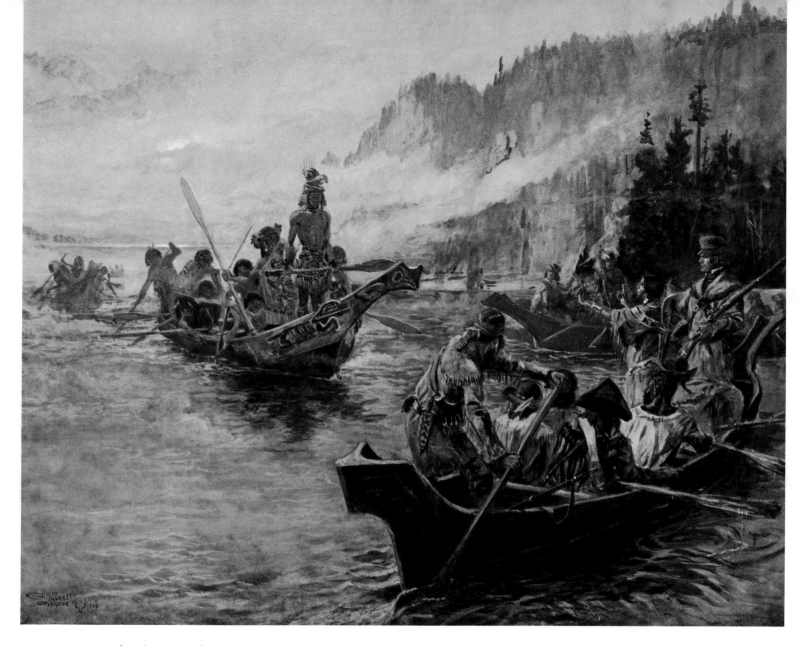

82. Lewis and Clark on the Lower Columbia

The exploits of Lewis and Clark had a fascination for Russell and his several paintings illustrating events described in their journals are of considerable historical importance.

The Lewis and Clark Expedition arrived at Gray's Bay on the lower Columbia November 8, 1805. Russell's painting, commemorating their historic meeting with the Chinook Indians, was completed, almost to the day, one hundred years later. Sacajawea, a principal figure in this painting, had been captured as a child and taken far east to a village of the Minnetaries. She was married and seventeen years of age when she joined the expedition as an interpreter. Shown here talking in sign language to the approaching Chinooks, she is probably bargaining for the beautiful robe of sea-otter skins that Captain Clark's journal mentions he had asked her to buy for him.

1905. Watercolor, 18 1/2×23 1/2″. Signed lower left: CM Russell! (skull) 1905. Ex-collection: Copley Amory, Washington, D. C. (ACM 195.61)

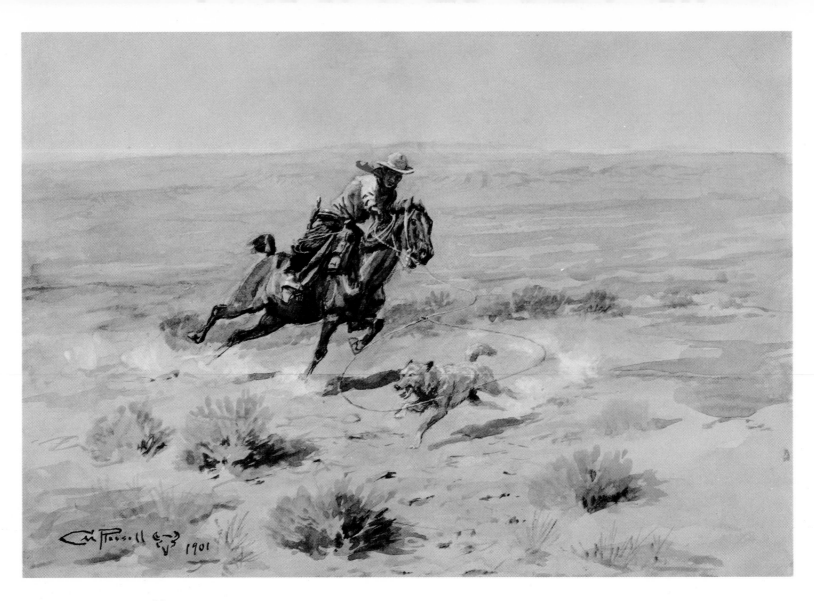

83. Roping a Wolf

Unlike the slinking coyote, whose prey was rabbits, mice, and an occasional chicken around the farmyard, the prairie wolf was noted for its boldness and ferocity. One pair of these animals was accused of killing twenty-one cattle within a two-month period and the early cowmen considered them an archenemy.* With a five-dollar bounty on wolf scalps, the cowboy who came across one took his rope down in a hurry. The wolf couldn't outrun a horse on flat ground but he could outdodge him and it took both a skillful cowboy and a knowing horse to collect the scalp of the wily animal.

For years there were stories of white wolves of prodigious strength in the Judith Basin country that Russell knew. These wolves were not pure white but a silvery grey. A huge one known as Old Snowdrift be-

came legendary. A government hunter once tracked Old Snowdrift to the Highwood Mountains and spent several months on his trail without success. He did find Old Snowdrift's den, however, and captured seven pups. One of these eventually had a career that paralleled that of a few Montana cowboys. After becoming somewhat civilized and getting some training, she went to Hollywood and played in motion pictures opposite the dog Strongheart.

1901. Watercolor, 10 × 14 1/8". Signed lower left: CM Russell (skull) 1901. Ex-collection: Oliver F. Wadsworth, Great Falls, Montana. (ACM 198.61)

* Anon., *Montana: A State Guide Book* (New York: The Viking Press, 1939), p. 252.

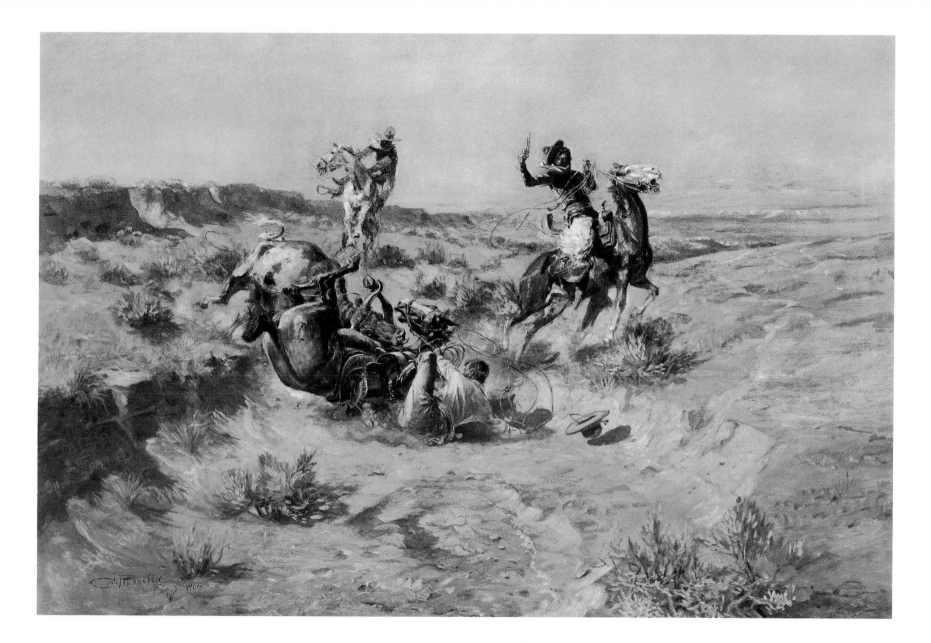

84. *The Broken Rope*

Many authorities feel that Russell's greatest work was done between 1902 and 1916, the period of this fine action painting. At this time the artist was painting the scenes that he loved best and that delighted his most critical audience, his cowboy friends. To them every detail in the painting, from the brand on the horse to the ring in the tail of the angry cow, helped tell the story. If they couldn't name the cowboy to the right they could spot him for a Texan from his tapaderos. These stirrup coverings of heavy cowhide were used to protect the rider's feet in the southern brush country, but were not used by Montana cowboys in the early days.

The angora chaps, which the cowboys called "woolies" were strictly "Montana," however. These were a real comfort in the winter or during the crisp days of the fall roundup.

Russell's admirers have always claimed "he was the only artist who could paint a horse with all four feet in the air and make 'im look natural," a point well demonstrated in *The Broken Rope*.

1904. Oil on canvas, 23 7/8 × 36″. Signed lower left: CM Russell (skull) 1904. Ex-collection: Benjamin B. Thayer, Anaconda, Montana. (ACM 191.61)

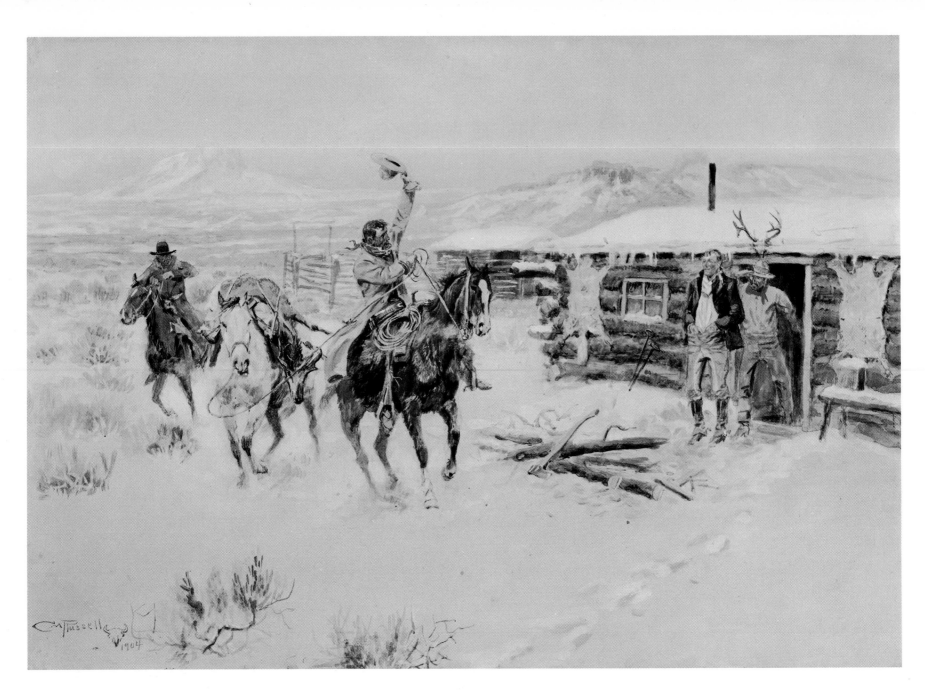

85. *Christmas at the Line Camp*

Ranches were few and far between in early-day Montana and cowboys "riding line" after the fall roundup were always welcome to drop in for a few days' visit before riding on. Their welcome was even more assured if they brought with them a freshly killed venison to augment their host's larder.

1904. Watercolor, 14 1/2 × 20 3/4". Signed lower left: CM Russell (skull) 1904. (ACM 392.61)

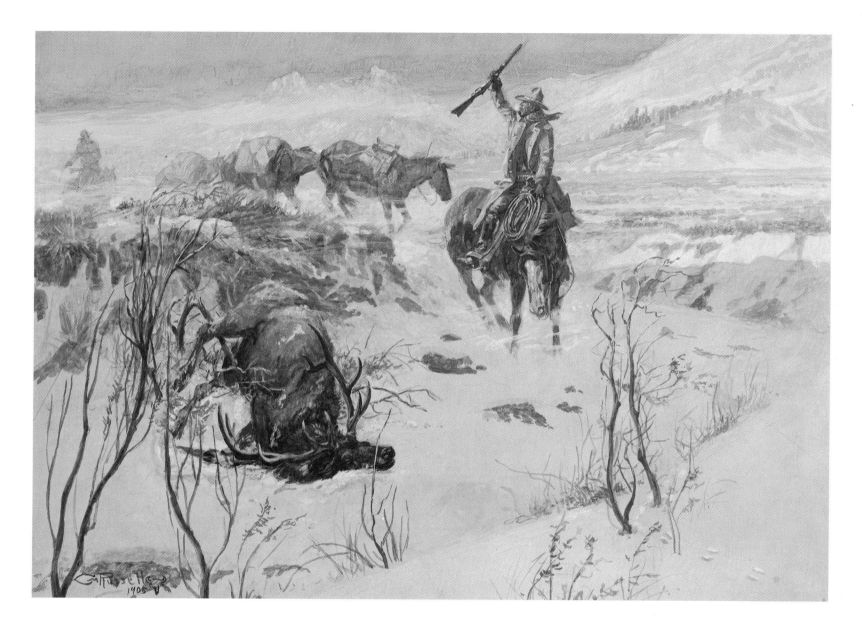

86. The Prize Shot

No season appealed to Russell more than the fall, when he could close his studio for a few weeks and get into the mountains for a hunting trip. His friends claimed that Russell never fired a shot on these excursions—that he was content to see the animals in their native haunts and to enjoy the companionship of a few close friends. This is probably true, but these fall hunts provided the artist with ideas for many paintings such as this. A somewhat similar painting in oils, called *Where Tracks Spell Meat*, was done some years later.

1905. Watercolor, 16 × 22 3/4″. Signed lower left: CM Russell (skull) 1905. (ACM 100.61) 111

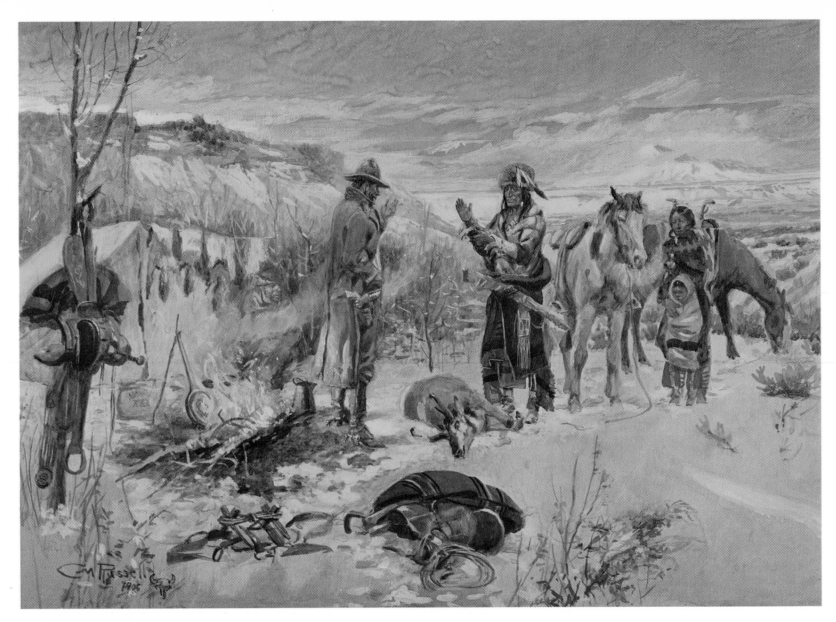

87. The Wolfer's Camp

Much of the interest in Russell's work lies in the fact that his characters were real people and that the incidents he painted were equally authentic. With the passing of the buffalo, wolves became a serious menace to early Montana cowmen and the cowboys were always glad to collect the bounty that had been placed on these marauders.

After the fall roundup many a Montana cowboy found himself laid off for the winter. With little chance for a job in the small frontier towns, and unwilling to hang around the saloons until their money was gone, some of them turned to "wolfing." Getting to-gether a camp outfit and a few wolf traps, they would put in the winter months hunting and trapping these wily marauders for the bounty on their scalps. Russell's watercolor shows a passing Indian visiting a wolfer's camp and offering to trade the carcass of an antelope for something he wants—likely to be tobacco, or perhaps ammunition for his rifle.

1906. Watercolor, 14 1/2 × 20 7/8″. Signed lower left: CM Russell (skull)
1906. Ex-collection: John A. Sleicher, Albany, New York; Miss Mary Sleicher, Albany, New York. (ACM 151.61)

RUSSELL AS AN ILLUSTRATOR

Charles Marion Russell had four of his own illustrated books published during his lifetime, with two others appearing posthumously. His first book, *Studies of Western Life*, which appeared in 1890, was a portfolio reproducing twelve of his earliest oil paintings. His fourth one, *More Rawhides*, published in 1925, was a collection of his own short stories illustrated with thirty-eight line drawings. Between these dates Russell illustrated approximately fifty books by other authors and nearly twice that number of magazine stories and articles. His reputation as an illustrator is indicated by the fact that many leading authors of the day, among them Bret Harte, Emerson Hough, Theodore Roosevelt, Stewart Edward White, and Owen Wister made use of his work. His illustrations also appeared in such leading magazines as *The American*, *The Artist*, *Fine Arts Journal*, *Leslie's Weekly*, *McClure's*, *The Saturday Evening Post*, *World's Work*, and many others.

One of Russell's important commissions was for forty-three line drawings to illustrate a special edition of Owen Wister's *The Virginian*, published in 1911. The commission to illustrate Carrie Adell Strahorn's monumental *Fifteen Thousand Miles by Stage*, which appeared that same year, was even larger. This book reproduced eighteen of the artist's paintings and sixty-eight of his line drawings.

In 1915 three of Russell's close friends formed the Montana Newspaper Association to syndicate a series of historical articles of primary interest to Montana readers. Russell both wrote and illustrated a few of the first stories. Called "Historical Recollections of Rawhide Rawlins," these appeared in many of the local newspapers under his by-line. Two years later the group launched a more ambitious series covering the vast scope of Western history, which they called "Back Trailing on the Old Frontiers." These stories, each one illustrated by a large line drawing by Russell, appeared in some seventy newspapers from coast to coast. Since they were intended for the Sunday editions and were to run for a full year, there were fifty-two of them, each one a well-written account of some historical event or incident. In subject and time span the stories ranged from Coronado's conquest of the Southwest in 1540 to the days of the Montana cowboys some three and a half centuries later.

Eighteen of the original pen drawings from the "Back Trailing on the Old Frontiers" series were purchased from the Nancy Russell estate by C. R. Smith of New York City and were later turned over to the Amon Carter Museum. These illustrations are presented on the following pages.

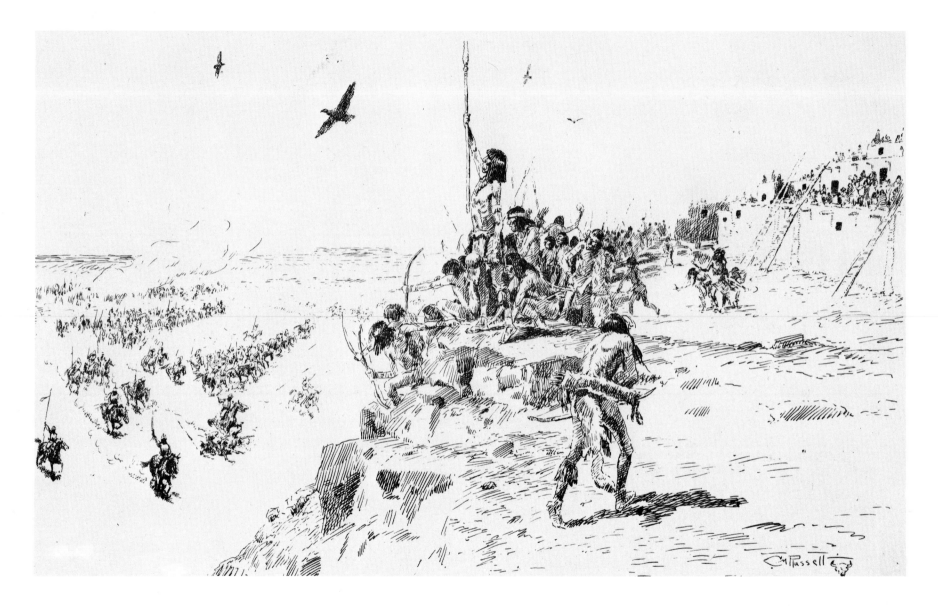

88. Coronado Advancing against a City of Cibola

Gold, reputed to exceed the treasure of the Aztecs, was the lure that led King Philip of Spain to order Francisco de Coronado to capture the seven cities of Cibola. Coronado captured the first of these walled pueblos in 1540, taking possession of a vast land in the name of the king. His failure to find the mythical treasure led to his disgrace and to his eventual removal from office as governor of Western Mexico.

c. 1922. Pen and ink, 19 7/8 × 27 3/4″. Signed lower right: CM Russell (skull). Ex-collection: C. R. Smith, New York City. (ACM 127.61)

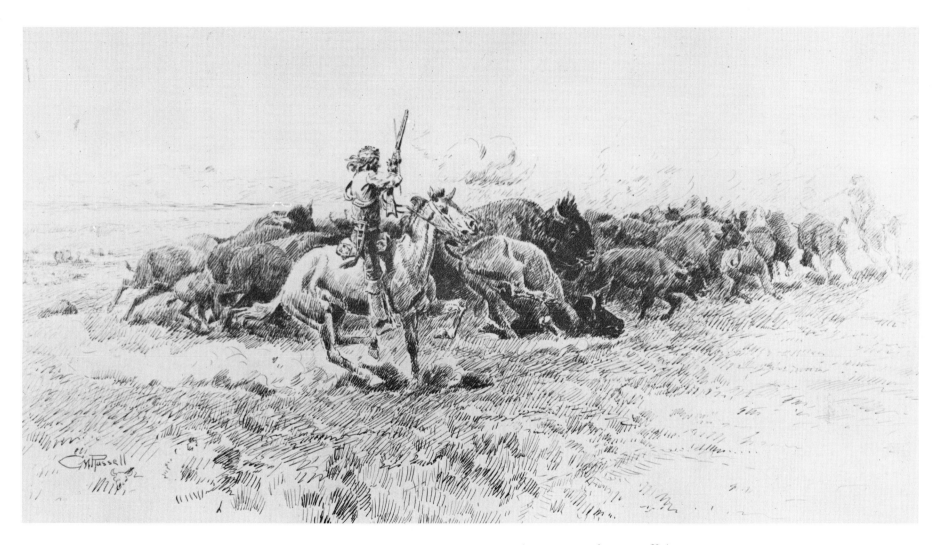

89. Early Day White Buffalo Hunters

The first white hunters, who were the mountain men and those who accompanied the early wagon trains to provide meat, hunted the buffalo in much the same manner as the Indians before them had hunted. Mounted on horseback, they used, instead of the Indians' bow, a long-barreled muzzle-loading gun with a ramrod carried in their hands to press home the powder and ball after each shot. While each hunter might kill only one or two buffalo with this method, this was ample for their needs. In contrast, the hide hunters who came later hunted on foot. Concealed downwind from the herd, the hide hunter might kill from thirty to fifty buffalo before the herd became alarmed and took flight.

c. 1922. Pen and ink, 19 7/8 × 27 3/4″. Signed lower left: CM Russell (skull). Ex-collection: C. R. Smith, New York City. (ACM 323.61)

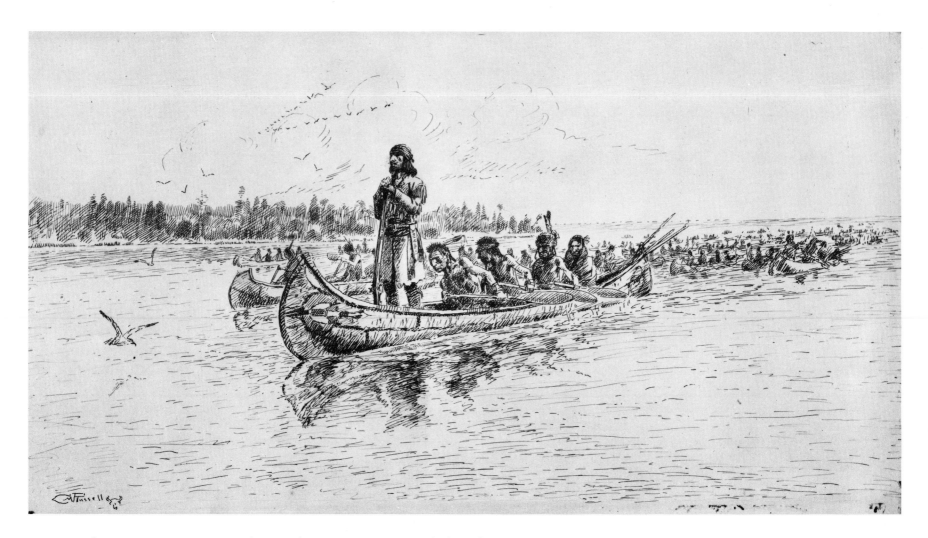

90. Radisson's Return to Quebec with 350 Canoes Loaded with Furs

Pierre Esprit Radisson was the intrepid young Frenchman who first explored the vast western wilderness from Hudson's Bay to the banks of the Mississippi. He was the first white man to see the upper reaches of this great river and it was his success in obtaining great quantities of furs from the Indians that led to the formation of "the Governor and Company of Adventurers of England trading into the Hudson's Bay."

c. 1922. Pen and ink, 19 7/8 × 27 3/4″. Signed lower left: CM Russell (skull). Ex-collection: C. R. Smith, New York City. (ACM 124.61)

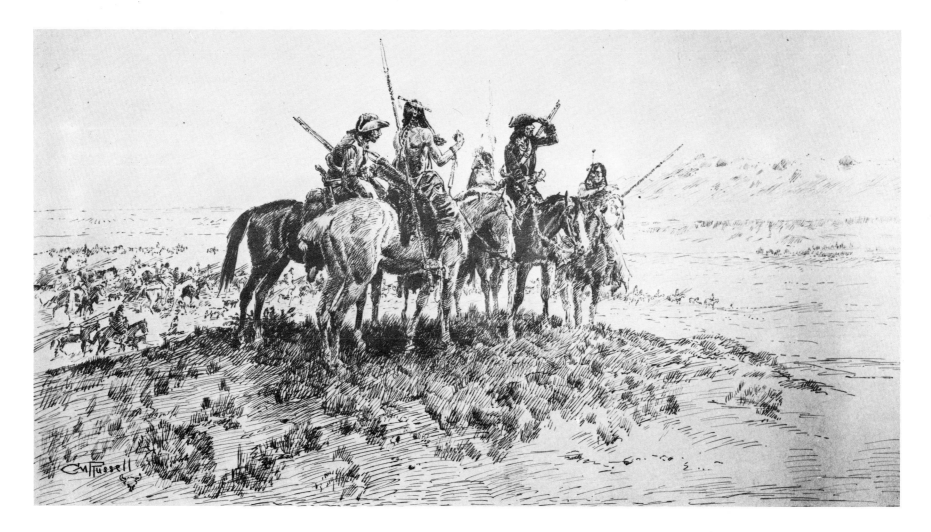

91. La Vérendryes Discover the Rocky Mountains

When France ruled half of North America it was the dream of many of her bold *voyageurs* to find the "Northwest Passage." One of these, Sieur de La Vérendrye, in seeking this mythical waterway with his two sons reached a point in present-day Wyoming. Seeing there a shimmering range, which they named the "Shining Mountains," they thus became the first Europeans to look upon the northern Rockies. On their return trip the La Vérendryes buried a lead plate inscribed with the date, 1743, as a token of their explorations. This tablet was discovered by chance in 1913 and is now in the possession of the South Dakota Historical Society.

c. 1922. Pen and ink, 19 7/8 × 27 3/4″. Signed lower left: CM Russell (skull). Ex-collection: C. R. Smith, New York City. (ACM 128.61)

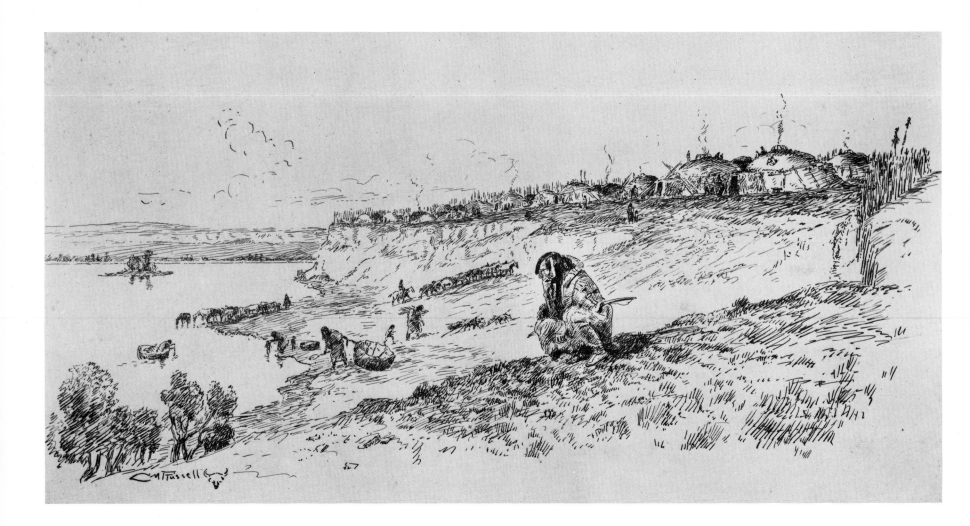

92. A Mandan Village

The Mandans, famed for more than two centuries for their hospitality to the whites, were one of the few plains tribes who practiced agriculture and who lived in permanent earth-and-log villages. The tribe numbered more than 6,000 when they were first visited by the La Vérendryes around 1740, but Lewis and Clark reported not more than 2,000 Mandans when the explorers' party spent the winter of 1804–1805 with them near the mouth of the Little Missouri. Repeated attacks of smallpox, the most severe one in 1837, reduced their numbers to fewer than 150 persons. Today "the polite and friendly Mandans" are practically extinct as a pure race.

c. 1922. Pen and ink, 19 7/8 × 27 3/4". Signed lower left: CM Russell (skull). Ex-collection: C. R. Smith, New York City. (ACM 131.61)

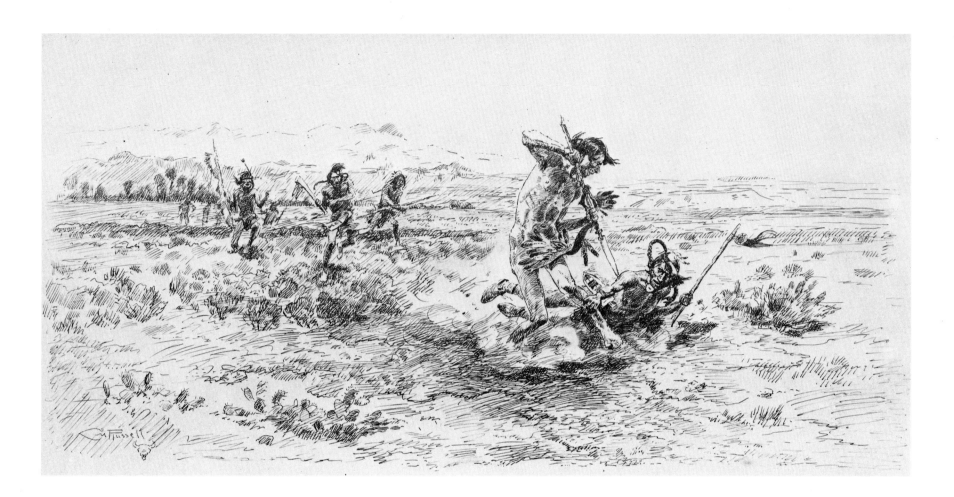

93. Colter's Race for Life

John Colter, who had been a member of the Lewis and Clark expedition, is best known for his discovery of "Colter's Hell," the area that became the Yellowstone National Park. In 1810 Colter and a companion named Potts were trapping on the headwaters of the Missouri when they were captured by the Blackfeet. Potts was killed trying to escape and, to amuse themselves, the Indians stripped Colter, gave him a short start, and told him to run for his life. After being chased for six miles over ground strewn with prickly pear, Colter killed the lead Indian with his own lance and made his way to the river, where he was able to conceal himself under some driftwood. Living on berries and roots, Colter reached Lisa's fort seven days later, still naked.

c. 1922. Pen and ink, 19 7/8 × 27 3/4″. Signed lower left: CM Russell (skull). Ex-collection: C. R. Smith, New York City. (ACM 129.61)

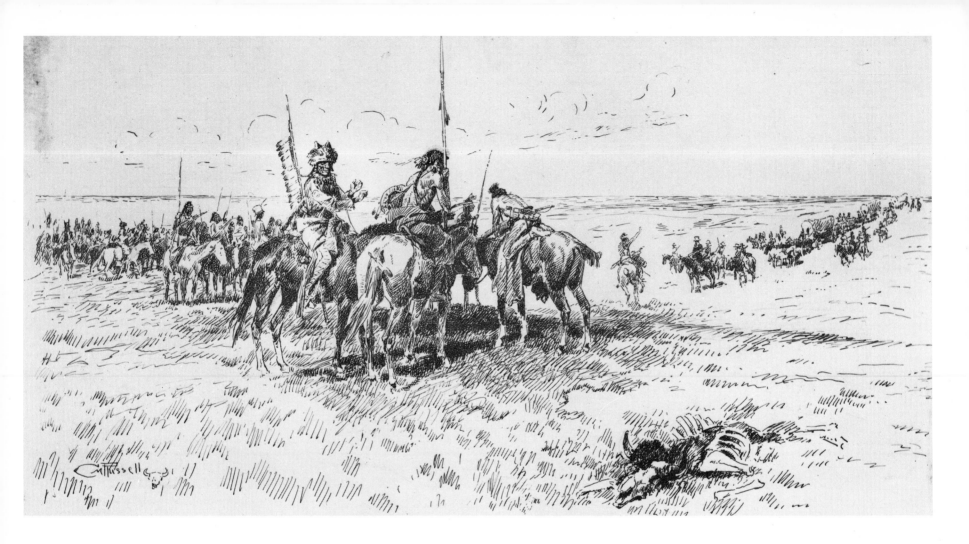

94. *Indians Meet First Wagon Train West of Mississippi*

Although Captain Zebulon Pike's military expedition of 1806 reported favorable opportunities for trade with the Mexicans, it wasn't until 1824 that the first wheeled vehicles creaked and groaned over the slow and weary miles to Santa Fe. For the next fifty years the Santa Fe Trail was the great highway of commerce west of the Mississippi, each year carrying millions of dollars worth of goods from Independence, Missouri, to be sold for Mexican gold.

c. 1922. Pen and ink, 19 7/8 × 27 3/4". Signed lower left: CM Russell (skull). Ex-collection: C. R. Smith, New York City. (ACM 125.61)

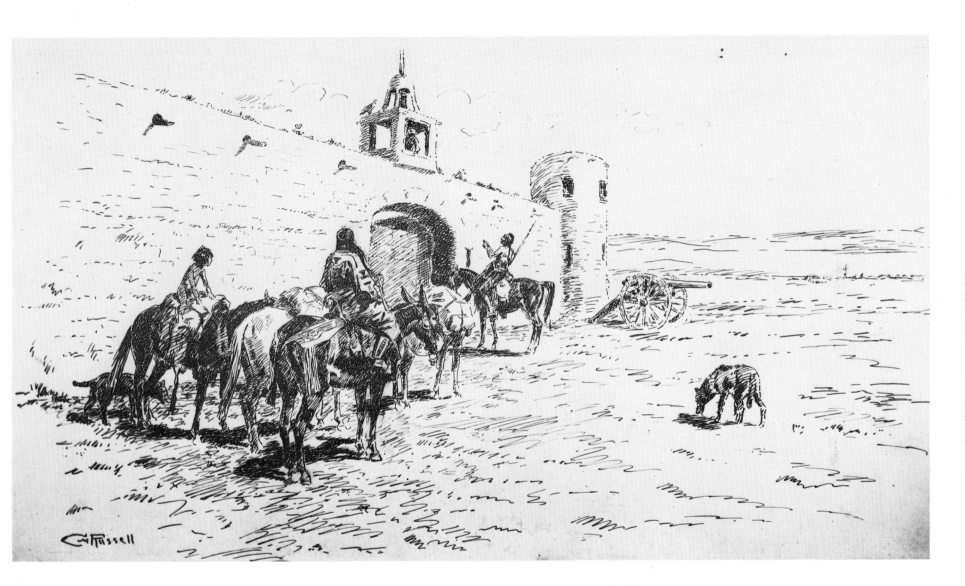

95. *Bent's Fort on Arkansas River*

William Bent, whose sister became the grandmother of Charles Marion Russell, was a noted Indian trader who had been on the upper Missouri in the early days of the American Fur Company. In 1828 Bent and his partner, Ceran St. Vrain, built on the Arkansas a trading post that became noted both as a mercantile establishment and as a frontier social center. Sooner or later, every famous traveler of the times visited this post. Kit Carson was the hunter for the fort from 1831 until 1842. Among some of the other famous visitors were Jim Bridger, "Broken Hand" Fitzpatrick, "Uncle Jim" Wooton, and Jim Beckwourth, the mulatto who became the war chief of the Crows.

c. 1922. Pen and ink, 19 7/8 × 27 3/4″. Signed lower left: CM Russell. Ex-collection: C. R. Smith, New York City. (ACM 320.61)

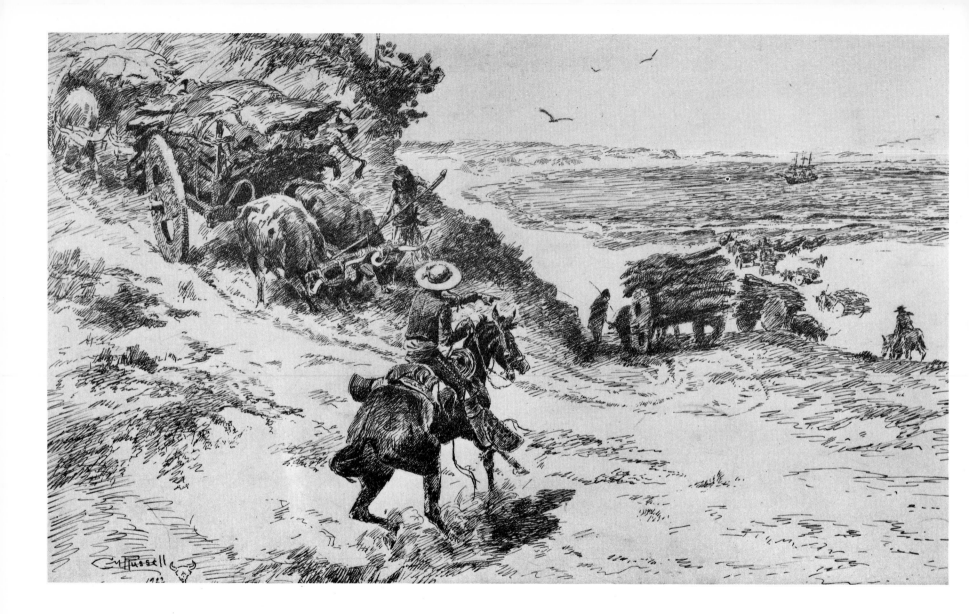

96. The Hide Trade of Old California

In the early days of the last century the herds of cattle in California had increased enormously and could be sold only for their hides and tallow. Yankee traders, always with a nose for a quick profit and aware of the demand for leather, sent their first ships around the Horn about 1830 to tap this rich resource. A cargo of trade goods worth $15,000 at an Eastern port could be exchanged for hides worth ten times that value; the resulting profits were the foundation of many a present-day Boston fortune.

1922. Pen and ink, 19 7/8 × 27 3/4″. Signed lower left: CM Russell (skull) 1922. Ex-collection: C. R. Smith, New York City. (ACM 332.61)

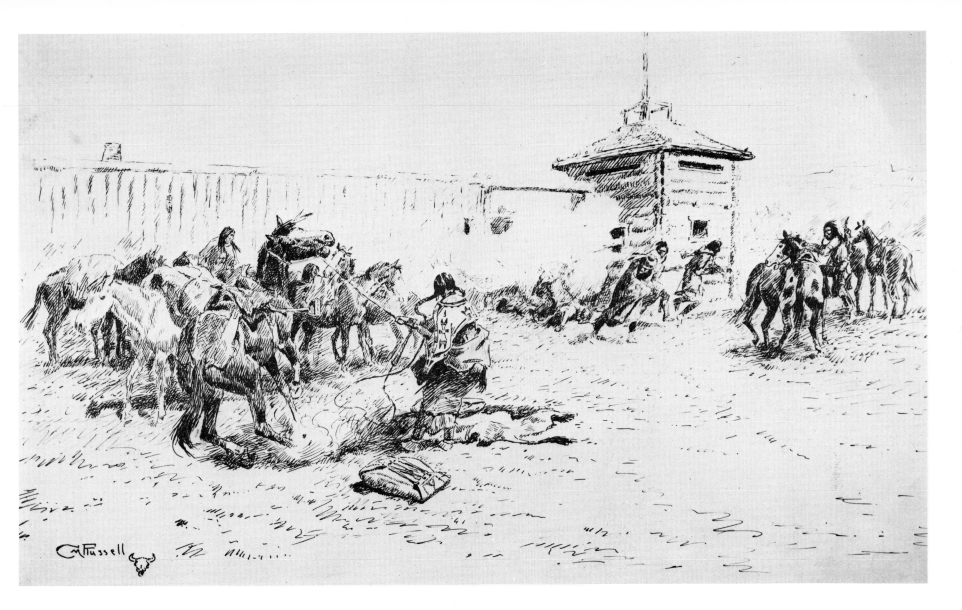

97. Attempted Massacre of Blackfeet at Fort McKenzie

Fort McKenzie, six miles above the mouth of the Marias River, had carried on a successful trade with the Blackfeet for twelve years when this incident took place. In 1844 the fort was placed in the charge of two brutal characters named François Chardon and Alexander Henry, who, to revenge the killing of a pig, determined to teach the Indians a lesson. Aiming the fort's cannon at the gate, they awaited the arrival of the next trading party. When the Indians assembled to gain admittance the cannon was fired, killing some thirty men, women, and children.

c. 1922. Pen and ink, 20 × 27 3/4″. Signed lower left: CM Russell (skull). Ex-collection: C. R. Smith, New York City. (ACM 130.61)

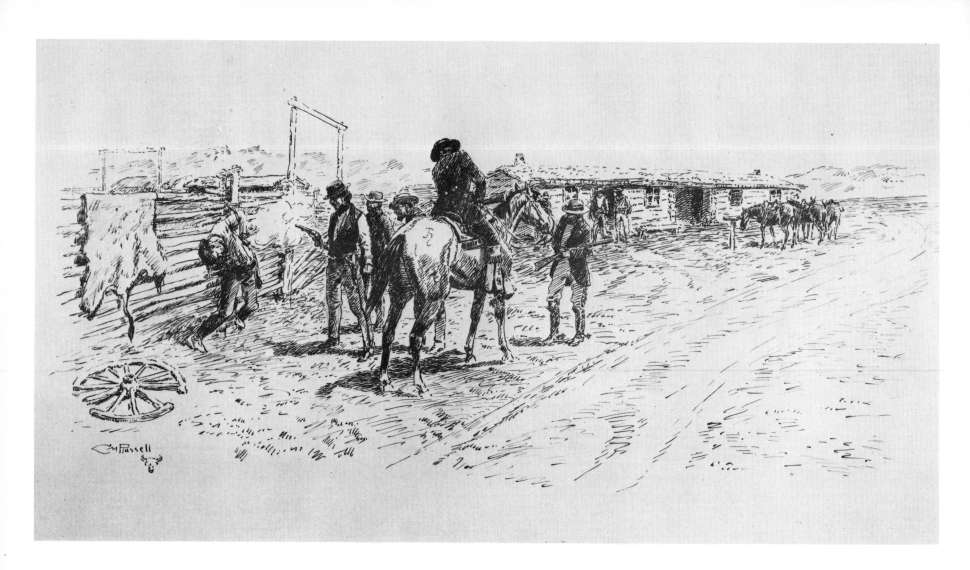

98 . *Killing of Jules Reni by Slade*

Joseph A. Slade was a ruthless character who made many enemies as the despotic division agent for the Great Overland Stage Route in the 1860's. One of these was a French Canadian named Jules Reni, who, after repeated quarrels, shot Slade while the latter was unarmed. The victim recovered and when his friends captured Reni and tied him to a corral post, Slade appeared and murdered his enemy in cold blood. Following his discharge from the stage company, Slade drifted to Virginia City, Montana, and after a series of further violent acts was hanged by the vigilantes.

c. 1922. Pen and ink, 20 × 27 3/4″. Signed lower left: CM Russell (skull). Ex-collection: C. R. Smith, New York City. (ACM 316.61)

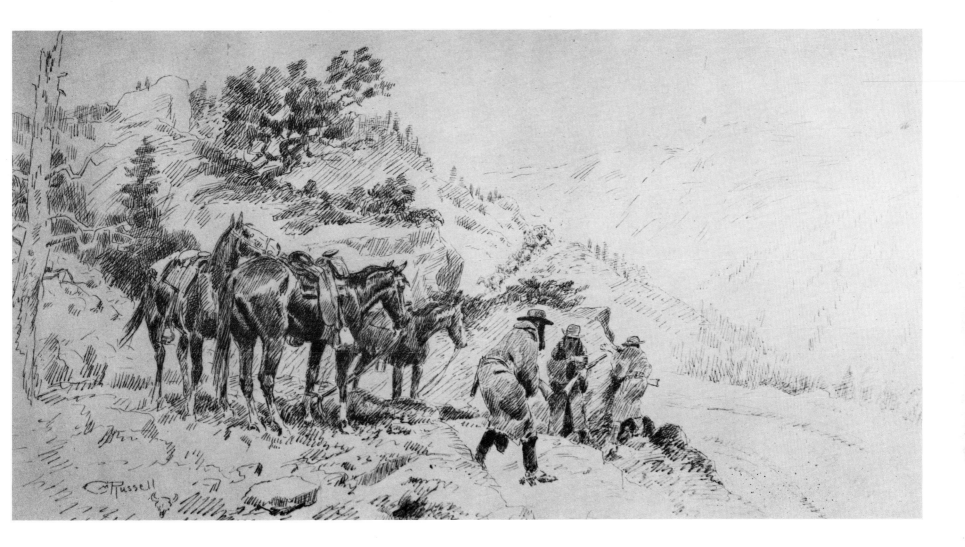

99. *Plummer's Men at Work*

Few outlaw bands have equaled the well-deserved notoriety of Henry Plummer's gang during Montana's early gold-rush days. By day Plummer was the sheriff of Bannock, playing the part of a respected officer of the law. By night he directed a well-organized gang of robbers and murderers whose activities led to the formation of the vigilantes. Even after a number of the outlaws had been caught, Plummer didn't lose his nerve. Shortly before Christmas, 1863, Plummer gave a sumptuous dinner party attended by the governor of Montana and a number of other prominent citizens. Among his guests were some of the vigilantes who took Plummer out and hanged him a few weeks later.

c. 1922. Pen and ink, 19 7/8 × 27 3/4″. Signed lower left: CM Russell (skull). Ex-collection: C. R. Smith, New York City. (ACM 315.61)

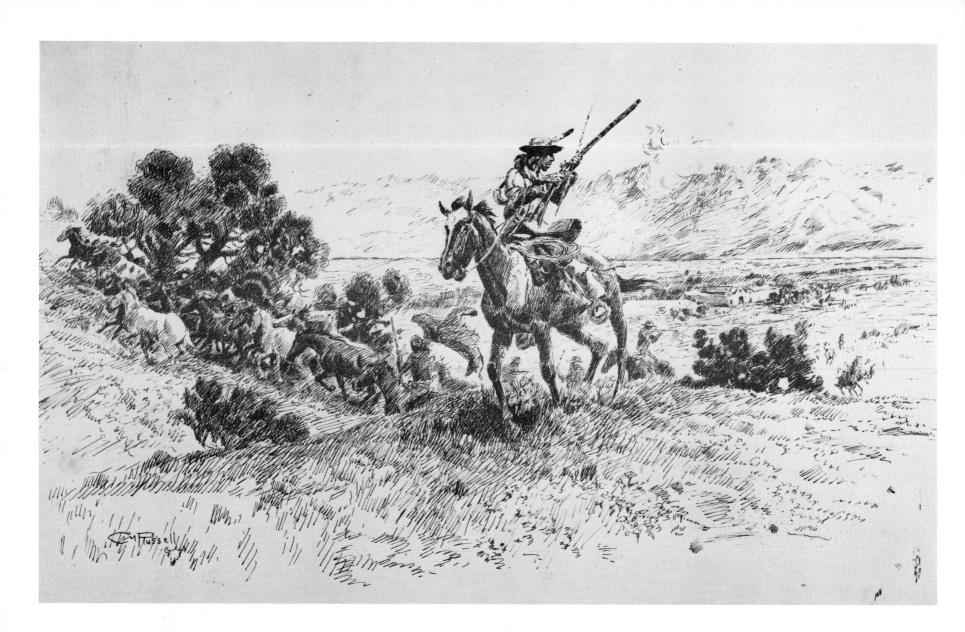

100. Rocky Mountain Trappers Driving Off
Horses Stolen from California Mission

After a successful season of trapping on the Yellowstone and a protracted spree at Bent's
Fort, in the late 1830's a party of frolicsome mountain men decided to raid the California
Missions. Crossing the Rockies they reached and captured San Fernando Mission, mak-
ing off with 400 horses and mules.

c. 1922. Pen and ink, 14 3/8 × 22 1/2". Signed lower left: CM Russell (skull). Ex-collection: C. R.
Smith, New York City. (ACM 319.61 b)

PAINTINGS 1907-1925

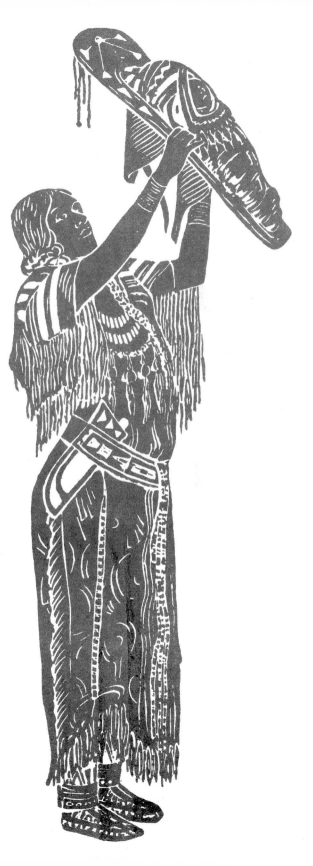

101. Indian on Horseback

Russell did one or more paintings of a single mounted Indian from every tribe with which he came in contact. These included the Arapaho, Assiniboin, Blackfoot, Blood, Cheyenne, Cree, Crow, Flathead, Kutenai, Nez Perce, Pawnee, Piegan, and Sioux; there are more than thirty such paintings of these various Indians.

1907. Watercolor, 12 3/4 × 11″. Signed lower left: CMR (skull) 1907. (ACM 156.61)

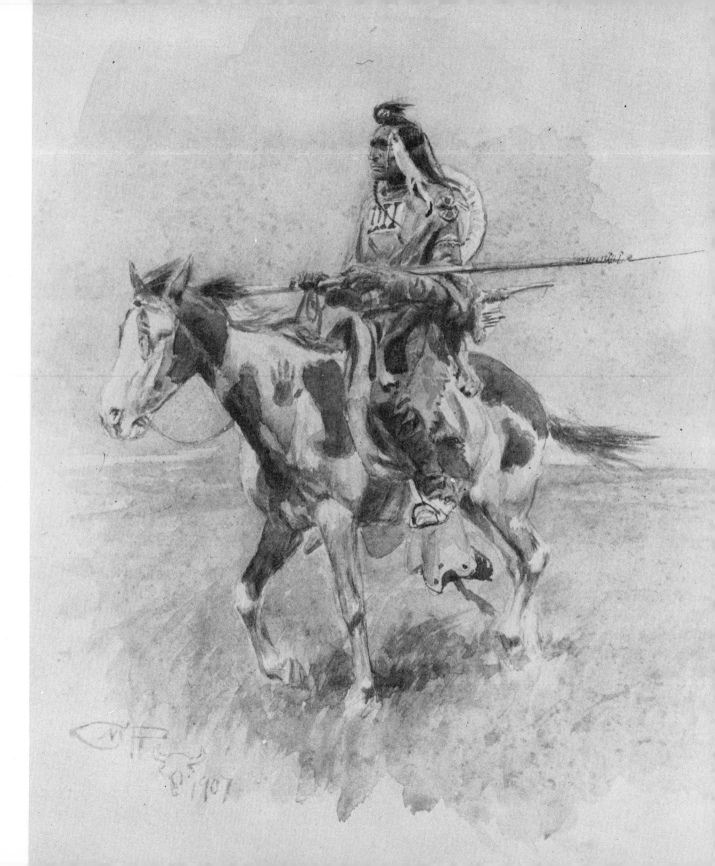

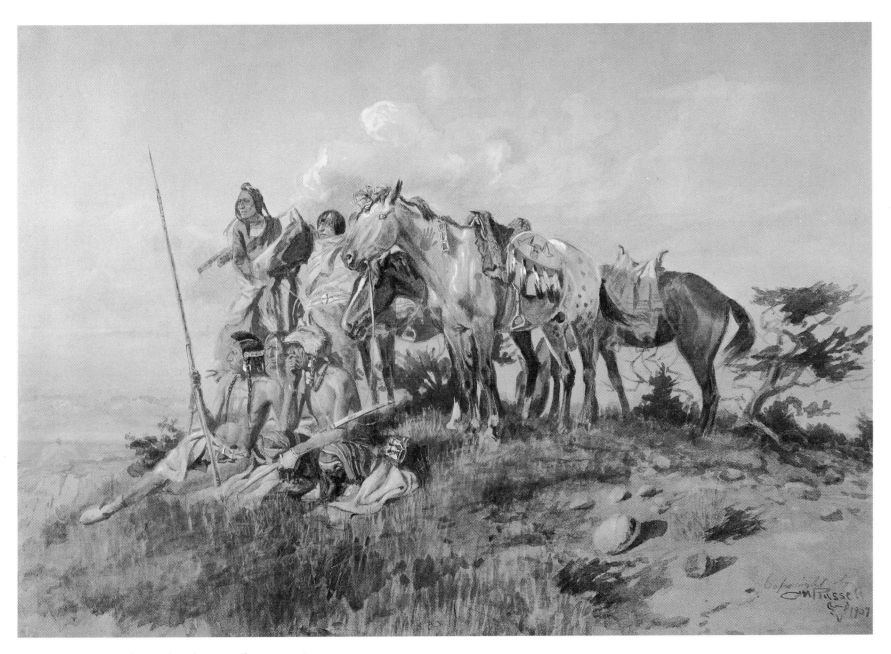

102. *Watching for the Smoke Signal*

The famed Appaloosa or spotted horse was uncommon among the Montana tribes of Indians, most of whom preferred the pinto or "paint" horse. This fact is reflected in the relatively few Appaloosas that appear in Russell's paintings. Most of the Appaloosas were bred by the Nez Perce Indians, who lived west of the Rockies, and the one shown here was probably stolen from that tribe. One of the seated Indians has apparently seen something unusual, his hand over his mouth signifying his astonishment.

This painting is also unusual in that it is signed in the lower right corner. Russell did this only in those rare instances where a signature at the left would detract from the composition.

1907. Watercolor, 24 1/4 × 32 1/2". Signed lower right: CM Russell (skull) 1907. Ex-collection: The Moody Estate, Galveston, Texas. (ACM 172.61)

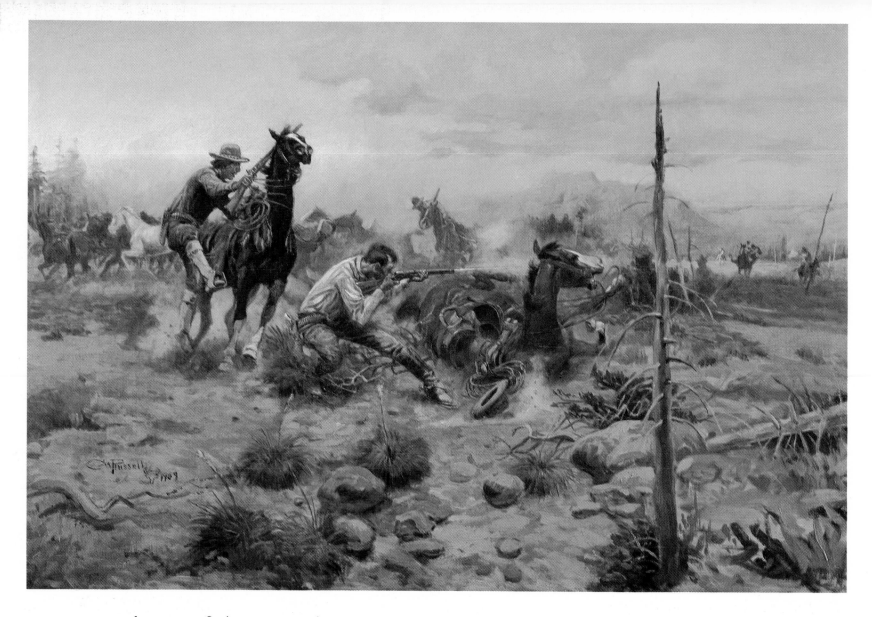

103. When Horseflesh Comes High

John R. Barrows, of Ubet, Montana, had known and admired Charlie Russell since their first years together in the Judith Basin. He thought his friend was stretching things somewhat when Charlie painted a posse riding hell-bent-for-leather into the face of rifle fire from two outlaws. Barrows had only admiration for the rest of the painting, however. In commenting on it, he observed to a friend, "Look at that saddle, it was built in Cheyenne on the old half-breed tree and the saddle strings look real enough you could tie your coat on with 'em."

The casual observer of this painting might think one of the out-laws has come to the rescue of his partner and is dismounting to help him stand off the posse. This isn't what Russell had in mind. As he saw it, the odds were too great for any sensible horse thief and the half-breed is actually deserting his partner. Instead of getting off his horse on the wrong side, he is getting on, Indian style, to make a fast getaway.

1909. Oil on canvas, 24 1/8 × 36 1/8". Signed lower left: CM Russell (skull) 1909. Ex-collection: Sir Henry Mill Pellatt, Toronto, Canada. (ACM 204.61)

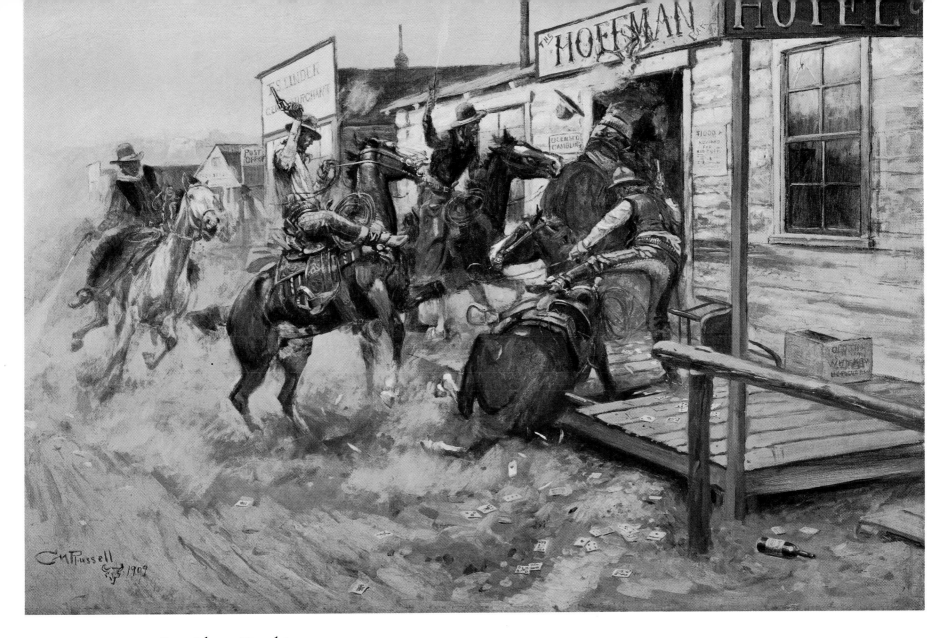

104. In without Knocking

In the fall of 1881 S. S. Hobson and a number of other Judith Basin ranchers were planning a drive to the railhead of the Northern Pacific, then building west and expecting to reach Glendive, Montana, before the first heavy snows. The night before the drive was to get underway some of the cowboys, among them Henry Keaton, the Skelton brothers, and Matt Price, rode in to the nearby town of Stanford for a little celebrating. Russell wasn't along —he was the nighthawk for the outfit and had to stay with the horse herd—but his friends described the details to him the next morning, at least those they could remember. *In without Knocking* is one of the many examples of the artist's remarkable memory. Although it was painted twenty-six years after the incident occurred, some of the participating cowboys swore the details in the painting were just as they had described them to Russell.

1909. Oil on canvas, 20 1/8 × 29 7/8". Signed lower left: CM Russell (skull) 1909. Ex-collection: Howard Elliot, St. Paul, Minnesota; Sir Henry Mill Pellatt, Toronto, Canada. (ACM 201.61)

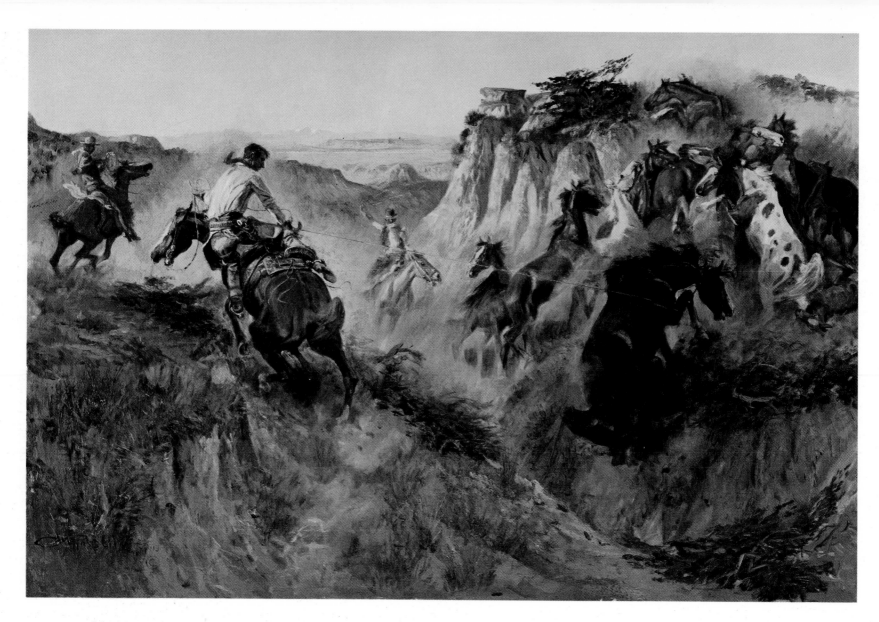

105. Wild Horse Hunters

In range parlance the cowboy with his rope on the wild stallion in this painting is a dally-man. After making his catch he has taken a dally or half hitch around his saddle horn and in case of trouble is in a position to either tighten up on the rope, or give it some slack. The term comes from the Spanish *dar la vuelta*, meaning to take a turn or hitch. The American cowboy corrupted this to "dally welter," or, more simply, "dally." In contrast, a tie-hard-man was a cowboy who tied the end of his rope to the saddle horn, in full confidence that he and his horse could handle anything on the other end.

1913. Oil on canvas, 30 1/8 × 47″. Signed lower left: CM Russell (skull) 1913. Ex-collection: Richard Mellon, Pittsburgh, Pennsylvania. (ACM 209.61)

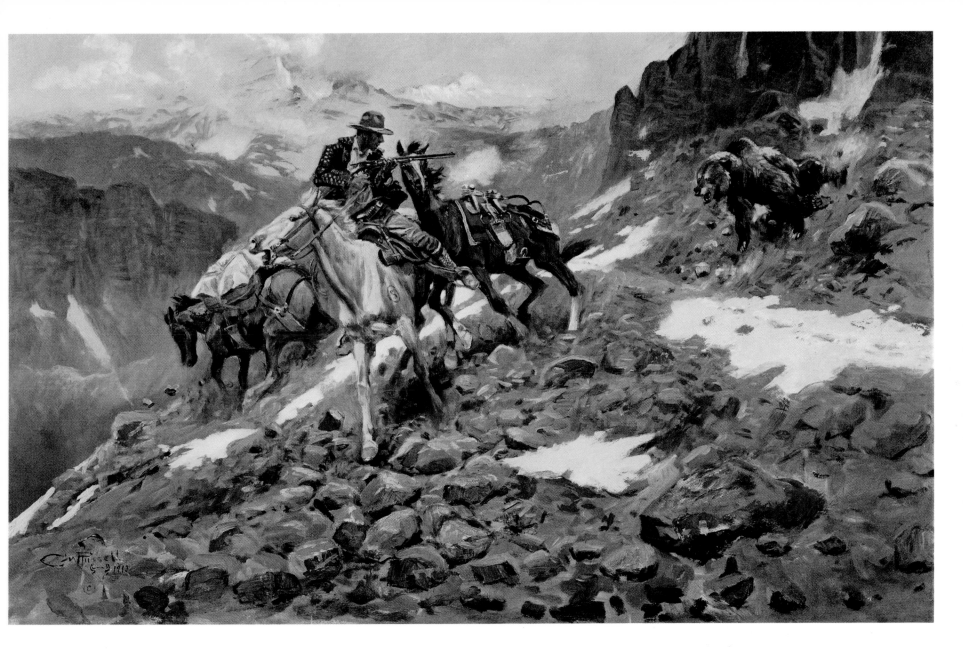

106. Crippled but Still Coming

Most Russell collectors will be surprised to see a brand on the saddle horse in this painting, knowing the horse is unbranded in the colored print with which they are familiar. After being reproduced, the painting was purchased by Judge James Bollinger of Davenport, Iowa. Some years later Russell visited the Bollingers and happened to ask Steve, the Judge's young son, what he planned to be when he grew up. "A cowboy," said Steve, who had been reading stories of the wild West. "What is your brand?" asked Charlie. To the amaze-ment of the Judge, who had been unaware of his small son's interest, the answer "Circle S" came quick as a flash. Russell promptly borrowed a brush and Steve's schoolboy paints and, to the delight of his audience, proceeded to add Steve's brand to the shoulder of the saddle horse in the painting.

1913. Oil on canvas, 30×48″. Signed lower left: CM Russell (skull) 1913.
Ex-collection: Judge James Bollinger, Davenport, Iowa. (ACM 207.61)

133

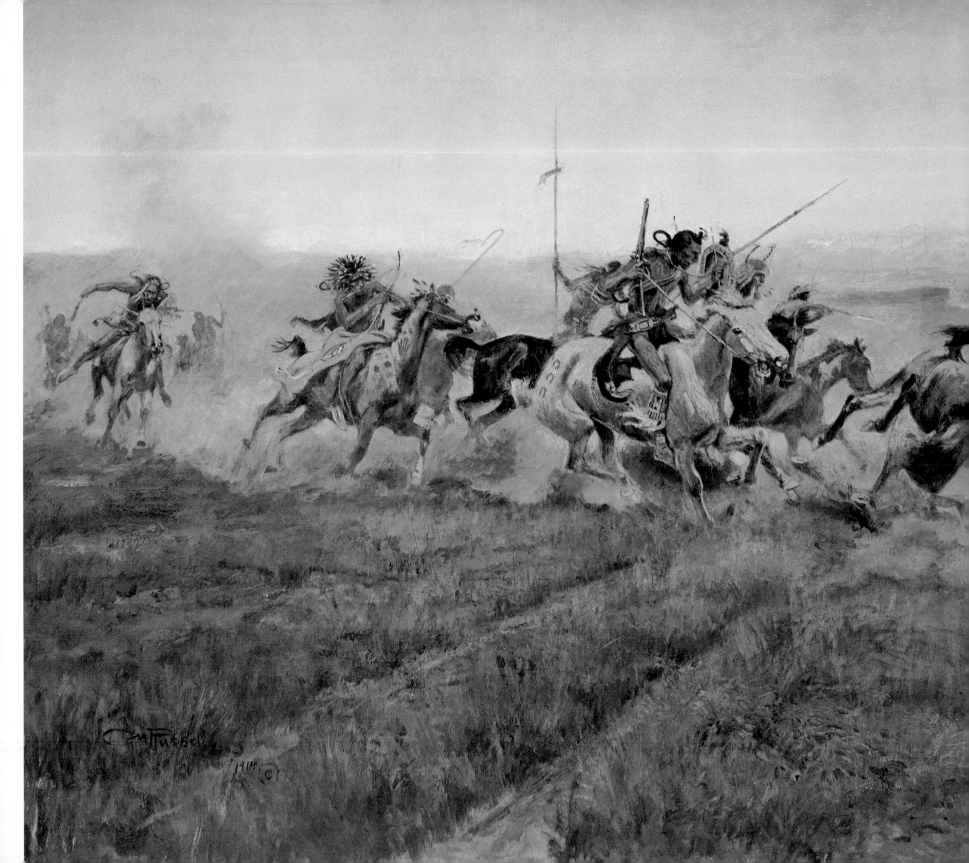

107 . Jumped

Being "jumped" by a band of plunder-minded Piegans was only one of the many hazards in the early days of the "Whoop-Up Trail." Long forgotten by many historians, this important avenue of commerce saw the movement of literally millions of dollars worth of supplies that linked the Canadian and American West. The trail was the route to the "whiskey forts" on the Canadian side of the line and got its name from the action of both traders and Indians who "whooped it up" after partaking of their principal trade goods—whiskey. Its northern terminus was Fort Whoop-Up, built in 1869 near the site of modern Lethbridge, Alberta. Its southern end was 240 miles to the south at Fort Benton, the head of navigation on the Missouri in Montana Territory.

Arrows, lances, and a few smoothbore guns were no match for the resourceful and heavily armed wagon masters and their crews who travelled the Whoop-Up Trail. After a few attacks the Indians found it wiser to let the wagon trains go through unmolested.

1914. Oil on canvas, 30×48″. Signed lower left: CM Russell (skull) 1914. Ex-collection: John E. Lewis, Belton, Montana; Nettie Claire Lewis, Belton, Montana. (ACM 157.61)

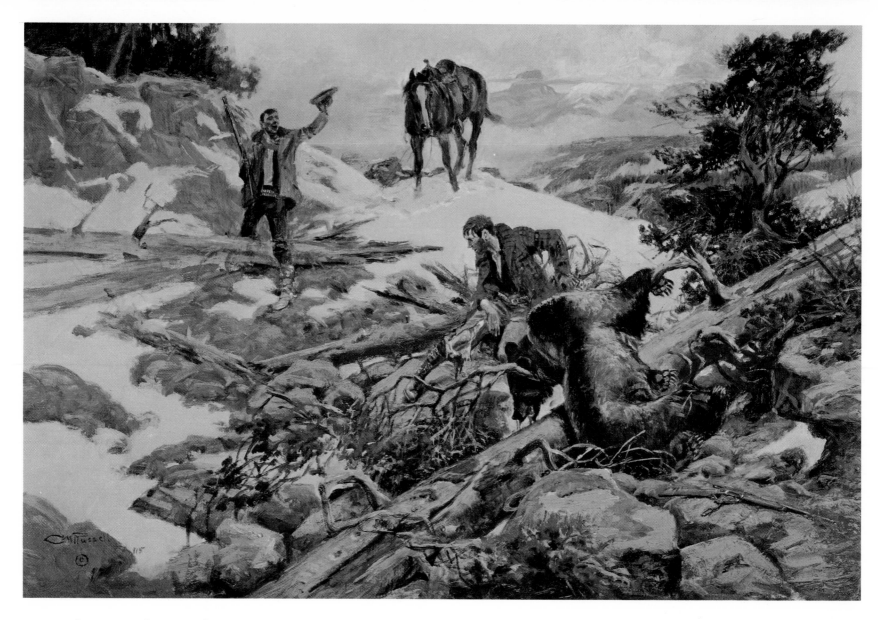

108. The Price of His Hide

Hank Winters and his partner, Bed-Rock Jim, were prospecting in the Big Snowy Mountains when their camp was raided by a bear. Winters decided he would have the bear's hide and the following morning started to trail the animal. As Winters told the story:

I plunge into the brush through the timber lookin' for trouble, an' it ain't long till I find it. I hear a roar like all hells turned loose, an' that bear's on me before I can bat an eye. I fire one shot but I'm so rattled she goes wild. Before I can throw in another ca'tridge he knocks the gun loose from my hand and his claws tear my right sleeve from the shoulder down, cuttin' my arm plumb to the bone. Just as everythings turnin' black, I hear Bed-Rock's Winchester an' the way he throws lead shows he ain't no stranger to a gun. When I come to I ain't got rags enough on to pad a crutch.*

The Price of His Hide was Russell's interpretation of Winters' story.

1915. Oil on canvas, 23 × 35″. Signed lower left: CM Russell (skull) 1915. Ex-collection: Sid Willis, The Mint, Great Falls, Montana. (ACM 210.61)

* *The Plevna Herald*, June 5, 1920, p. 3.

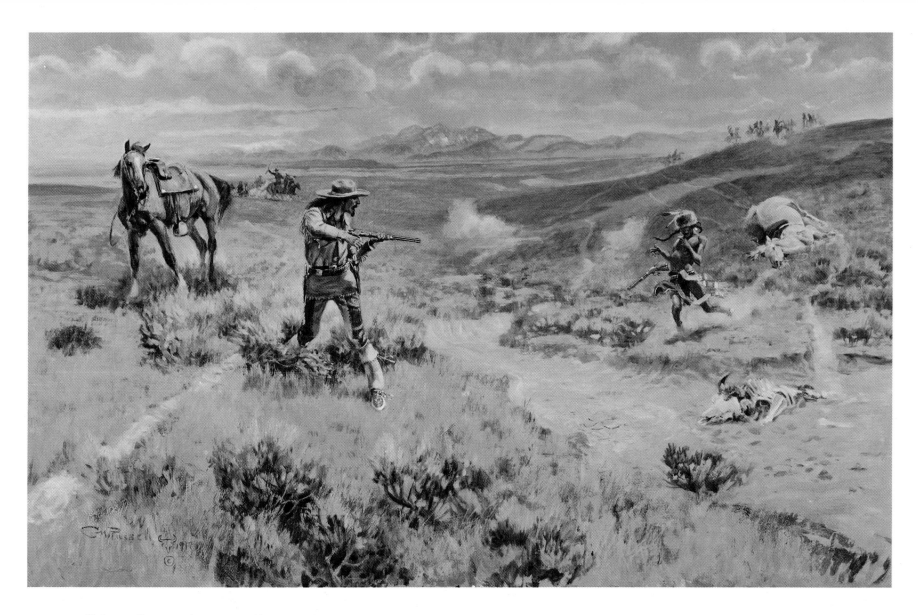

109. Buffalo Bill's Duel with Yellowhand

Three weeks after Custer's annihilation the Fifth Cavalry, under the command of Major General Wesley Merritt, took to the field to cut off the Cheyennes reportedly about to bolt the Red Cloud Agency in northwestern Nebraska. Buffalo Bill was the chief scout for the outfit and on the morning of July 17, 1876, was leading a small detachment toward an advance party of Indians seen approaching along War Bonnet Creek. Signalman Chris Madsen was stationed on a nearby butte with a telescope and it was probably his eye-witness account that furnished Russell with the factual basis for this pen-and-ink drawing. According to Madsen:

Cody was riding a little in advance of his party and one of the Indians was preceding his group. The instant they came face to face their guns fired. Cody's bullet went through the Indian's leg and killed his pony. The Indian's bullet went wild. Cody's horse stepped into a prairie dog hole and stumbled. Cody jumped clear and taking deliberate aim, fired a second shot after the Indian's second shot had missed. Cody's bullet went through the Indian's head and ended the battle. Buffalo Bill went over and neatly removed the scalp of the fallen Indian, who, it turned out, was a Cheyenne subchief called Yellow Hair, or Yellowhand.*

1917. Oil on canvas, 29 7/8 × 47 7/8″. Signed lower left: CM Russell (skull) 1917. Sid W. Richardson Collection.

* D. Russell, *Buffalo Bill*, p. 226.

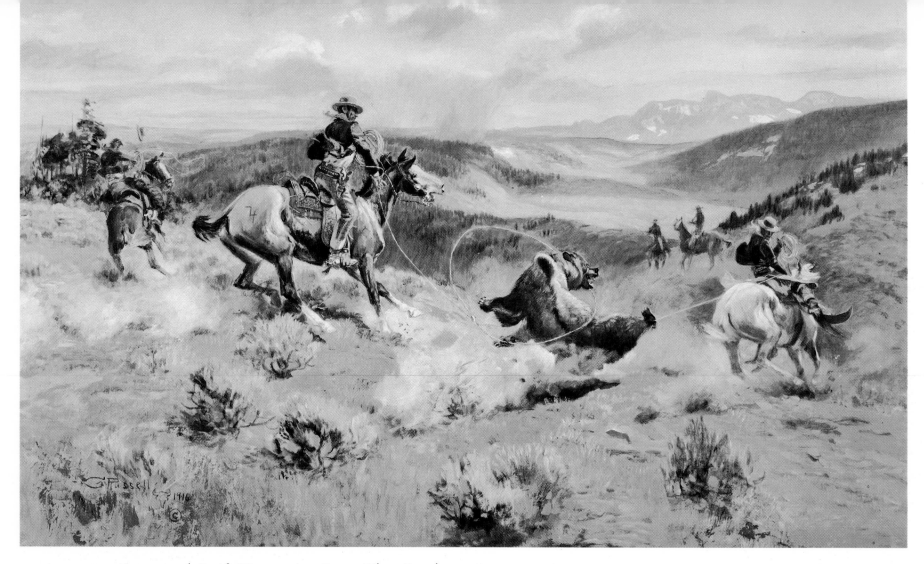

110. *Loops and Swift Horses Are Surer Than Lead*

Wallace Coburn, who wrote *Rhymes from a Round-Up Camp*, told his friend Charlie Russell about this incident which occurred in 1904 at the head of Larb and Timber creeks south of Saco, Montana.* Coburn was "reping" for the Circle C outfit and Charlie Shufelt, Joe Reynolds, and Frank Howe were some of the other cowboys on the roundup.

It had been raining and early in the morning the nighthawk reported that about forty head of horses had gotten away during the night and were still missing. William Jaycox, the foreman, rode to the top of a hill and discovered the missing horses coming toward camp at breakneck speed. After shouting that they were not being chased by a man he started toward them at a lope. About the same time the searching cowboys discovered the horses and saw they were being chased by a huge brown bear. Shufelt, astride a big bronc, got in close to the bear, who took a swipe at his horse, pulling out a pawfull of its tail. The frightened

horse stampeded and Shufelt spent the next few minutes trying to stay aboard. Reynolds and Howe made several casts at the bear but every time they got a loop over the bear's head she would throw it off. Finally, Reynolds managed to get a rope on her hind feet, giving Howe a chance to drop a loop over the bear's head. There wasn't a gun in the crowd and so the frightened horses held the bear while the men killed her with rocks.

In painting the scene Russell had to have at least one of the cowboys properly dressed and he has shown Frank Howe wearing a gun.

1916. Oil on canvas, 29 1/2 × 47 1/2". Signed lower left: CM Russell (skull)
1916. Ex-collection: C. C. Conway, New York City; H. Edward Manville, Pittsburgh, Pennsylvania. (ACM 180.61)

* *Great Falls Tribune*, November 7, 1937, p. 3; February 15, 1939, p. 5.

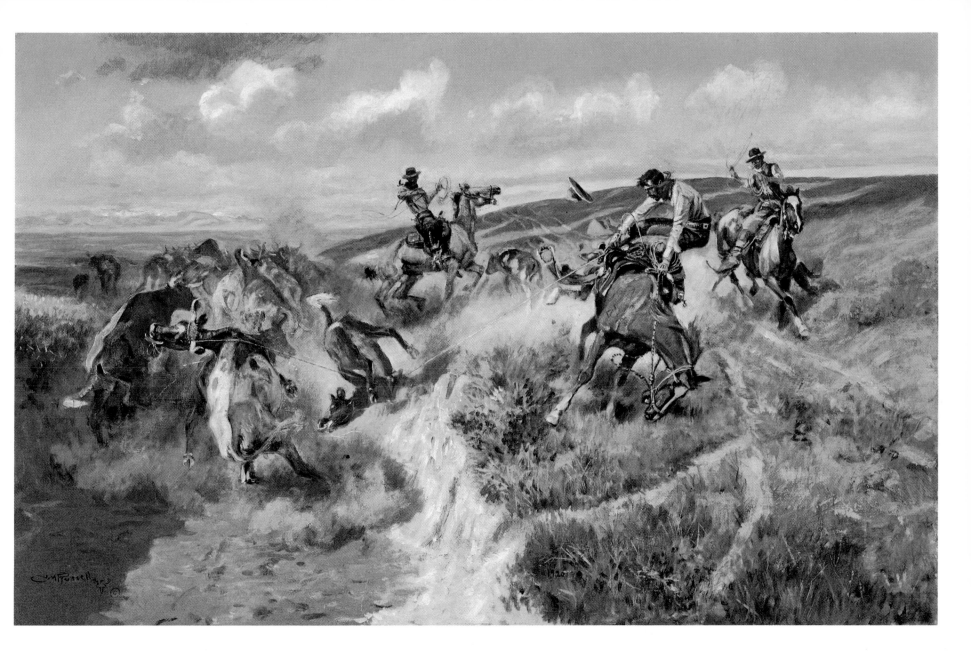

111. A Tight Dally and a Loose Latigo

The "dally" was the half hitch the cowboy took around his saddle horn after making a catch; the latigo was the strap connecting the cinch and the riggin' that held his saddle on. When one was tight and the other loose, the cowboy was in trouble, especially if his bronc decided to start pitching at about that time. The famous Judith Basin appears in the background of this painting and the Bar Triangle brand on the horse tells us that the cowboy was from the Greely Grum outfit ranging south of Judith Gap. As he did with so many of

his paintings, the artist left a part of the story to the imagination of the observer. We can only guess whether the cowboy gained control of his horse, or the saddle slipped and the rider ended up under the feet of one of the frightened animals.

1920. Oil on canvas, 30×48″. Signed lower left: CM Russell (skull) 1920. Ex-collection: C. R. Smith, New York City; H. E. Britzman, Pasadena, California. (ACM 196.61)

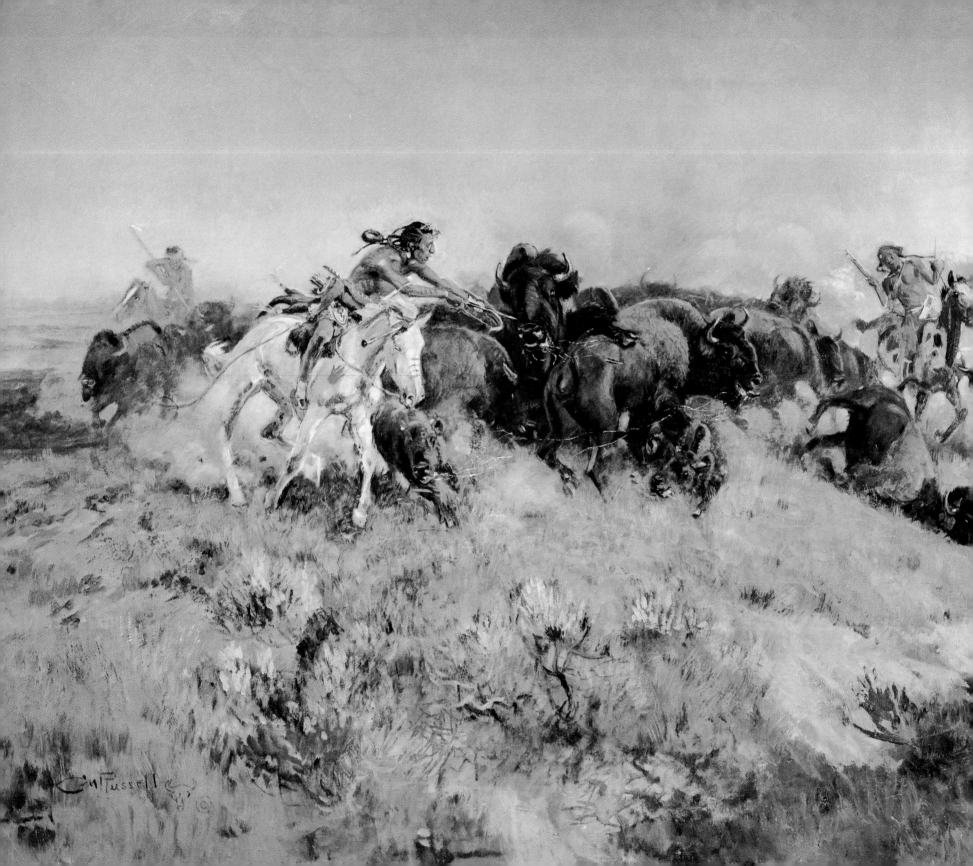

112. The Buffalo Hunt No. 40

No two of the hundreds of paintings that Russell completed during his lifetime are identical. This one, and the painting shown in Plate 76 are so nearly alike in composition, however, that they might have been the same scene a few seconds apart. *The Buffalo Hunt No. 39* was destined for a show at the Minneapolis Institute of Arts in 1919 when it was unexpectedly sold to the artist's friend Will Rogers. Russell thereupon proceeded to paint this one to meet his commitment to the Minneapolis gallery.

1919. Oil on canvas, 30 × 48″. Signed lower left: CM Russell (skull) 1919. Ex-collection: H. Edward Manville, Pittsburgh, Pennsylvania. (ACM 208.61)

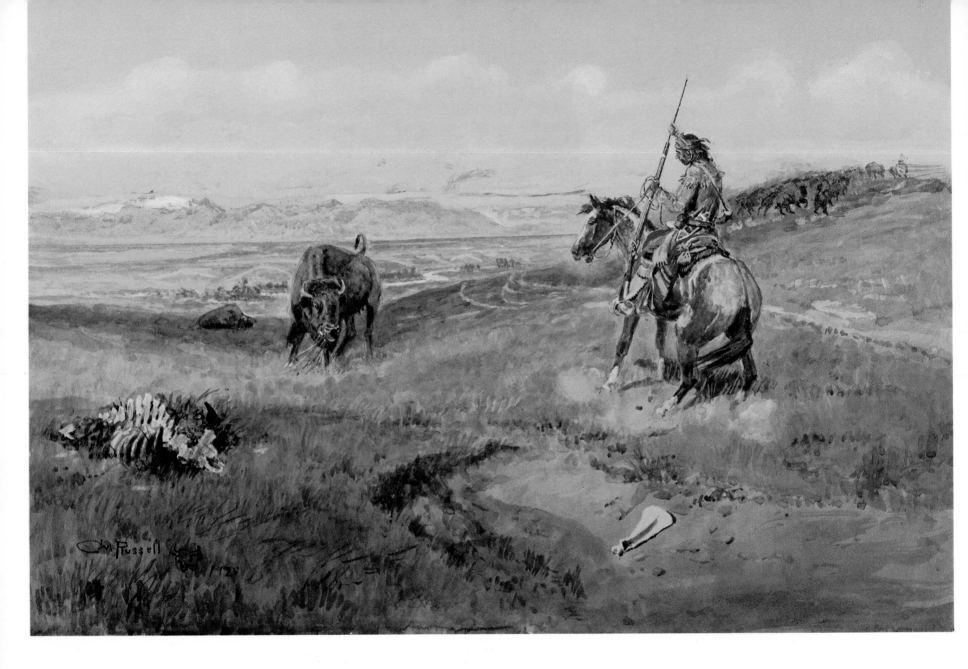

113. *Flintlock Days—When Guns Were Slow*

Few of Russell's works better express the artist's deep feeling of nostalgia for the passing of the early West than this, one of his last paintings. By 1925 the rich lands of the Judith Basin, which he has shown in the distance, had been turned grass side down. Even the bawling longhorns had long since come and gone. Russell was remembering the people and the country as he had seen them a half century earlier. His buffalo, mortally wounded but

glaring defiance at the mountain man tamping down a ball for a second shot, might well express Russell's own defiance at the thing he hated most—the advance of civilization.

1925. Watercolor, 20×29 3/4″. Signed lower left: CM Russell (skull)
1925. Ex-collection: John E. Lewis, Belton, Montana. (ACM 101.61)

ILLUSTRATED LETTERS

For an artist who completed between three and four thousand works of art during a comparatively short lifetime, it is surprising that Russell had very much time for letter writing. The fact remains, however, that he carried on a correspondence with literally hundreds of his friends. Russell illustrated almost all of his letters, sometimes with a pen drawing, more often with a beautifully executed little watercolor painting. Nineteen of these letters and one illustrated Christmas card are in the Amon Carter Collection. Since they have been previously published in *Paper Talk* (Fort Worth: Amon Carter Museum of Western Art, 1962), four are published here; the others are only listed.

114. Friend Sid [Willis], May 3, 1907 One watercolor illustration; one page, 6 1/4 × 10″. Signed: CM Russell. Ex-collection: Sid Willis, The Mint, Great Falls, Montana. (ACM 309.61)

115. *Friend Sid* [Willis], April 20, 1914

One pen, ink, and watercolor illustration; one page, 6 1/2 × 8 3/4″. Signed: CM
Russell. Ex-collection: Sid Willis, The Mint, Great Falls, Montana. (ACM 302.61)

GREET NORTHERN HOTEL
NEW YORK

March 2¹ 1916

Say Sid
 dont let
nobody tell you this
is a good place to
winter
for snow this camp
would make Neihart
look like Palm beach
an if it wasent for shovel
men Little Bears folks
could come back here an git all
kinds of coin building snow shoes
for these Cliff dwelers
of corse the thermometer dont fall
down like it dos out in Gods coun
try
but its a safe bet thes breeses

aint no relation to a chinook
I can tell the sun shines here by
the light on the sky serapers
but I have onley seen the sun
once and then I was looking
streight up
the onely one I seen from out
home was a Silver tip in
Sentral Park and he looked
home sick
Sid theres a few people in montana
I dont care for but when I git
back here theres nobody out
home I dont like so give my
regards to everybody
and your self
 your friend
 C M Russell

116. *Say Sid* [Willis], March 21, 1916

One pen, ink, and watercolor illustration; two pages, each 6 1/2 × 5″. Ex-collection: Sid Willis, The Mint, Great Falls, Montana. (ACM 307.61)

Aug 2⁵ 1917

Friend Jim

I got a box of cantilope
there was no name with them

all so a big water melon
but Im a good guesser
Jim among moovies your not always a good picker
But in a melon patch your a Judg and a Gentilman
Iv been told that to read the good things in a melon
through its hide must be learned in boy hoods happy
hours if this is true judging from the quality of frute
you sent us its a saf bet you got bird shot in your
hide right now
As well as I know you Purk if I owned a patch of the
water frute and I saw you in the naber hood right then
when Id start night hearding my melons and Id
hang a bell on the big ones
 give my regards to the home gard
for your self at the sugar store hold som out
 with many thanks your friend
 CM Russell

117. *Friend Jim* [Perkins],
August 25, 1917

One pen, ink, and watercolor illustration; one page,
10 3/4 × 8 3/8″. Signed: CM Russell. Ex-collection: Sid Willis,
The Mint, Great Falls, Montana. (ACM 306.61)

BARROOM AND OTHER HUMOR

All but one of the humorous sketches that follow were originally in The Mint Collection. Some of these were done specifically for Sid Willis, the artist's long-time friend and the proprietor of this famous saloon. Others include a series of humorous watercolors Russell did for reproduction on post cards, Willis acquiring the originals after they were used for this purpose. A few are the for-men-only type, which were hung in one of the private rooms of The Mint and were not seen by the general public.

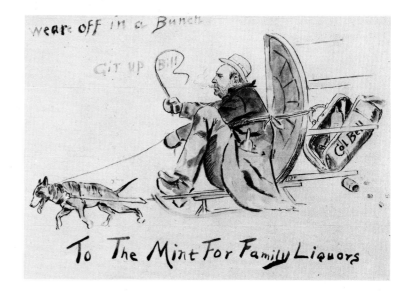

118. Colonel Bell

Colonel Bell was an old-time Great Falls gambler, who made book on the races. Russell's cartoon shows him leaving Great Falls after getting news of the Alaska gold rush. The Colonel's title, like his favorite beverage, was of the "Kentucky" variety.

n.d. Pen, ink, and watercolor, 12 1/8 × 19 1/4". Unsigned. Ex-collection: Sid Willis, The Mint, Great Falls, Montana. (ACM 283.61)

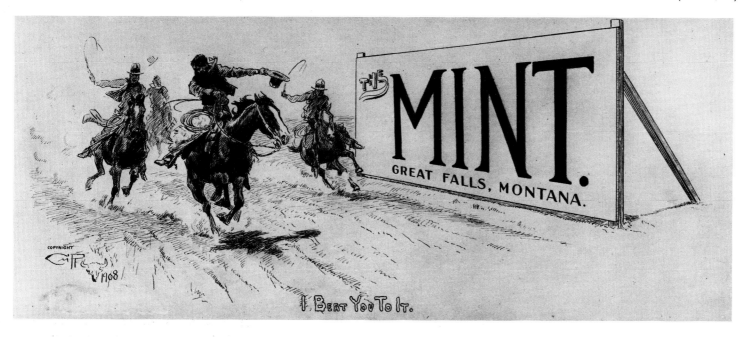

120. I Beat You to It

Cowboys are shown racing to the huge sign that stood on the outskirts of Great Falls in the early days. Russell did this watercolor for reproduction on The Mint letterheads.

1908. Pen, ink, and watercolor, 8 1/8 × 19 5/8". Signed lower left: CMR (skull) 1908. Ex-collection: Sid Willis, The Mint, Great Falls, Montana. (ACM 296.61)

William H. Rance, the proprietor of the Silver Dollar, wanted something decorative that would appeal to his rowdier patrons and Russell was persuaded to do this series of four watercolors depicting some of the hardships of cowboy life. The contents of the bottle in the last scene are not whiskey, as might be assumed, but a well-known pain killer of that period.*

After the Silver Dollar closed its doors with the coming of Prohibition, the four paintings passed into the possession of The Mint, the equally famous establishment across the street in Great Falls.

* *Great Falls Tribune*, January 14, 1898, p. 4.

119. *Just a Little Sunshine*

c. 1898. Watercolor, 13 1/8 × 9 3/4″. Signed lower left: CM Russell (skull). Ex-collection: William H. Rance, the Silver Dollar, Great Falls, Montana; Sid Willis, The Mint, Great Falls, Montana. (ACM 281.61)

120. Just a Little Rain

c. 1898. Watercolor, 13 × 10 7/8″. Signed lower
left: CM Russell (skull). Ex-collection: William
H. Rance, the Silver Dollar, Great Falls, Mon-
tana; Sid Willis, The Mint, Great Falls, Montana.
(ACM 282.61)

121. *Just a Little Pleasure*

c. 1898. Watercolor, 13 1/2 × 10 1/2″. Signed
lower left: CM Russell (skull). Ex-collection:
William H. Rance, the Silver Dollar, Great Falls,
Montana; Sid Willis, The Mint, Great Falls,
Montana. (ACM 285.61)

122. *Just a Little Pain*

c. 1898. Watercolor, 13 3/8 × 10 3/8″. Signed lower left: CM Russell (skull). Ex-collection: William H. Rance, the Silver Dollar, Great Falls, Montana; Sid Willis, The Mint, Great Falls Montana. (ACM 286.61)

123. *When East Meets West*

The early West also saw a few lady dudes. This one was probably on her way to the
Bon Ton, Great Falls' fanciest store, when Russell did this watercolor.

c. 1907. Pen, ink, and watercolor, 12 1/2 × 20. Signed lower left: CM Russell (skull). Ex-collec-
tion: Sid Willis, The Mint, Great Falls, Montana. (ACM 132.61)

The cow-boys were very kind – lending me what they called a lady's saddle horse. I found the animal rather rough – but you know riding is splendid exercise and that is what the Dr. advised.

Stay with him!

126. *Stay with Him*

Giving the visiting Easterner the roughest horse in his string, while assuring him the animal was "plum' gentle," was a standard cowboy joke. Of course this was before the days of the modern dude ranchers, who like to have their guests come back for a second visit.

1907. Pen, ink, and watercolor, 7 1/2 × 11 1/8″. Signed lower left: CMR (skull) 1907. Ex-collection: Sid Willis, The Mint, Great Falls, Montana. (ACM 291.61)

127. *Bold Hunters: Heavens! A Grizzly Bear*

Porcupines were a common sight around the Russells' summer home on Lake McDonald, but it took Charlie's vivid imagination to see the resemblance between one and a mighty grizzly.

1907. Pen, ink, and watercolor, 7 1/2 × 12 1/4″. Signed lower left: CMR (skull) 1907. Ex-collection: Sid Willis, The Mint, Great Falls, Montana. (ACM 295.61)

Bold Hunters
Heavens! a grizzly bear

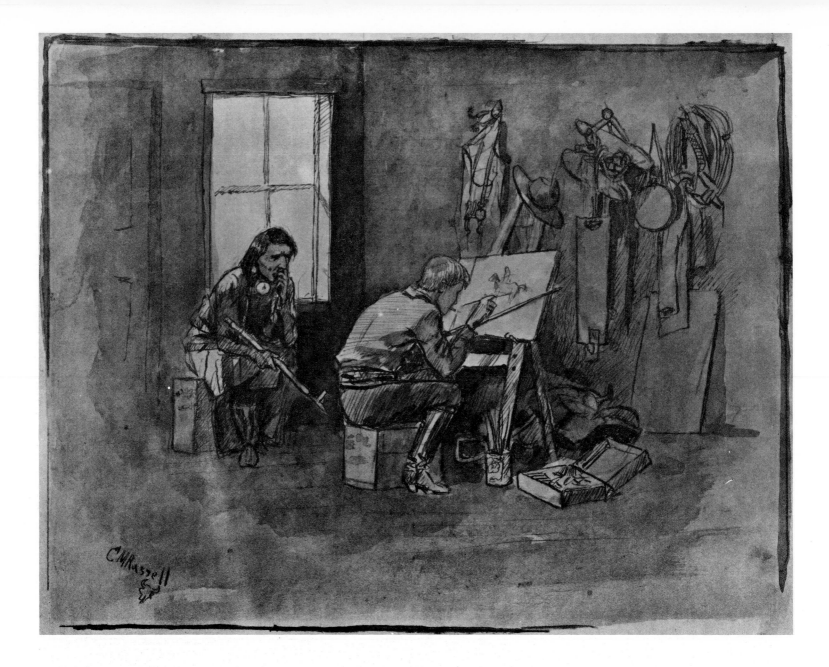

128. Contrast in Artist's Salons — Charlie Painting in His Cabin

Russell's first "studio" was a corner in Jim Shelton's saloon in old Utica and after he moved to Great Falls he had similar working places in The Maverick and The Mint. The studio in this drawing was a small shack on the Ben Roberts' place in Cascade, Montana, where Charlie spent a winter before his marriage. The sketch had been dis-

carded and was found there by Mr. Roberts after Charlie left for the spring roundup.*

c. 1891. Wash drawing, 6 1/2 × 8 3/4″. Signed lower left: CM Russell (skull).
Ex-collection: Sid Willis, The Mint, Great Falls, Montana. (ACM 305.61 A)
* *Helena Record Herald*, July 12, 1929, p. 5.

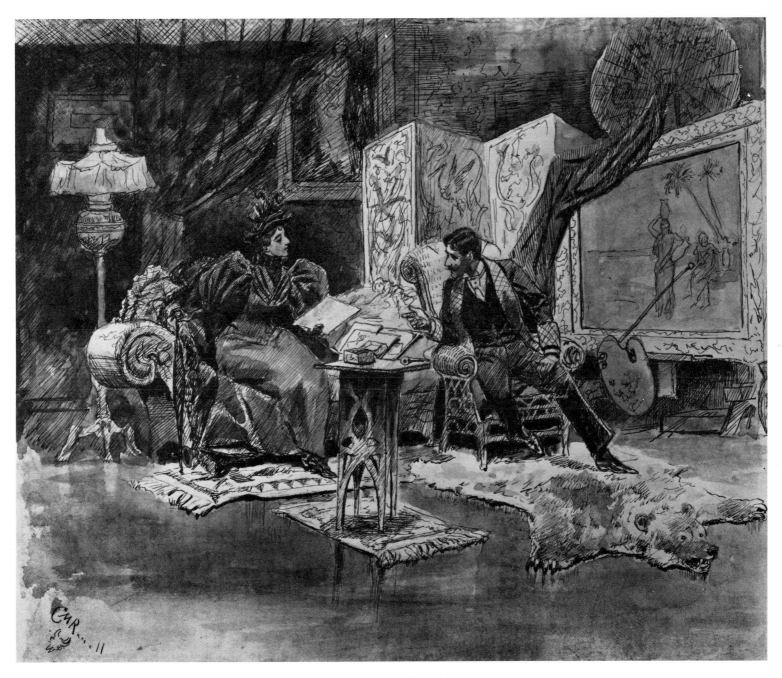

129. *Contrast in Artist's Salons — My Studio as Mother Thought*

Charlie's dream of having a studio where he could paint undisturbed was finally realized in 1903. This was a specially built cabin of telephone poles on the lot adjoining the Russells' home in Great Falls. During its construction a friend asked if he was building a corral, which almost made him abandon the project. Once it was finished it was his pride and joy. Charlie's mother in far-off St. Louis may have visualized the kind of a studio Charlie has shown in this drawing. In reality, instead of the elaborate furnishings, Charlie's pack saddle, Indian relics, and other "gatherings" of his early days in Montana adorned the walls.

c. 1891. Wash drawing, 7 5/8 × 8 1/2″. Signed lower left: CM Russell (skull). Ex-collection: Sid Willis, The Mint, Great Falls, Montana. (ACM 305.61 B)

TYPICAL RUSSELL SIGNATURES AT DIFFERENT PERIODS

1880 CMR

1881 CMR

1885 CMR

1887 CMR CMRussell

1888–1891 CMRussell

1892–1895 CMRussell

1895 CMRussell

1896 CMRussell

 CMRussell

1897–1926 CMRussell

INDEX

157